Photo Story

Photo Story

Selected Letters and Photographs of
Lewis W. Hine

Edited by DAILE KAPLAN

Smithsonian Institution Press
Washington and London

Editor: Gretchen Smith Mui
Production Editor: Duke Johns
Designer: Susan Lehman

Library of Congress Cataloging-in-Publication Data
Hine, Lewis Wickes, 1874–1940.
 Photo story: selected letters and photographs of Lewis W. Hine /
[edited by] Daile Kaplan.
 p. cm.
 Includes bibliographical references and index.
 ISBN 1-56098-169-5
 1. Hine, Lewis Wickes, 1874–1940—Correspondence.
 2. Photographers—United States—Biography. I. Kaplan, Daile.
 II. Title.
 TR140.H52A3 1992
 770'.92—dc20
 [B] 91-37951

British Library Cataloguing-in-Publication Data is available

Manufactured in the United States of America
99 98 97 96 95 94 93 92 5 4 3 2 1

♾ The paper used in this publication meets the minimum requirements of the
American National Standard for Permanence of Paper for Printed Library Materials
Z39.48-1984

The editor has made every effort to trace copyright holders to all preexisting materials
included in this book. If in good faith any acknowledgment has been overlooked, the
editor should be contacted in care of the publisher, Smithsonian Institution Press,
Washington, D.C. 20560. For permission to reproduce illustrations appearing in this
book, please correspond directly with the owners of the works, as listed in the
individual captions. The Smithsonian Institution Press does not retain reproduction
rights for these illustrations individually, or maintain a file of addresses for photo
sources.

For Donna

Contents

6. The Social Documentary Photograph as Art, 1938–39

7. Hope and Loss, 1939–40

Illustrations

"Looking out on Lower Manhattan from the Empire State Building."
"Placing the Derrick."
"A Connector Goes Aloft."
Cover photograph for *Men at Work*.
Image from Hine's Empire State Building series.
Work portrait triptych.

Editorial Policy

Lewis Hine's photographs address a range of social issues emblematic of twentieth-century concerns, but his letters do not reflect stylistic conventions associated with modern epistolary form. Hine's typical punctuation after salutations—a colon followed by a dash—has been retained. A common form of punctuation in the texts of the letters themselves is a comma followed by a dash, which in most instances has been changed to a comma; however, if greater emphasis is required or if sentence structure dictates, it has been changed to an em dash. Hine habitually put periods after dates at the beginning of letters and after typed names at the end of letters; these have been omitted, as have commas at the end of lines within addresses. Apostrophes have been added to contractions and to possessives where necessary. Ampersands have been retained. Obvious misspellings have been silently corrected. Since many of the letters are typewritten and reflect the inconsistencies of an unskilled typist, odd spaces between words or between a word and a mark of punctuation have been corrected.

Hine's capitalization of his invented terminology (for example, "Work Portraits") and of the concepts of his photo stories ("Industry," "Child Labor," and so forth) has been retained. Words that Hine hyphenated unnecessarily (such as "to-night," "slow-down," and "broad-casting," for example) have been set solid. However, for words related to Hine's

developing field of endeavor (such as "photo-studies," "roto-features," and so on), hyphens have been retained.

The letters generally have been arranged both chronologically and thematically. In the interest of maintaining thematic unity, occasionally a grouping of letters devoted to a particular issue will breach the confines of a strict chronological sequence. In instances where a letter is originally undated and a date has been added at some later point by the recipient of the letter, that date appears in brackets.

When a letterhead on a sender's stationery appears for the first time, it is given in the first note to the letter. Addressees and persons referred to in the letters are identified as fully as possible in citations that follow. In instances where the letters are carbon copies and do not contain a signature, first or full names have been added where appropriate. An abridged reference to the source or collection is the final element.

Foreword

I first saw Lewis Hine's work in a magazine and decided to go and visit him. My reaction was that strong; a good photograph fascinated me, and Hine had his own style.

I went to his home in Hastings-on-Hudson in 1937. It was clear that he was having grave economic difficulties. He had had intermittent work throughout the decade but was quite worried. I wanted to help him.

I bought some of his photographs and introduced him to several photo editors. I also introduced him to members of the Photo League. Later on, Elizabeth McCausland and I organized a retrospective of his work at the Riverside Museum in New York. I actually made some of the prints for that exhibition. While the show brought his photographs to the public's attention, it was not a big success; there wasn't then the interest in or appreciation of photography as an art form.

Today there is a lot of discussion and dispute about whether someone like Hine made "documentary photographs." Or whether photography is an art form. These are simply labels—the American desire to reduce everything to a formula. I don't see Hine's work as being politically

In response to Daile Kaplan's invitation to provide a foreword for this book, Berenice Abbott agreed to an interview in June 1990. These comments are excerpted from the interview transcript.

motivated; he was a photographer who was good at his profession. In a way, just about any photograph is a document. And photographs don't become art unless they're good photographs.

<div align="right">Berenice Abbott</div>

Acknowledgments

There is a phenomenon in the photographic community—dare I say tradition?—of contemporary photographers rescuing the work of historical photographers: Berenice Abbott's efforts vis-à-vis Eugène Atget, Lee Friedlander's in relation to E. J. Bellocq, and Walter Rosenblum's with regard to Lewis Hine. No doubt, many more instances of this phenomenon have occurred. Nothing like it appears to exist in other artistic fields. Hine is the only photographer who has been the beneficiary of such an endeavor not just once but twice.

More than a decade ago, as a young photographer I became enamored of a group of unattributed photographs in a photograph collection owned by the United Methodist Church with which I was working. Deeply moved by the imagery, I decided to find out who made them and for what purpose. After much investigation and a good bit of detective work, I discovered that they were Lewis W. Hine's "lost" European prints, made under the aegis of the American Red Cross, which scholars had attempted to locate for forty years. I never anticipated how Hine would alter my own work and shift my focus from making pictures to writing about them. Nevertheless, this book, as well as the one that preceded it, *Lewis Hine in Europe: The "Lost" Photographs*, is the result of yet another photographer being profoundly affected by a historical photographer's vision.

During the past eleven years I have been fortunate to have worked with many marvelous professionals, all of whom helped make this book possible. Thanks are due George Hobart, photographic specialist, Prints and Photographs Division, Library of Congress, Washington, D.C., and Katherine Crum for their continual support and Claire Monnier for sharing her insightful reading of Hine's letters. My appreciation goes to David Klaassen, Social Welfare History Archives; Andy Anderson and David Horvath, University of Louisville; F. Jack Hurley, Memphis State University; Mary Alison, Hastings Historical Society; Kitty Hobson, Oshkosh Public Museum; and Rachel Stuhlman, International Museum of Photography at George Eastman House, for their clarification of most of the unfamiliar names and issues raised in the letters. A very special thanks to Beaumont Newhall and Berenice Abbott, both of whom discussed their recollections of Hine as they knew him in the late 1930s.

I appreciate the generosity of Mercy P. Kellogg, Carter H. Manny, Jr., Phyllis W. Wilson, Beaumont Newhall, and Naomi and Walter Rosenblum in making materials available for publication. I am grateful to Harry Lunn, Jr., Bob Mann, the New York Public Library, and Columbia University in the City of New York for extending permission to reproduce photographs from their collections. My thanks to the following institutions, which provided access to correspondence: Lewis W. Hine Collection, International Museum of Photography at George Eastman House; Paul U. Kellogg Papers, Social Welfare History Archives, University of Minnesota; Elizabeth McCausland Papers, Archives of American Art, Smithsonian Institution; and Roy E. Stryker Papers, Ekstrom Library, University of Louisville. I am deeply grateful to the Kaltenborn Foundation, the American Photographic Historical Society, and the Smithsonian Institution Press Scholarly Book Fund for grants that allowed me to complete the manuscript. To Amy Pastan, special kudos: her love of books and Hine's work made the process of editing the letters a delightful one. Finally, a debt of gratitude to editors Duke Johns and Gretchen Smith Mui, who skillfully worked with me and gracefully coordinated the myriad details of this project.

Introduction

Within the past fifteen years, perhaps no other American photographer has been the subject of and subject to such concentrated critical and popular attention as Lewis Wickes Hine (1874– 1940). The landmark exhibition "America and Lewis Hine," which opened at the Brooklyn Museum in 1977 and then toured nationally, reintroduced Hine's photographs of immigrants, child laborers, European war refugees, and industrial workers after almost forty years.[1] Subsequently, his name became synonymous with gritty images of the human condition. Indeed, in the pantheon of photographers, Hine's works were hailed as addressing issues inherently American and "photographic," in the tradition of Alfred Stieglitz, who first proposed photography as a medium of self-expression.[2]

Since then, Hine and his photographs have been celebrated in numerous national and international exhibitions, articles, and books. His photographs of immigrants at Ellis Island and in New York's Lower East Side, child workers, and war refugees have emerged as icons of American social history and are inextricably linked with the progressive-era social agenda and postwar internationalism. In addition, they are readily appropriated for magazine advertisements featuring a restored Ellis Island or promotions for community-minded corporations. Nevertheless, Hine continued to produce photographs during the 1920s and 1930s, al-

though his attempts at rendering Depression-era industrial relations have confounded aficionados and scholars alike.

The Origins of the Work Portrait

To a large extent much of the published material about Hine focuses on the first half of his career. Recently, however, scholars have begun to examine the problematic shift his photographs took after World War I, when he adopted a new methodology and began producing "photo interpretations" (his own term) of American labor, which he called "Work Portraits." Several critical issues have been raised about this later period, each of which relied on the obligatory formalist reading of his photographs: Was his approach political or artistic? Did he become an apologist for corporate America? Does the label "social documentary photographer" obscure his contributions as a photojournalist? Was he a "genius" whose later years were "glorious?"[3] As multiple layers of interpretation have been heaped on his photographs, something important has been lost: rarely has Hine's own written work elucidated his expectations and goals.

In this respect this book, which features material about Hine's early life and work and highlights aspects of the second half of his life, may bridge an important gap. In the letters Hine clarifies his motivations for embarking on what proved to be the very bumpy road of his postwar methodology. Alternately personal, professional, and philosophical, they describe the development and maturation of a principal figure in 20th-century photography, one who combined an Old World (that is, post-Victorian) moral sensibility with a modernist's eye for translating quotidian experience into transcendental imagery.

This book includes previously unpublished credos, diary entries, and letters Hine exchanged with prominent members of the photography, art, and social welfare communities, including Jane Addams, founder and director of Hull House, Chicago; Berenice Abbott, the photographer, and Elizabeth McCausland, the art critic, who together were responsible for mounting the first Hine retrospective; Beaumont Newhall, librarian and acting curator of photography at the Museum of Modern Art; Walter Rosenblum, photographer and member of the

Photo League; Roy E. Stryker, chief of the Historical Section, Farm Security Administration; and Paul U. Kellogg, editor of the progressive journal *Charities and the Commons* (renamed *The Survey* in 1909 and the *Survey Graphic* in 1921), the organ of the social welfare movement. In addition, it includes correspondence regarding work projects Hine completed for Sidney Blumenthal, president of Shelton Looms, as well as personal exchanges with Frank A. Manny, his mentor and former superintendent of the Ethical Culture School, where Hine first worked, and Owen Lovejoy, former director of the National Child Labor Committee, the organization Hine was affiliated with for more than seventeen years. The letters are arranged in chronological sequence to create a narrative flow. Although nearly all the letters were written during the last half of Hine's career, they pertain to his entire oeuvre.

The book's centerpiece is the correspondence between Hine and Kellogg, Hine's lifelong collaborator. Kellogg, who gave Hine his first professional assignment and by-line, championed his work tirelessly during the photographer's lean years, from 1920 to 1940. In their range of personal and professional themes, these letters best outline Hine's methodology and his pioneering experiments in and awareness of the creative process today known as photojournalism. Infused with wit, lyricism, and élan, they also detail a historically unique professional relationship between photographer and editor—one that prefigured the ballyhooed collaborations on *Life* and *Look* magazines from 1936 on.[4]

While much has been written about Hine's contributions as a social documentary photographer, who produces works in which social themes and social goals are paramount, these missives underscore his contributions as a photojournalist, who describes topical events through images and text. Hine proposed photo assignments to Kellogg, suggested photo layouts, shared insights into his methodology, and argued about picture rights and credits. From the letters it is clear that Hine understood the value of picture currency, and he lobbied to retain possession of his negatives and prints and exercise control over the manner in which his photographs were reproduced. (The importance of this issue was underscored once again in his correspondence with Roy E. Stryker.)

In addition to their discussions about work, these letters have a chatty quality, especially when Hine addresses the stuff of everyday life. Several

of his notes were handwritten; many are replete with personal touches—jokes, puns, and humorous adaptations of his and Kellogg's names. In the late 1930s, however, as the gravity of Hine's financial situation becomes increasingly clear, the drama of their exchange takes on a cinematic montage-like flow that circumscribes the tragedy of Hine's impending personal and financial losses—the death of his wife, Sara, in 1939 and the loss of his home the same year.

While Hine worked in a social documentary style, from the beginning he defined himself as an artist and even wrote about photography as an educational and artistic tool. Hine joined the storytelling and artistic possibilities of a photograph at a time when such a marriage was considered an anathema by "high art" photographers such as Alfred Stieglitz. As an artist Hine also sought to shape the ways in which his work was disseminated. He wrote descriptive captions for his photographs, designed exhibitions for the National Child Labor Committee that featured his own photographs, and, nearly eight years after he started working in this format, coined the term "photo story" to describe his assemblages of pictures and words.

In reviewing the legacy of Hine's published work, it becomes clear that he was not simply an "illustration" photographer who provided photographs to editors and writers to be used as they wished; he was an active participant in shaping the format in which his photographs were reproduced. Indeed, during the lengthy period he was employed by the National Child Labor Committee, Hine made photographs, but he was also responsible for providing caption information, which he compiled like an investigative reporter: What was the child's age? Height? Family situation? Years of employment? Job? Illnesses? Schooling? He then integrated—Hine would later use the term "synchronized"—this textual information with the photographs. The sequencing and designing of pictures and words would appear in several variations of the photo story format: picture books, exhibitions, and portfolios, a selection of ten to twenty original photographs arranged by Hine and produced in a limited edition.

By ordering a group of images in multipage graphic designs, Hine recognized the latent power of the iconographical image (along with authoritative text) as an effective and compelling communications tool.

Thus, these letters crystallize Hine's responsibility in developing a new graphic language instrumental in photography's successful assimilation into popular culture—the picture essay or photo story format. Hine used this sequencing of images and words consistently throughout his career; in his postwar work he used it effectively in a book he designed for adolescents called *Men at Work,* which featured work portraits from his Empire State Building series. [5]

A mystery that surfaced in researching Hine's letters is the absence of a comprehensive group of materials pertaining to the Empire State Building, the apotheosis of Hine's work portrait methodology. In 1930 Hine apparently made contact with the building's publicity firm through John Shreve, [6] one of his Hastings-on-Hudson neighbors. Although he spent at least six months documenting the construction of the building, balancing himself on high girders to make his masterful photographs, only a handful of letters relates to this project. The paradox of erecting the world's tallest building as a symbol of New York's economic prowess during the worst depression the country had ever experienced elicited the ire of the press and public alike. Did the controversy surrounding "Big Al's Shanty" cause Hine's uncharacteristic silence? This remains a question for future scholars to unravel.

Another oddity concerns the letters Hine exchanged with Roy E. Stryker. Hine made repeated attempts to convince Stryker, the 1930s' leading spokesperson for documentary photography and chief of the Historical Section, Resettlement Administration (later known as the Farm Security Administration), to hire him. But while Stryker paid homage to Hine in his correspondence and lectures and actively encouraged "his" F.S.A photographers to appropriate the documentary style Hine pioneered, [7] he refused to offer Hine freelance work as a staff photographer. Why he ignored Hine's direct pleas is not clear. Whereas Stryker supported Hine and helped him find important sponsors for the Riverside Museum retrospective, in the end the potential conflict posed by Hine's shrewdness regarding picture currency and his proprietary attitude toward his negatives may be possible reasons for Stryker's reluctance to take him on. [8]

The last group of correspondence—between Hine and the art critic and educator Elizabeth McCausland and the photographer Berenice

Abbott—is rich with details about his early life and photographic techniques. Hine shares anecdotes about his first trips to Ellis Island and his experiences as an investigator-photographer for the National Child Labor Committee. Although the boyish enthusiasm of the Kellogg letters pervades this material as well, these late-life epistles reflect Hine's heightened sense of himself as a historical figure. In this portion of the book one can begin to grasp photography's transformation as a medium. Turn-of-the-century Americans could not accept photographs as a form of illustration (they could not meet the "high art" standards of good taste epitomized by drawings or etchings of tranquil domestic or genre scenes) and viewed them as an invasion of privacy—not that of the people shown but of those who had to look at them. However, the readers of *Life* magazine accepted them as a form of documentation. Indeed, the documentary style Hine pioneered had been begun to be appreciated as "art."

At the inception of his career Hine was seen as a sociological photographer. His work was used primarily in social welfare journals and was an unconventional if not heretical approach to photography. But by 1938, the year he was introduced to McCausland, Hine saw others' photographs highlighted on the pages of *Life* and *Look,* whose editors overlooked him for freelance assignments, and photographers elevated to the status of artists.[9] That same year he was the subject of two articles by Beaumont Newhall, then librarian-curator at the Museum of Modern Art.[10] It is Newhall who truly rediscovered Hine and articulated the multiple layers in his work: "These photographs were taken primarily as records. . . . The presence in them of an emotional quality raises them to works of art."[11]

Abbott, who in the 1920s had rescued the work of another photographer, Eugène Atget, became aware of Hine's photographs after reading Newhall's first article. Soon after, she and Hine met at his Hastings-on-Hudson home. Abbott, who shared a house with McCausland and her sister Margaret in Greenwich Village, introduced Hine to McCausland.[12] Although both women were responsible for arranging a retrospective at the Riverside Museum (now the Nicholas Roerich Museum) in January 1939, Hine's letters are primarily to McCausland, who helped Hine make his selection of photographs and wrote a provocative catalogue essay.

During this six-month halcyon period, Hine was essentially preparing for the exhibition and ruminating about his life's work. He discussed his early influences and life experiences; the influence of his wife, Sara Rich Hine; his aesthetic orientation; his views about Stieglitz and the Photo-Secession; his methods of gaining access to factories and mills as an agent for the National Child Labor Committee; the special surveys for the American Red Cross in Europe; his frustration at not being able to sustain his family financially; and his feelings of disappointment at being overlooked by the art photography community.

The achievement of the Riverside Museum exhibition provided an upbeat note in an otherwise difficult decade. This elusive recognition makes his last letters so poignant. In them Hine simultaneously struggles with accepting his wife's death, dealing with the Federal Home Loan Bank Board's foreclosure on his home, and attempting to find sponsors for future projects. One of his last letters is to Stryker, whose support he hoped to enlist for a Guggenheim Fellowship.

Given the ongoing debates about the nature of photography and contemporary art as well as the breadth and richness of Hine's photographs, differing interpretations about his work continue today. This volume is not an attempt to quell debate or controversy. Rather, it provides an opportunity for the voice of this extraordinary writer and photographer to be heard.

Progressive Ideals and a Photographer's Coming of Age

Lewis Wickes Hine was born on September 26, 1874, in Oshkosh, Wisconsin, the youngest of three children and the only son. His father, Douglas Hull Hine, was of New England stock and during the Civil War had been a drum major on the side of the North. He had briefly been a sign painter but changed vocations because of an injury. His mother, Sarah Hayes Hine, was a teacher. Years later, in conversations with Elizabeth McCausland, Hine noted that "the education idea ran through the family."

During the late 1860s the Hines and their eldest daughter, Lizzie, moved to San Jose, Costa Rica, where Douglas's brother, Dr. Mark Hine, was the American consul. Sarah taught English and Spanish to the

children of diplomats. After Dr. Hine's death the family returned to the United States, where they settled in Oshkosh and ran a restaurant. They also maintained a house in Cairo, New York, a small, rural upstate community, not far from where Hine himself would later settle.

In 1892, the year Lewis turned eighteen and graduated from high school, his father died in an accident. Hine took a series of sweatshop-type jobs to help support the family. In his first job, at a furniture upholstery factory, he worked thirteen hours a day; subsequently he worked in clothing department stores, sold water filters, and worked as a janitor in a bank, "where after several years I worked up as far as supervising sweeper."

The sequence of events during this formative period has been pieced together from a few extant letters but remains somewhat vague. During this time Hine learned stenography and studied drawing and sculpture. He also took university extension courses, available because Wisconsin was a pioneer in progressive education. He subsequently met Frank Manny, principal of the State Normal School in Oshkosh, an institute for pedagogy, who urged him to give up sweeping and attend the Normal School. He did and in 1900–1901 took classes at the University of Chicago to become a teacher, studying with two of the nation's most prominent liberal educators, John Dewey and Ella Flagg Young.

In 1901 Manny was appointed superintendent of the Ethical Culture School in New York and brought Hine and several other teachers with him. The school was a progressive institution whose student body consisted of eastern European immigrants. There Hine taught nature study and geography and regaled his students with his antics as a first-rate actor. Soon after, in 1904, Manny conceived of the idea of "visualizing school activities with the camera." Although Hine had never handled a camera, he was appointed school photographer and documented meetings of the dance, music, and science clubs. (Although Hine's images do not appear in the school's publications, perhaps they were mounted for school exhibitions or appeared on bulletin boards.) He quickly mastered the art of making photographs but throughout his career assiduously avoided darkroom work, employing assistants whenever possible.

Hine's photographs of school life were so effective that Manny suggested using photography as an educational tool. Given the constitution

of the school's student body and the public's aversion to the great influx of "foreigners," Hine and Manny made a point of photographing immigrants arriving at Ellis Island so that E. C. S. pupils "may have the same regard for contemporary immigrants as they have for the Pilgrims who landed at Plymouth Rock." Hine and Manny made the first trip to Ellis Island together; Hine returned many times, even as late as 1926, when immigrant quotas were reinstituted. Shortly after that first trip he began teaching photography to students at the school. In 1904 he returned to Oshkosh to marry Sara Rich, a teacher whom he brought back to New York, and in 1905 he received a master's degree in pedagogy from New York University. Although the idea of photography as his life's work had never before entered his mind, Hine had found his métier.

The effect of Hine's Ethical Culture School experience on his personal and professional development cannot be overestimated. The school was conceived as a nonvocational institution "designed to give special fitness to those who will be artists later on." Hine, whose youthful aspirations had included becoming a wood sculptor, apparently also took advantage of its strong commitment to printing and graphic arts. Not only was he keenly aware of the artistic elements of an image; he also had an uncanny sensibility regarding its photographic components—that is, how the syntactical units of picture and text appeared on the printed page and resulted in a new form of printed communication.

In addition to making his own photographs, in 1906 Hine wrote and published several articles for *The Elementary School Teacher, The Outlook,* and *The Photographic Times* about using photography as a teaching aid. He continued to document school life—dancing clubs, science classes, and so forth—and from 1905 to 1908 made about 1,000 glass negatives. Although a handful of prints has survived (these are housed in the school's archive), the plates were sold for scrap during World War I.

During this period Hine also attended the Columbia School of Social Work, where in 1904 he met Arthur Kellogg, who worked at a fledgling social welfare magazine called *Charities and the Commons.* Kellogg introduced Hine to his younger brother Paul, the magazine's assistant editor, and other members of the social welfare community, such as John Spargo. Hine's relationship with the Kelloggs would be instrumental in his growth as a photographer. Whereas Paul worked closely with Hine

on projects and assignments for thirty-five years, Arthur guided him in much the same fashion as Frank Manny did. It was Arthur, for example, who first suggested that Hine become a "sociological photographer," a code term denoting those who photographed child workers.

Thus, while still teaching at the Ethical Culture School, Hine began doing freelance photography for the National Child Labor Committee (N.C.L.C.), an agency whose purpose was to help enact laws prohibiting child labor. Paul Strand, a student of Hine's at the Ethical Culture School in 1908, later remarked on his "courage" in undertaking such work, for while the public was unwilling to accept the existence and proliferation of premature workers, management reacted to N.C.L.C. efforts with increased violence and hostility. Hine's photographs, which he later referred to as "detective work," appeared in popular, progressive, and agency publications and proved invaluable in discrediting those who insisted "such conditions did not exist."

An image of Hine during his years with the N.C.L.C. begins to come into focus. Nattily dressed in a suit, tie, and hat, Hine the gentleman actor and mimic assumed a variety of personas—including Bible salesman, postcard salesman, and industrial photographer making a record of factory machinery—to gain entrance to the workplace. When unable to deflect his confrontations with management, he simply waited outside the canneries, mines, factories, farms, and sweatshops with his fifty pounds of photographic equipment and photographed children as they entered and exited the workplace.

In the newly evolved social welfare community, where scientifically trained social workers had begun to replace the rhetoric associated with charities workers, photography emerged as an important tool. Hine helped redefine the role of photography to encompass social images and reformulate the field of social work, where the emphasis shifted from issues to individuals. Within this community there was a growing acknowledgment of the value of photographs that dignified human life and of Hine's camera work. In his portraits of immigrants, child laborers, and the indigent he elevated what was formerly perceived as a quotodian drabness into a sign of struggle and pride.

Nevertheless, Hine always envisioned himself as an artist, although his style radically differed from the prevailing soft-focus, painterly pho-

tographs espoused by Alfred Stieglitz, who from 1904 to 1917 was America's leading spokesman for photography as a medium of self-expression, and those of the Photo-Secessionists, the exclusive community of art photographers (whom Hine referred to as the "Seceshes"). But as Stieglitz looked toward the modern art movement in Europe as his ideal, Hine found in the American vernacular tradition of Emerson, Whitman, and Twain the principles that constituted his own vision of art. Indeed, Hine too assimilated "high art" concerns. His photographs may not have manifested a fracturing of the picture plane (a modernist issue treated extensively in *Camera Work,* the magazine Stieglitz edited), but the multiple points of view and serial nature of his photo stories—a fragmentation of sorts—reflected his own interpretation of modernist issues.

Hine once stated in a lecture that "the picture is a symbol that brings one immediately into close touch with reality." Indeed, even the stalwart staff and executive members of the N.C.L.C., whose missionary zeal would eventually alienate Hine, became convinced of the importance of Hine's photographs in countering the idea that child laborers did not exist. Under the pseudonyms "The Kodak" and later "Small Kodak," Hine began designing booklets containing photo essays. And in 1907 a sophisticated photo story appeared in *Charities and the Commons.* Credited to Hine and entitled "The Newsboy at Night in Philadelphia," it was a multipage piece that featured Hine's child labor portraits and captions, the first of many such assemblages of pictures and text.

Just as Paul Kellogg was challenging prevailing beliefs with the opposing theory that people were poor not because they were lazy but because of social or economic circumstances, Hine repudiated the iconography associated with the "indigent type." As Paul implemented editorial reforms that reflected the value of "first-hand inquiry" and also began using Hine's empathic photographs, the reputation of the magazine and its young editor grew. In 1908 Kellogg was asked to direct the first comprehensive examination of social conditions in an American city. Called *The Pittsburgh Survey,* it was a ground-breaking investigative study whose analyses relied on the new social sciences and humanistic photography.

Kellogg's notion of orienting the survey toward "individual health

and happiness" correlated with Hine's belief that "the individual is the big thing after all." As the focus of social work shifted to show how economic and social circumstances can create poverty, pictures helped tell the story. With the success of the survey, Kellogg was promoted to editor, the magazine soon changed its name to *The Survey,* and Hine was hired as its first staff photographer.

Subsequently, the two operated as an editor-photographer team on several other influential photojournalistic projects. These included every major child labor exposé that Hine conducted; "Construction Camps of the People," a lengthy photo story about the living and working conditions of immigrants who constructed the Ashokan Dam, one of New York City's water-supply systems, an investigation Hine photographed for the co-authors Lillian Wald, Mary Dreier, and Frances Kellor; "Roving Children," a photo insert about the children of immigrant workers, which Hine photographed and designed; and a series of picture-text assemblages about child labor issues, presented in diptych and triptych form, which Hine called "Time Exposures." Together, Hine and Kellogg created a revelatory graphic language centered on the common man, woman, and child. They collaborated on the process of editing, arranging, and combining photographs with informative texts. In a sense the graphic language they invented transcended the needs of the social welfare community and may best be understood as human interest journalism.

By 1918 Hine had been associated with the National Child Labor Committee for more than twelve years. His photographs of children were legendary; he was recognized as the nation's leading social photographer. However, after having been denied a raise and having his salary reduced, Hine became increasingly restless. He decided to leave the agency and find other work. In a letter to Arthur Kellogg, Hine inquired about the possibility of a wartime assignment for the American Red Cross in Europe.

Although the progressives were steadfast in their pacifism at the outbreak of war and were instrumental in endorsing an international peace movement, in 1917 attitudes began to change. Several of Hine's colleagues had left for Europe to work in relief programs. Paul Kellogg

spent almost a year abroad reporting on reconstruction projects in France, Belgium, and Italy. In 1918 Hine was hired by the American Red Cross as Lt. Col. Homer Folks's special assistant and photographer.

Soon after, Hine left for Paris, where he was to be one of thirty-seven photographers chronicling American Red Cross relief efforts. In the pre-Armistice months Captain Hine set out across northern and southwestern France to photograph refugees and public health programs. After the signing of the Armistice on November 11, 1918, Hine became part of a team of specialists, called the Special Survey, that documented "the human costs of the war." From November 1918 through January 1919 he photographed refugees, many of them children, in Italy, Serbia, and Greece; in April 1919 he photographed the former German-occupied territories along the western front in France and Belgium.

Hine accumulated a body of a thousand negatives on his European tour, but few of his prints actually appeared in Red Cross publications (although they did appear in *The Survey*). Typically, Red Cross workers did not occupy center stage in his photographs; we do not see them in action lending a helping hand or dispensing supplies. Rather, to represent the agency's good works Hine focused on the refugees' strength and fortitude. Perhaps this is why so few of his photographs were used.

Nevertheless, the large body of European photographs that Hine produced, which had been lost for almost fifty years, is a bridge between his early studies of the poor and oppressed and his later celebrations of the worker as hero and heroine. After returning to the United States in May 1919 and briefly working for the American Red Cross, Hine decided to modify his photographic approach. For the remaining twenty years of his life, Hine would expand the graphic language of human interest journalism that he and Kellogg had pioneered.

Although the subtext of his prewar work had been conflict, Hine jettisoned this point of view to focus on what he considered more positive documentation—that is, depicting "industry from a human angle." The name he gave to this body of images was "Work Portraits," a term suggested by Arthur Kellogg that fell under Hine's rubric of "interpretive photography." When successful, as in the Empire State Building series, these work portraits mirrored the social-realist "heroic worker"

portraits produced by the Soviet photographer Alexandr Rodchenko; when ineffective, as in "Postal Service in the Big City" (1922) and "Hands: Work Portraits" (1923), they served as mawkish tributes to the American laborer.

Although Hine was still associated with *The Survey,* he essentially carried out his endeavor independently. A letter to Paul Kellogg in the summer of 1921, in which he thanked him for his "first income in nearly a year," is the first of many such notes and appeals. Hine was confident of the relevance of the work portrait motif, however, and viewed his financial struggle as temporary, attributable to the national economic slump. His major concern was "whether there will be plenty of progressive industry ready to pay the freight."

This new methodology is the focus of the letters. Just as Hine worked as a publicity photographer for progressive agencies such as the National Child Labor Committee, which he briefly resumed working for in the early 1920s, with characteristic alacrity he pursued this positive industrial direction. However, the inherent paradox of a photographer with his worker-oriented sympathies making himself available as "a camera for hire" to the skewed needs of corporate America was never fully addressed. It was not that Hine (and Kellogg) did not recognize the political and social changes wrought by the war. Rather, Hine thought he could find support in an increasingly apathetic milieu.

Hine's credo of "showing that the worker is not a lower form of life" translated into freelance assignments for primarily public service organizations. He interpreted life and labor for the American Clothing Workers, the National Tuberculosis Commission, the Tenement House Commission, the Boy and Girl Scouts, the Milbank Foundation, the Harkness Foundation, and the Interchurch World Movement. Although he completed assignments for *Western Electric News* and *Vacuum Oil News,* his difficulty finding any work at all, let alone projects for "progressive industries," grew.

Hine's work portraits contain an element of lost innocence that to some degree reflects his background as a rural midwesterner transplanted to the big city. Hine remained the perennial innocent whose personal values were rooted in a traditional midwestern upbringing—indepen-

dent, moral, and at times perhaps a bit corny. Yet the letters' enduring impression is of a complex man with a vision, one that he tried—at times desperately in the postwar years—to share with the world around him.

Four years into his work portrait project Hine received his first recognition. In April 1924 the Art Directors Club of New York awarded him its medal for photography at the Exhibition of Advertising Art. His work portrait "The Engineer," from the photo essay "The Railroaders," which had appeared in the premiere issue of *Survey Graphic* in 1921, was even printed on the club's menu. Also in 1921 another series of work portraits, entitled "The Powermakers," was published; in its design and layout it clearly represented Hine's vision of parity between worker and management.

In an article entitled "He Who Interprets Big Labor," which appeared in the September 1926 issue of *The Mentor,* Hine expressed his belief that his photographs could help improve relations between workers and employers:

> As I see it, the great problem of industry is to go a step beyond merely having the employer and employee 'get along.' The employee must be induced to feel pride in his work. . . . I try to do with the camera what the writer does with words. People can be stirred to a realization of the values of life by writing. Unfortunately many persons don't comprehend good writing. On the other hand, a picture makes its appeal to everyone. Put into the picture an idea and, if properly used, it may be transfered to the brain of the worker. . . . Interpretive photography, properly used, will do that, I know, for it has been done (p. 43).

One area of social and economic relations that Hine successfully chronicled was women's working conditions. Although the issue of economic parity for women was recognized by the Socialist Party in the early 1900s and picked up by progressives, during the Roaring Twenties such issues were once again obscured. For one photograph of a housewife, for example, Hine's caption read, "The home-maker deserves recognition as one of our workers." A group of covers he did for *Western Electric News* in

1923 and 1924 feature women actively engaged in work. By focusing his camera on women workers throughout the 1920s and in the Shelton Looms series of 1933, Hine revealed his penchant for journalism. But this eye for topical, investigative stories was inherently inimical to business's interest in good public relations pictures.

In the 1930s Hine worked for New Deal agencies such as the Tennessee Valley Authority, the Rural Electrification Administration, the Works Progress Administration, and the National Research Project and corporations such as General Electric, Shelton Looms, and the Empire State Building. But his refusal to relinquish his negatives and prints made him less than an ideal candidate for free-lance assignments. Recommendations consistently referred to his "artistic temperament" or the fact that satisfactory arrangements could not be negotiated. Judith Mara Gutman noted that "a telegram recommending him to the Rural Electrification Administration in 1935 read: IS TRUE ARTIST TYPE. REQUIRES HANDLING AS SUCH."

Yet Hine's relationship with Sidney Blumenthal, president of Shelton Looms, Shelton, Connecticut, represented the ideal he sought throughout the 1930s and 1940s. Blumenthal was considered by Hine to be, and probably was, one of the more progressive leaders in industry. In a 1917 article that appeared in *Textile World Journal,* he "advocated company-provided disability compensation, life insurance and pensions." On assignment at the factory for several months in 1933, Hine produced a portfolio entitled "Through the Threads of Shelton Looms," which included twenty photographs and text.

The portfolio was an artistic and professional success and eventually led to Hine's working for government-sponsored agencies. His first assignment was with Dr. Arthur E. Morgan of the Tennessee Valley Authority, for whom he photographed the construction of dams and the people affected by the T.V.A. project. In 1936–37 he served as chief photographer of the Works Progress Administration's National Research Project. With David Weintraub, director of the project, he documented the effects of technology on the workers of many industries, showing how "the growing technology had cost workers their jobs and others their craftsmanship." In their earliest stages these projects represented a

confirmation for Hine that the work portrait idea was needed. Ulti-mately, however, he was frustrated by Morgan's, Weintraub's, and oth-ers' lack of appreciation and acknowledgment of his pictorial efforts.

The cynosure of Hine's work portrait methodology, then, was his majestic Empire State Building series. During a six-month period in 1930, Hine and his son worked for the building's public relations de-partment, making photographs of Mohawk Indians balanced on beams one hundred stories above the ground or men in cherry-pickers hovering in the sky. Because of their worker-oriented emphasis, these photographs were rarely used in commercial advertisements for the tallest building in the world. In this instance, too, Hine maintained control of the negatives and prints, later sepia-toning and enlarging many of them into stunning works of art.

Hine's labor-focused ideology begs the thorny question of his political affiliations. The answers are elusive, at best. In the prewar years, when Hine worked for the National Child Labor Committee and *The Survey*, his work was also reproduced in vernacular and political magazines. From 1911 to 1915, for example, his images appeared intermittently in the *International Socialist Review*, perhaps at John Spargo's instigation. These stories dealt with union issues, such as "The Fighting Garment Workers" and "The Call of the Steel Worker," to name but two, and prefigure the direction Hine's work would take in the 1920s and 1930s.

In Hine's conversations with Elizabeth McCausland, a "left-wing" art critic and educator, there was no mention at all about his political alliances. Her notes focus on biographical information, Hine's camera techniques, and motivations for photographing immigrants. McCaus-land's interrogatories and essays about Hine in the 1930s, when trau-matic changes engulfed Europe and Russia, deal primarily with his contributions to an American vernacular culture and the ways in which his documentary photographs may be appreciated as art. But she and Abbott did introduce Hine to the Photo League, whose members were socially conscious photographers; in fact, many were targeted as Com-munists during the McCarthy era.

Hine indirectly addresses this issue in a letter written a few months before his death to J. B. Hardman, editor and director of educational

activities, Amalgamated Clothing Workers of America. To the accusation that Hine was "not a Union man" the irate photographer replied:

> . . . if there were any union that covered just a few of my activities, I'd belong all right. More than that, anyone who knows the work I have done for a third of a century will agree that I have done much more than most of your 100% Union members. . . . Moreover, partly because of this overemphasis upon bare membership in the union, I have had very scanty support for my work from the unions. . . . the Unions and the Workers have been the losers by this lack of vision and understanding.[13]

In the letters Hine emerges as an articulate spokesman for progressive ideals. Indeed, after the dissolution of the progressive movement in the postwar years, he continued to subscribe to its ideology, perhaps because it represented the perfect venue for his style of photography. But in the 1920s and 1930s, when such noble ideas were out of fashion, Hine found himself virtually alone. The result was a life riddled with economic uncertainty. Could a political affiliation have mitigated his circumstances? Probably not. Although his politics were certainly labor-oriented, they were a complex amalgam of socialist-democratic-populist positions. In the end issues of survival, not political concerns, dictated Hine's last decades.

To those familiar with Hine's photographs, this book offers a behind-the-scenes glimpse into the man who "plumbed the depths (coal mines) and scaled the heights to visualize some aspects of life for those who need to be shown." It was fitting that Hine's photographs were reintroduced during the 1960s—in a book with the auspicious title *Lewis Hine and the American Social Conscience*—for this, like the progressive era, was a great transforming period in American history. Today, in light of the desire for social reform that has reemerged once again, Hine's photographs and credos resonate more than ever.

Notes

1. Naomi and Walter Rosenblum, who still hold unpublished papers of Hine's, were the curators of the exhibition. A monograph published by Aperture that year featured a

seminal essay by Alan Trachtenberg. Ten years earlier Judith Mara Gutman wrote the first book about Hine, *Lewis Hine and the American Social Conscience* (New York: Walker and Company, 1967).

2. The title of the Hine exhibition mounted by the Rosenblums alludes to *America and Alfred Stieglitz*, Waldo Frank, Lewis Mumford, and Dorothy Norman, eds. (New York: Doubleday, 1934), a collective portrait assembled on the occasion of Stieglitz's seventieth birthday.

3. See Peter Seixas's award-winning essay "Lewis Hine: From 'Social' to 'Interpretive' Photographer," *American Quarterly* 39, no. 3 (Fall 1987), pp. 381–409; Judith Mara Gutman's "The Worker and the Machine: Lewis Hine's National Research Project Photography," *Afterimage* 17, no. 2 (September 1989), pp. 12–15 (this originated as a catalogue essay for a show organized by the Photofind Gallery, New York); and my *Lewis Hine in Europe: The "Lost" Photographs* (New York: Abbeville Press, 1988).

Lewis Hine in Europe treats a cache of Hine's European photographs, which had been "lost" in the American Red Cross Collection housed at the Library of Congress. I cracked a cataloging code and was able to identify nearly a thousand prints Hine made of western and eastern Europe during and after World War I.

4. For more about the editor-photographer relationship, see my "The Fetish of Having a Unified Thread: Lewis W. Hine's Reaction to the Use of the Photo Story in *Life* Magazine," *Exposure* 27, no. 2 (Spring 1990), pp. 9–20.

5. *Men at Work* was first published by MacMillan & Company in 1939; in 1977 Dover Publications reissued it with eighteen supplemental photographs.

6. Shreve was a principal in the architectural firm of Shreve, Lamb & Harmon Associates. William Lamb was responsible for designing the Empire State Building.

7. See Stryker's article "Documentary Photography," *The Complete Photographer*, Willard Morgan, ed., 4, no. 2 (Chicago: National Educational Alliance, 1942), pp. 1,364–74.

8. Photographers employed by the Farm Security Administration were required to relinquish their negatives to Stryker, whereupon they became the agency's property. But some, including Walker Evans, Dorothea Lange, and Arthur Rothstein, believed the negative was rightfully theirs. They were incensed that Stryker altered their images (by cropping them to eliminate important details) and revised their captions (to manipulate their point of view). The fact that photography was increasingly viewed as a creative medium meant that more photographers balked at the loss of control over their work. Eventually, Lange and Rothstein managed to reclaim their hallmark images, "Migrant Mother" and "Dust Storm," and copyright them in their own names. Since Hine had a reputation as an "artistic type," Stryker's unwillingness to hire him becomes clearer under these circumstances.

9. See Wilson Hicks, *Words and Pictures: An Introduction to Photojournalism* (New York: Harper & Brothers, 1952); and Kaplan, "Fetish of Having a Unified Thread," p. 20, n. 28.

10. Newhall's articles were "Documentary Approach to Photography," *Parnassus* 10,

no. 3 (March 1938), pp. 3–6, and "Lewis Hine," *Magazine of Art,* 31, no. 11 (November 1938), pp. 636–37.

11. Although the term "documentary" was apparently first introduced in the 1920s and conceived of as an "anti-aesthetic term" (in John Grierson's description of Robert Flaherty's film *Nanook of the North*), by the 1930s Hine witnessed its successful use by Farm Security Administration photographers such as Dorothea Lange, Walker Evans, and Arthur Rothstein and *Life* magazine photographers, such as Margaret Bourke-White and Alfred Eisenstaedt, who were subsequently embraced as artists.

12. McCausland and Abbott collaborated on *Changing New York* (New York: E. P. Dutton & Company, 1939), a Federal Art Project series, which was republished by Dover Publications in 1973 as *New York in the Thirties*.

13. See Hine's letter of April 16, 1940. His handwritten notations (at the top of the page in the original version) indicate that someone other than Hardman referred to him as "not a union man."

Selected Letters of Lewis W. Hine

1.
Becoming a Sociological Photographer, 1900–1910

On the death of his father in 1892, Hine, after graduating from high school, took a series of menial jobs to help support his mother and older sister. At a bank where he was "supervising sweeper," he met Frank A. Manny, then principal of the State Normal School, an institute for teaching. Although only six years older than Hine, Manny in many ways assumed the roles of mentor and father figure. He urged Hine to study teaching, which he did.

In 1901 Manny moved to New York City to become superintendent of the Ethical Culture School, a progressive institution for eastern European immigrant children. He invited Hine to come with him and teach nature study and geography. During this period, Hine's identity as an artist took shape as he worked closely with Manny and also availed himself of the school's specialization—the teaching of printing and artistic skills. In 1904 at Manny's suggestion Hine began photographing school activities and later that year visited Ellis Island for the first time to chronicle immigrants.

➤ ➤ ➤

April 7, 1900

Professor Frank A. Manny
196 W. Irving St.
Oshkosh, Wis.

Dear Professor Manny:-

Yours of April 4th is at hand. I should judge from what you say about
the young man that he is just the one to help us out in the office for his
tuition. I can certainly offer him that, and perhaps he may earn more.
We want just such men, and I thank you for calling my attention to
him. I can promise him now his free tuition for the work he will do in
our office. Our plan is to receive only strong people. The young man
may communicate with me at any time, and I will do what I can for him.

Very truly yours,

Francis W. Parker
President

Letterhead: Chicago Institute, Academic and Pedagogic. Office: 603 Marquette Building,
Chicago.

Source: Naomi and Walter Rosenblum.

➤ ➤ ➤

[1906?]*

Dear Mr. M;-

I met Dr. Adler just coming out of Mr. Lewis's office (where I have no
doubt he had taken my letter to him). Greeted me with more than
usual consideration & took me aside (for a wonder) where there were
more to overhear. Said first that he had his doubts as to whether I have
the "broad sociological outlook that would prevent too much scatter-
ing of effort." I told him (meekly) that I aimed to get that outlook as I
worked into it. That there is a crying need for photographers with even
a slight degree of appreciation & sympathy. Then he brought up the
question whether it were a safe financial venture which I didn't argue
with him. I was mightily relieved to see he did not oppose the charge

but said he could see no other reasons to deter me. Said it might be a good plan to "talk it over with Mr. Lovejoy and get his point of view."

Am writing Mr. L. tonight telling him I am no longer an applicant for E.C.S. Perhaps I have not told you that the last time he saw Mr. Stark (at least I have good reason to believe) he told me soon after that he wanted me to come back next year & throw my heart and soul into the work & let outside matters go. I said I could not decide that yet. He said he would have to begin to look for a successor at once & would place me on the same footing with other applicants. I told him I would take the risk. Now I think it best to make the break. Have had the satisfaction of leading the game so far and see no necessity for waiting to be squeezed out.

> Hopefully,
> L

* In 1938, as he prepared for the Riverside Museum retrospective, Hine apparently reviewed what little correspondence he maintained. The bracketed, asterisked dates in this and subsequent letters represent these later notations. Since he mentions meeting with Adler, writing to "Mr. L." (Owen Lovejoy, director of the National Child Labor Committee), and wanting "to make the break," the letter was probably written in 1907, rather than 1906, for the following year Hine left the school to work full time for the National Child Labor Committee.

Addressee: Frank Manny.

Dr. Felix Adler was founder and director of the Ethical Culture School (E.C.S.) and a founder and member of the board of directors of the National Child Labor Committee.

Source: Naomi and Walter Rosenblum.

[1906]*

Dear Man;-

It is nearly time for a "showdown" at the school. Mr. Kelly has asked me to let him know before long whether I want to stay next year or not & if perhaps I would take only the Geog. work. He says he wants me to stay.

I just hauled up Mr. Kellogg, editor of *Charities,* & have started him thinking over the advisability of hiring a man (good-looking, enthusiastic & capable, of course) to do the photog. for his magazine, & for the

various committees & societies in the building, part time to be spent in writing for *Charities*. As they have all been in the habit of paying $2.00 a print for photos they use, the economy of money & effort appeals to them and Kellogg is greatly interested.

It might mean all day work and it might be they would have only half a day for me this coming year, leaving mornings for E.C.S.

Of course I shall not be hasty in deciding. It means too much to give up all these years of training without due consideration, but it has done its work, perhaps. Anyway it has done some work.

> In good hope,
>
> L

Please return the Northwestern clipping.

Date added by Hine in 1938 in preparation for the Riverside Museum retrospective of his work.

Addressee: Frank Manny.

Apparently, Hine began selling photographs to Paul Kellogg, assistant editor of *Charities and the Commons*, in 1906, for his first (although uncredited) photo essay, on public playgrounds, appeared in the journal that year (see *Lewis Hine in Europe: The "Lost" Photographs,* p. 33). The following year a second photo story was published; this one featured photographs from a freelance assignment Hine completed for the National Child Labor Committee. Entitled "The Newsboy at Night in Philadelphia," it was one of the first pieces that Hine photographed, wrote the captions for, and designed (see February 2, 1907, issue, pp. 778–84).

An article by Hine appeared in the *Oshkosh Daily Northwestern,* October 3, 1903, about a trip he took to the Catskill Mountains. See also *Lewis Hine in Europe,* page 17.

Source: Naomi and Walter Rosenblum.

In August 1908 Hine terminated his association with the Ethical Culture School and was hired on a fulltime basis by the National Child Labor Committee at one hundred dollars a month plus expenses. His social documentary work took him all around the country; even without the benefit of air transportation, he traveled as much as 30,000 miles a year. Apparently the fact that he traveled so extensively put a strain on his marriage. In 1911 Hine's wife, Sara, accompanied him to Mississippi and Virginia, where they collaborated on a report about "thirteen cotton mills, ten knitting mills, five silk mills, three woolen mills, and glass and shoe factories." The following year their son, Corydon, their only child, was born.

Hine's photographs appeared regularly in newspapers, N.C.L.C. and other

progressive publications, stereopticon slide shows, and, under his own direction,
exhibitions. By 1913, when he was promoted to director of the N.C.L.C.'s
exhibits department, Hine was considered the most successful photographer of
social welfare work in the country.

[May 2, 1910]*

Dear Man;-

James says it doesn't pay to get blue; but I think I have convinced him
that when these same ultraviolet rays have penetrated deep enough
to start the works "up again and at 'em," the state has some sort of
justification.

Anyway, I am just coming out of the daze; the events and the feel-
ings, only James himself can depict. Well. This is it. For two years I
have been working away, trying to demonstrate to the social workers
that I had a place and that it was worth supporting. For a year I have
been battering away at Lovejoy to get him to ease up on the financial
stringency and only a few weeks ago he told me he thought 150 a month
was all the Com. would stand for. Well. I simply wilted, but I did
have one little last glimmer of hope left, enough to get me as far as
Mrs. Kelley's sanctum. I think I told you her vigorous denunciation of
"sweated labor in social work," and she made me an offer on the spot of
150 for half time. Pretty soon Lovejoy came back with a raise & finally
he met her proposition & I have a full year laid out, beginning today, at
$75 a week & all expenses & magazine income & profits from darkroom
(which promise to amount to something). Paul gets a thousand this
year & a share in the profits of his work.

A good feature of the new year is that at least half of it is to be confined
to N.Y. City. The question of being away from home is getting more &
more troublesome. For a while, I shall have to go wherever there seems
to be need, but it cannot always be necessary for one to break up his
home, even in a good cause. I just ran across Dr. Dewhurst's *Dwellers in
Tents* and one thought he emphasizes is, "there can be no enduring
motive for bringing light & beauty & enlargement of life to others,

except upon the presupposition that what is good for others is good for ourselves."

The New Year is but begun, but it seems to have good promise and good opportunity, and *you* know that the finances are very decidedly secondary to the *work*.

At this moment I am running over to St. Louis (how I wish I could have been there when you were!) to work a couple of weeks on Street Traders, etc. Then back to Del. (Wilmington) adding two more states to my repertoire. Willard writes, "Tis a wild life that you lead, & a lively one, dodging in & out of the capillaries of the social system, at the seat of inflammation, like a hungry phagocyte, seeking whom to devour!"

I have had, all along as you know, a conviction, that my own demonstration of the value of the photographic appeal, can find its real fruition best if it helps the workers to realize that they themselves can use it as a lever even tho it is not the mainspring to the works. More than the specialists, we certainly need the many who can make practical use of the small (and usually hidden) talent (photographic).

Please remember both of us to the Ladies.

When shall we all meet again?

> Love a-plenty,
> Lewis

Address

> Lincoln Park
> Yonkers, N.Y.

Write oftener, can't you?

*Date added by Hine in 1938 in preparation for the Riverside Museum retrospective of his work. Addressee: Frank Manny.

Hine is probably alluding to William James, whose credo of moral strength might best characterize the photographer's own political motivations. In his book *Men at Work*, Hine quotes from James's essay "The Moral Equivalents of War," which appeared in *Everybody's* magazine in 1910: "Not in clanging fights and desperate marches only is heroism looked for, but . . . on freight trains, on vessels and lumberrafts, in mines, among fishermen and policemen, the demand for courage is incessant and the supply never fails. These are our soldiers, our sustainers, the very parents of our life."

Florence Kelley was director of the National Consumers' League, an agency that monitored home work among immigrants.

Paul Schumm was Hine's darkroom assistant.

Source: Naomi and Walter Rosenblum.

[1910?]*

Thank you, My Dear, for the thoughtful word dropped into my box. You are a "heap" more real help and comfort than all the rest of the school including the worthy philosopher. I am very certain I am right. Some interesting complications seem to [be] arising down there (it doesn't seem like "here" any more). When you come to Exhibit drop into 506 when it isn't rush hours & maybe we can have a bit of a chat.

 Love,

 L

My child labor photos have already set the authorities to work to see "if such things can be possible." They try to get around them by crying "fake," but therein lies the value of data & a witness. My "sociological horizon" broadens hourly.

* Date added by Hine in 1938 in preparation for the Riverside Museum retrospective of his work.

Addressee: unknown. He or she was more than likely a former associate at the Ethical Culture School.

The "worthy philosopher" was Dr. Felix Adler, who also helped formulate policy for the National Child Labor Committee.

Source: Naomi and Walter Rosenblum.

2.

The Transition to Interpretive Photography, 1918–19

As Hine's efforts on behalf of the National Child Labor Committee to secure legislation to outlaw child labor increased, so did his ambivalence about the agency's tactics: "I have to sit down, every so often, and give myself a spiritual antiseptic. . . . Sometimes I still have grave doubts about it all. There is a need for this kind of detective work and it is a good cause, but it is not always easy to be sure that it all is necessary." In 1918, after the agency voted to reduce his salary, Hine left. During the twelve years he had been affiliated with the organization, Hine had written and designed photo stories, children's books, and exhibitions. To describe the new documentary style he pioneered, he had also developed a lexicon of terms including "photo story," "picture serial," "time exposures," "photo mosaics," and "human documents."

With World War I raging on, Hine, now 44, approached Arthur Kellogg about contacts overseas and secured a position as a captain in the American Red Cross. Working for Lt. Col. Homer Folks, a prominent social worker who had been involved with the N.C.L.C. and the Charities Aid Association in New York and was familiar with Hine's work, Hine chronicled Red Cross public health activities in Paris. While awaiting further assignment, he traveled to northern and southwestern France to photograph refugees.

Thus, the correspondence jumps several years from the topic of child labor projects to an inquiry about wartime work.

March 9, 1918

Dear Arthur;-

Can you give me the present address and phone number, if possible, of our friend, Benj. Marsh? T'anks.

 I guess the France job fizzled out.

 Cordially,

 H

Letterhead: Hine Photo Company, 27 Grant Avenue, Lincoln Park, Yonkers, N.Y.

Although the bulk of the Hine-Kellogg correspondence is between Lewis and Paul, Hine's first contact was with Arthur Kellogg, Paul's older brother and managing editor of the journal, whom he had met when they were students at the Columbia School of Social Work. Arthur introduced Hine to the social welfare community and to Paul, who increasingly championed his photographs.

Source: Social Welfare History Archives.

After several months of working independently and traveling alone to areas north and south of Paris, on the night of the Armistice Hine set out with seven team members on the first American Red Cross relief tour. Called the Special Survey, the team traveled to Italy, Serbia, and Greece. Whether Hine kept a diary during the two-month tour or compiled these notes on the group's return to Paris in January 1919 is unclear.

➤ ➤ ➤

Trip Notes

En Route to Italy

We left Paris the evening of Nov. 11th, the day the official announcement of the signing of the Armistice was made. Paris had held herself in check up to this moment but when there was no longer any doubt, the people broke loose, flooded the streets in extempore processions, marching, surging, singing, shouting. With passports and papers to finish, packing to close up, and baggage to get to the station, the jammed streets seemed far from pleasant and there was no time to join the festivities. My taxi crawled along, a gendarme would jump and direct us a

while, some of the marchers, young and old, would mount the running board and insist upon shaking hands with the "bon Americaine," cannons boomed in the street nearby, two of our party were delayed by it all and had to follow on next day, but everybody was jolly, the "porteur" wheeled my baggage in with a cheery comment on the "finis le guerre." Good-bye, Paris.

Italy

Marvelous glimpses of snow-capped peaks, wonderfully tinted slopes now pink, now brown through the hazy autumn atmosphere, interrupted by tantalizing dashes into all sorts of tunnels, then, descending by degrees down the Italian slope of the Alps—bird's-eye views of wine-covered valleys, broad and long sweeps of country with quaint Alpine cottages and villages, which I was interested to know were not all confined to Switzerland.

One of the more modern of Italian cities but with the real Italian stamp on the people is Turin. They were still celebrating—bands and crowds surging up and down, groups stopping to "Vive Americain" at us when they spied our caps, or in some instances to break out again. An hour here, then on the train again.

The "wagone-lite" are real sleepers, compartment style, with two or four in each room. If you happen to draw a French or Italian partner, the room is closed up tight and you feel pretty stuffy by morning. If your fellow-passenger agrees to ventilate, then you get frosted before the night has gone very far. . . .

The Tyrhhean [sic] Sea was a constant delight. This is Italy indeed, I kept saying to myself—old walled towns, peasant groups, adobe houses painted in a real flesh-pink, stretches of real fertile land very much unused and neglected. But oh, the gamin, begging promises and cigarettes at the stations, the Little Mothers with pale-face babes, the olive-skin[ned] maiden.

Rome

First day in modern Rome, the office section, closing with evening dinner out at Villa Aurelia in the suburbs at the abode of Major Burne, Red Cross Official in Rome. . . .

There's nothing reticent about the church bells here. They begin about four A.M. and by six I decided to give up and get up, so I slipped out, visited three of them and was back in time for breakfast. The old folks predominate still, with a liberal sprinkling of maidens telling their beaux[?] off in silent supplication for the soldiers who had not yet returned, some of them not to return. I think I prefer the French cathedrals to the Italian. The picturesque street life makes me long for time enough to picture it.

The Italian King returned from the front. He has been doing service at the front, coming home on "permission," the same as the others, and has been very popular. He says he will be the first President of the new Republic when it develops. The large open square at the Terminal Station surrounding a lovely fountain and facing the old Roman Baths of Dioclesis [sic] was crowded with all sorts and conditions of people, but the entire sense of enthusiasm on their part was very noticeable. It may presage some very decided action in the near future will be hastened if the government is not able to cope with the difficulties of providing for the returning soldiers, especially those who have been prisoners in Austria and whose return has strained the food and transportation facilities of the country to the utmost. The socialist factions have grown to great strength here and are not disposed to be very lenient with any kind of inefficiency at this time.

Then I wandered out into the "village" alone, to try my hand at getting lunch. Owing to the discrepancies of the waiter's vocabulary and mine, I ordered soup (and drew spaghetti), asked for filet of sole (got some minnows), pleaded for meat ('twas a meatless day), and went back to the hotel, and fished my dessert out of the grip for we manage to keep a supply of chocolate and sugar. The hotel meals were all right but expensive, so the next day we all tried a nearby restaurant. My neighbor found some foreign livestock in his soup (meatless day, too). Another had to move his chair because his chum's fish was on the windward side of him. . . . Spent the evening with the Yale Prof. just back from the northeastern part of Italy toward which we were headed. He had great tales of desolation and difficulties, some of which came true in a few days.

Another day of rambling 'round Rome on my own. I had a letter of

introduction to an Italian minister asking for permission to select some shots for our use. He referred me to their Bureau Off. on the edge of town and I started bravely. I was getting glimpses of Rome all right but not exactly getting very many of the photos I needed. A kind-hearted youth took pity and directed me to the Bureau where I succeeded in finding a woman who talked a little English. She talked more than she understood, however, and when both my gestures and patience gave out, I went back to the hotel with six prints, more or less usable, and a round of Italian experiences.

The Colosseum carries me back to the impressions made by the Grand Canyon of Arizona—massive, aged, weather-worn, full of suggestions of a crowded past, historic and geologic. I wanted to camp out there for a week. Instead, we stole over after dinner, spent the moonlight evenings, and part of a morning, saw it from above, below and every side, getting angles, arch-vistas, panoramas. Jupiter and Venus smiled down on us and gave a sentimental touch that was heightened by a group of Italian serenaders (terribly out of tune, but still acceptable). I should like to do a series of seasonal photos here. It would be wonderful in a blizzard, in contrast to the glare of the summer sun. The gamin, who turned cartwheels just outside and then demanded pennies, the little rheumatic Dago mother who couldn't understand why I should want to include her when I asked permission to photo her babe. . . .

We have done most of our riding by night to save our days for work. Fortunately, we have been able to get sleepers most of the time, in spite of [the] crowded state of traffic. So much for being attached to a COM-MISSION. In most places we are given the best of accommodations that are available.

Spent two days autoing around the devastated region just north of Venice. This is the country that has been occupied by the Germans, Austrians and Hungarians, on both sides of the famous Piave River. Worked out from Padua (Portia's country, was it not?), a city that shows evidence of both great age and modern rebuilding.

We were not able to catch even a glimpse of Venice, this time. Rode on through roads that still bore evidence of the camouflaging used to hide the passage of troops and stores from the enemy just over the

ridges. Went over the Piave on a temporary rope bridge that swung and humped as [illegible]. . . . Many homes and buildings partly or entirely blown up and fields much pitted by shell holes, but there was much less damage on the whole than we expected and two of our party, who have been along the front in France, say that the damage in France is infinitely worse. At Treviso we found hundreds of Italian prisoners returning from Austria—some of them talked good English (having lived in [the] U.S.), and they walked for days and weeks in order to get to their homes, only to find themselves herded like cattle, by officers of their own country, because the Armistice had found the Italians unprepared to cope with the difficulties of furnishing food and coping with disease. In Trieste there were thousands arriving daily, in starving and diseased condition, penned upon the wharves and with machine guns guarding their movements, little or no food for them, while across the road the life of the city, rather gay and prosperous, was going on as usual before the very eyes of these soldiers—many of whom had been at the front for two years. . . . Slept in a hotel recently held and occupied by Austrian officers, in good condition because they left in such a hurry there was no time to damage it as had been done with many houses around here, where windows and doors were taken out, floor out for firewood. . . .

Off in the distance, a peaceful background for all these grim sights. The Venetian Alps, including the famous Dolomites. These took me back to a similar setting for a different malevolence, out in Colorado. I'll never forget the feeling of relief out there when I had been following up the families of sugar beet workers and wallowing in their stories of overwork and degradation, then looking up and around me to the range of snow-capped Rockies off in the distance, undisturbed by all this as they had been by so many other scenes in the past hundreds of years. If one could strike a happy mean between the stolid indifference of the distant range and the feverish sympathy of the human being who wants to cure it all in a hurry, maybe it would all go along more rapidly in the long run.

At Ites . . . the camion carried us over steady and steep grades at a regular and apparently breakneck pace, and there were actually hundreds of other camions coming both ways, passing each other at dangerous turns. . . .

We questioned some of the children working on the roads (for they abound in Athens, shoesmakers, blacksmiths, tenement-home workers, and the overstatement of age was very plain). A Greek with the party said that there are state labor laws regulating ages, hours of labor, etc.

Spent the day at a military stop in Bralo getting snapshots of some of the tiny (and timid) goats and sheep. . . .

Source: Naomi and Walter Rosenblum.

January 22, 1919

Dear Sara & Lola;-

Ran across the *original* Michaelangelo's *Moses* today. Tucked away in an obscure church, within a stone's throw of the Colosseum but off on a little side street, one has trouble finding the church and I can conceive it possible that a visitor could easily wander in and out without seeing the masterpiece. It seems so much more virile in the marble than in any form of duplication that I have ever seen (of course). The attendant figures do not show in the postcard view, but I rather like them— placid females hovering around & doing their usual ministering, without which poor man (from Mose down to Me) could not get very far for any length of time. What I started to say was that their sweet femininity makes a good setting for his strong, stern dominant personality. It is unfortunate that the eye is on the level of the figure's knee, which gives undue prominence to the lower half of the figure when you are close up, but some lovely glimpses are gotten as you approach the statue from a distance, looking thro the pillars around the centre of the church. The rest of the church seems insignificant, just a plain setting for such a jewel.

Expect to leave Rome soon for Paris. After a bit I may know more about the immediate future.

 Love to All
 Lewis

Letterhead: Regina Carlton Hotel, Rome.

Addressees: Sara Rich Hine, his wife, and Lola, his older sister who lived with them.

Source: Naomi and Walter Rosenblum.

July 26, 1919

Dear Kellogg;-

At Major Folks' suggestion, I have put together a bunch of my recent photos at St. Etienne which I think might lend themselves to a photo-spread for the Survey. If so, please give me [a] credit line as Staff Photographer American Red Cross in France. If not, would you kindly send it down to the Art Department of *Everybody's* Magazine. Keep track of any postage, etc., that you may waste in these efforts.

Of course I have not had time to get any answer from my wild note of inquiry I sent you a while ago. I do not see much hope of our getting any relief for some time at least (in that Bureau), but I shall be interested to know whether you would entertain such a proposition if any other possibilities open up. I'd like, mightily, to see you over here for a season. (Please do not say anything yet.)

Give me your reaction to my photos.

As ever, Cordially,

Lewis W. Hine

P.S. I find that the photos have to go via Washington, so I send this to you direct.

Letterhead: American Red Cross, 4 Place de la Concorde, Paris.

Addressee: Paul Kellogg.

Folks was Hine's supervisor and director of the American Red Cross's Department of General Relief in Paris, a position that led to his appointment as director of the Special Survey. Several of Hine's photo stories relating to European relief efforts were published in *The Survey* in 1919 and 1920. His photographs also appeared in Folks's book, *The Human Costs of the War* (New York: Harper & Brothers Publishers, 1920).

Source: Social Welfare History Archives.

August 27, 1919

Dear Hine:

I have written to Mr. Folks as enclosed. Don't you think this is a happy outcome. Can you send us the photographs for this final October in-

stallment within the next ten days? The scheme was to choose them so as to fit somewhat Mr. Folks's text, the general treatment of which you will remember.

Sincerely,

Paul

Source: Social Welfare History Archives.

Because all Paul Kellogg's extant letters are carbon copies of the originals, his signature does not appear on any of them; his name has been added by the editor.

September 5, 1919

Dear Art;-

Am planning to be in N.Y. September 11 or 12 & will bring along my photos for War & Children layout. Is that soon enough? Please try to have the Folks mss. on hand (or in mind) at that time so we may make final selection.

Cordially,

Hine

Hope we can get a cover for that issue too for a final windup of Red X stuff. Wish you'd mail me a couple of Sept. issue[s] here. Address: Hotel Oxford, Penn. Ave. & 15 St.

Letterhead: The American Red Cross, National Headquarters.

Addressee: Arthur Kellogg.

Hine returned to the United States in June 1919 and worked for the American Red Cross national headquarters in Washington, D.C.

"The War and the Children" appeared in the November 8, 1919, issue of *The Survey*, pages 79–85.

Source: Social Welfare History Archives.

3.

The Work Portrait and the Evolution of Photojournalism, 1921–33

Two months after Hine and Folks toured northern France and Belgium—the notorious western front—Hine returned to the United States. Headquartered in Washington, D.C., he continued to travel for the American Red Cross. His photo stories about refugees and reconstruction programs appeared in *The Survey* throughout 1919 and 1920.

Perhaps as a result of the postwar crises his camera recorded, Hine decided to shift gears in his work. On returning to New York, he reoriented his photographic program from "negative to positive documentation." His focus became depicting industry from a human angle. Hine changed his studio advertisement to read "Lewis W. Hine, Interpretive Photography" to reflect this new methodology, which he called "Work Portraits," a term suggested by Arthur Kellogg.

Although Hine was still associated with *The Survey*, which in 1922 changed its name to the *Survey Graphic* to underscore its pictorial emphasis, he essentially carried out his studies of life and labor independently. He envisioned the portraits of laborers as "kind of publicity and morale stuff" for industry. Although Hine had increasing difficulty finding corporate assignments, he was staunch in his resolve; the Kelloggs—particularly Paul—supported him completely.

➤ ➤ ➤

June 20, 1921

My dear Paul;-

I have just finished a series of photographs showing the Human Side of The System (Pennsylvania), the very best thing I have ever done. The industrial lead I have been following is tremendous and virgin soil. It is possible that you might make use of some of this material in the new Pictorial. At any rate, do you want to spend a lunch hour on it? If so, meet me at [the] Civic Club at 12:30 some day, and advise me a few days in advance.

Cordially,
H

Source: Social Welfare History Archives.

➤ ➤ ➤

July 7, 1921

Dear Paul;-

I appreciate your note of encouragement and I am sure that you can find use for various kinds of this material as the work goes forward. It will be hard sledding for some time, I fear me, but that is an old story. The theme is fundamental and needs to be emphasized in every form of expression. Whether we can get Industry to pay the freight, or not—there's the rub.

Will see you Tuesday, next, at 11:00 A.M.

As ever,
H

P.S. If you find it necessary to postpone it, please phone me (Hastings, 1023) some time Monday.

Hine is referring to the work portraits, an upbeat portrayal of industry and corporate America.

Source: Social Welfare History Archives.

➤ ➤ ➤

July 26, 1921

Dear Paul-

As soon as you get to go over the railroad layout with the persons you spoke of, please let me know so I can show it to my Pennsylvania man. Meantime, I am pushing along on Harbor and Powerhouse series.

 Sincerely,

 H-

Letterhead: Lewis W. Hine, Edgars Lane, Hastings-on-Hudson, N.Y. Throughout the correspondence Hine's street name is spelled variously as Edgar Lane, Edgar's Lane, and Edgars Lane. According to the Hastings Historical Society, the correct name is Edgars Lane.

Hine's first photo story reflecting his new approach to photography was called "The Railroaders: Work Portraits" and appeared in the October 29, 1921, issue of *The Survey*, pages 159–66.

Source: Social Welfare History Archives.

➤ ➤ ➤

November 4, 1921

Dear Paul;-

The love feast was delightful. Wevill & I are working on the Powermakers layout. It has big possibilities, "much different" from the R.R.-ers.
 Will be ready for your perusal next week some time.

 H

Letterhead: National Child Labor Committee, Incorporated to promote the interests of children, 105 East Twenty-second Street, New York City.

Hine occasionally had lunch or high tea with the Kelloggs and *The Survey* staff and is probably referring to the food and support heaped on him by Paul and Arthur.

"The Powermakers: Work Portraits" appeared in the December 31, 1921, issue of *The Survey*, pages 511–18.

Wevill was Hine's darkroom assistant.

Source: Social Welfare History Archives.

▶ ▶ ▶

St. John's Hospital, Yonkers
November 26, 1921

Dear Paul;-

Thank you for the check. I'll need it. It was a bad break but it is healing well. May be some time before I can carry my apparatus again. In the meantime I'll have to market what I have done, and the Pennsy people are considering the Reprints and may decide before long.

I shall be here perhaps a week longer, & glad to see Wevill any time he can come.

A while ago, I wrote Thorndyke (Columbia) that I would like to reinforce the value of the appeal of some of my Work Studies with actual tests to show how these workers compared in general intelligence, etc., with those in the professions & elsewhere. He says he will cooperate, provided enough tests are made to make it of real value. The next trouble is to finance it. Perhaps he can find someone, who is working for a doctorate along those lines, willing to do the tests. Perhaps other ways may open out. Maybe Pennsy-Systems would do it. Anyway I think it would give my pictorial presentation of the Human Side of Industry a better footing.

> Hopefully,
> H

There is no documentation of this accident among Hine's papers or in newspaper accounts at the Hastings Historical Society. Given the gymnastics to which he often resorted to make his photographs, he probably broke a leg.

Hine's mention of Thorndyke, a professor of economics at Columbia University, refers to a study he wanted him to conduct. Apparently, it was through this initial inquiry that Hine met Rexford G. Tugwell, Thomas Munro, and Roy Stryker, the graduate student who served as picture editor on Tugwell and Munro's economics textbook, *American Economic Life and the Means of Its Improvement* (1926). As picture editor Stryker cropped Hine's photographs without his consent.

Source: Social Welfare History Archives.

November 28 [1921]

Dear Paul;-

I find, among my notes, a copy of these verses that I tried to get Miss P-
to use in the first series, and I still feel that Kipling said it better than
we can, for the theme, at least. Brief explanatory labels might be
necessary.

Still on the mend, slowly.

As ever-

Hine

I am unsure which verses Hine is referring to, since none appeared in the *Survey Graphic's* photo
story "The Powermakers: Work Portraits," in its December 31, 1921, issue. Nevertheless, his
fondness for Kipling's work may be seen in the photo essay "The Child's Burden in the Balkans"
(*The Survey*, September 6, 1919). On a page entitled "A Macedonian Gunga Din," Hine quotes
from the Kipling poem:

> The uniform 'e wore
> > was nothin' much before,
> An' rather less than arf o'
> > that behind,
> For a piece of twisty rag
> An' a goat skin water-bag
> Was all the field equipment 'e
> > could find.

For Hine's use of another Kipling poem, see "He Who Interprets Big Labor," *The Mentor*,
September 1926, page 41.

Source: Social Welfare History Archives.

November 28, 1921

Dear Lew:

I am glad that you are making such good progress.

Mr. Wevill and I went over the pictures and I agree with him that
you have a real treasure trove here. But I disagree with you as to the
number we can effectively put in any eight-page series. I know that all
your geese are swans. Not only in your own eyes, but in reality; yet,
none the less, you can put too many swans on a page.

We are taking your scheme as a base and simplifying it and will let you see the results before going ahead. Mr. Wevill is rather driven just at this season and I doubt whether he can attempt to come to the hospital with them. I have asked Mr. Van Doren, our new art man, to put the layout in practical shape to lay before you, and you will have every opportunity to have your own judgment and wishes count before it goes to the engravers.

With best wishes.

> Sincerely,
> Paul

Source: Social Welfare History Archives.

March 17, 1922

Dear Lew:

Half a dozen copies of our Coal Number—some of the first from the press—will go off to you as soon as they are out. With them goes my keenest appreciation of your spirited collaboration in this issue.

> Sincerely,
> Paul

Source: Social Welfare History Archives.

April 25, 1922

Dear Mr. Hine:

I enclose [a] copy of my letter to the *Literary Digest* and their reply.

After assuring you of one thing they should have stuck to it. But the incident illustrates a point which I think we should clear up.

(a) That you would give us the magazine rights of these work portraits and other special photographs you take for *The Survey*—until released by us.

(b) That when so released you can sell the photographs to other magazines as you please.

(c) That when a magazine like the *Literary Digest, The Outlook* and *The Review of Reviews* wants to draw on *The Survey* as a source, we are at liberty to let them use our prints without charge as part of our publicity function. If they prefer to get originals from you and pay for them—all right; but I don't see why they should be put to that expense and it would only be done on the basis that they give us the same credit that they would do if they got them from us for nothing. Otherwise, apart from their broken promise, the position they take seems to me absolutely sound. The advertisement that it would have been to us to have that credit line is worth a lot more than the $4.00 they paid you for the picture.

(d) In the case of an article, say, on coal, in a magazine which had nothing whatever to do with the *Survey Graphic,* you could, of course, sell the pictures outright. Once we have released them to you, that is an entirely different situation from one which a digest magazine is quoting from.

(e) Better take up the releasing of the pictures from time to time and get it in writing from us.

> Sincerely,
> Paul

Kellogg had allowed the *Literary Digest* to publish Hine's photographs—which had been submitted to the *Survey Graphic,* where they were subsequently stored—without the photographer's knowledge or consent. At a time when photographer's rights were virtually unheard of, Hine was acutely aware of the financial value of his pictures as well as the necessity of receiving a credit line and a reproduction fee. While Kellogg was sympathetic in this instance, the problem of picture rights arose again in 1934, with a less satisfactory outcome for Hine. The issues of by-lines and artistic control of photographs and negatives are recurring leitmotifs in Hine's postwar correspondence.

Source: Social Welfare History Archives.

➤ ➤ ➤

May 25, 1922

P. U. K.:-

You did release all the coal photos (except the few that we laid aside for future use) a couple of weeks before *Lit. Digest* called on me to furnish prints.

Hereafter, you may handle all photos that have a publicity value for the *Graphic*. Even then, you'll find many a slip occurs.

Hine

Source: Social Welfare History Archives.

➤ ➤ ➤

Day Boat
August 14, 1922

Dear Paul;-

I wrote Mrs. Stern where to find the article on motor trucking.

Can't you bring out, somewhere, the idea that the motor has helped them to hitch their wagon to the star—Pegasus out of a dump cart—or words to that effect.

If I could tell the story in words, I wouldn't need to lug a camera; & we could run the mag. without you & Lasker (maybe).

Thank you for your patience. I hope to get mine back before I return.

Cordially,
Hine

The "Day Boat" refers to a trip up the Hudson River, perhaps to the Hine family's summer home.

Bruno Lasker was a journalist who contributed articles about international issues to the *Survey Graphic*.

Mrs. Stern was a secretary on the journal's staff.

Source: Social Welfare History Archives.

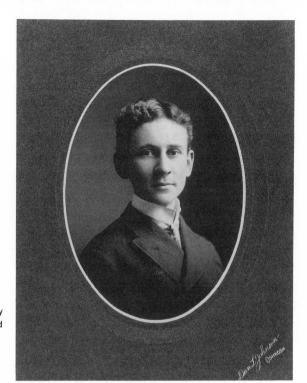

Lewis W. Hine, about 1890.
Hine originally aspired to be an
artist, but he did not imagine a
career as a photographer. (Courtesy
of Lewis W. Hine Collection, United
States History, Local History and
Genealogy Division, The New York
Public Library, Astor, Lenox and
Tilden Foundations)

Frank Addison Manny, about
1890. Hine first met Manny in
their native Oshkosh, Wisconsin.
When Manny later became
superintendent of the Ethical
Culture School in New York, he
invited Hine to join the faculty.
(Courtesy of Carter Manny, Jr.)

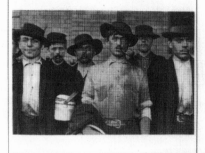

As They Come
to
Ellis Island

The Slavs

IMMIGRANT TYPES IN
THE STEEL DISTRICT

PHOTOGRAPHS BY LEWIS W. HINE

GOING HOME FROM WORK.

"As They Come to Ellis Island," Hine's first photo story to be featured in Charities and the Commons, *appeared in its September 5, 1908, issue.* (Courtesy of Social Welfare History Archives, University of Minnesota, Minneapolis, Minnesota)

"Immigrant Types in the Steel District," which appeared in the January 2, 1909, issue of Charities and the Commons. *Hine's collaboration with Paul Kellogg on the* Pittsburgh Survey *resulted in photo stories that visualized and humanized the plight of immigrants in industrial cities.* (Courtesy of Social Welfare History Archives, University of Minnesota, Minneapolis, Minnesota)

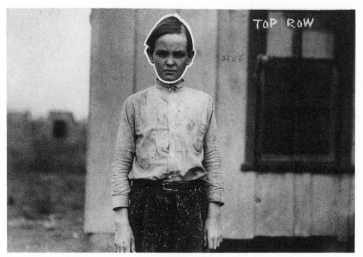

TOP ROW

Because the technical apparatus of the camera was limited to medium-distance compositions, Hine often cut out faces or altered his photographs by adding white or black paint to emphasize pictorial details. These appeared in photomontages, exhibit panels, and photo stories he designed for expositions and publications of the National Child Labor Committee. (Courtesy of Harry Lunn, Jr.)

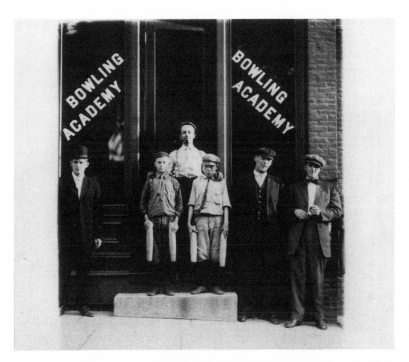

"Child Laborers outside Bowling Alley," a product of the kind of subterfuge Hine resorted to in chronicling "premature workers." Hine was staff photographer for the National Child Labor Committee for more than fifteen years. (Courtesy of Harry Lunn, Jr.)

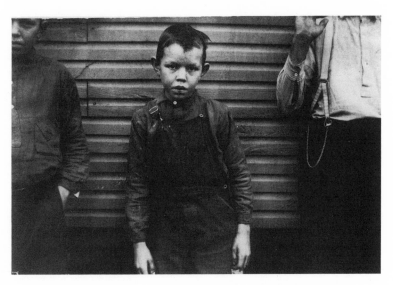

The artistic nature of Hine's documentary photographs may be seen in this photograph, where the boy's posture and forlorn expression symbolize the cruelty of child labor. (Courtesy of Harry Lunn, Jr.)

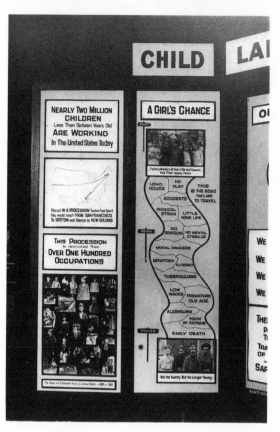

This exhibition panel reflects Hine's imaginative method of assembling pictures and text. The panel was displayed at the San Francisco Exposition of 1915, attended by more than 20,000 people. (Courtesy of Harry Lunn, Jr.)

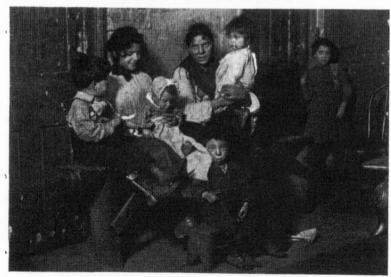

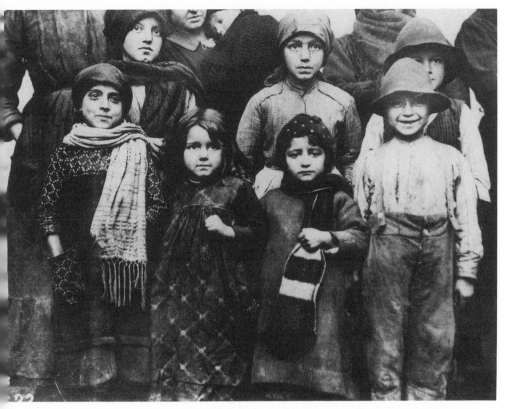

"Italian Refugees, November 1918." Hine was part of the American Red Cross Special Survey team that toured Italy, Serbia, and Greece immediately after the Armistice was signed. (Courtesy of the Library of Congress, Washington, D.C.)

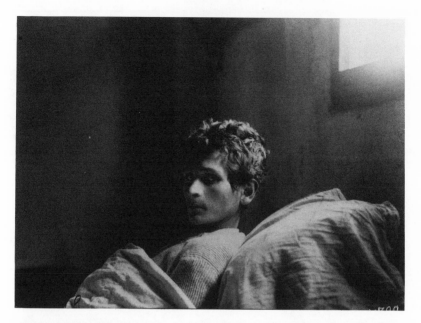

"Giuseppe Ugesti, Italian Soldier in 223rd Infantry. He was an Austrian prisoner at Milowitz (reported to be very bad) for ten months. He is now confined to his bed with tuberculosis. January 1919." Hine's European photographs represent a maturation of the photographic style he developed in his American assignments. (Courtesy of the Library of Congress, Washington, D.C.)

"A Christmas Street Fiddler, Belgrade. December 1918." After the war Hine shifted his focus from "negative to positive documentation." In many ways his European ouevre, *where his photographs of child laborers were produced from a more lyrical orientation, reflects this new approach.* (Courtesy of the Library of Congress, Washington, D.C.)

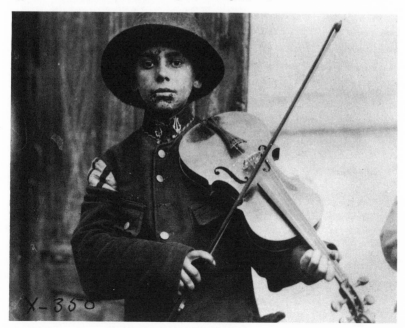

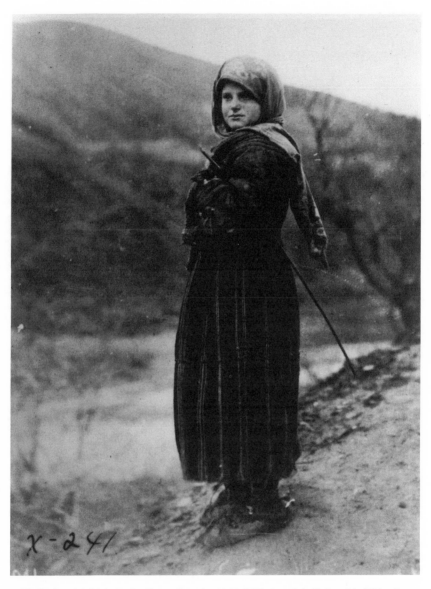

"Shepherdess with Stick. Bralo, Greece. December 1918." Hine's special affinity with children is evident throughout his work, but those in his American Red Cross images frequently radiate confidence and pride rather than the victimization often reflected in the NCLC pictures. These qualities would carry over into his postwar portraits of industrial laborers. (Courtesy of the Library of Congress, Washington, D.C.)

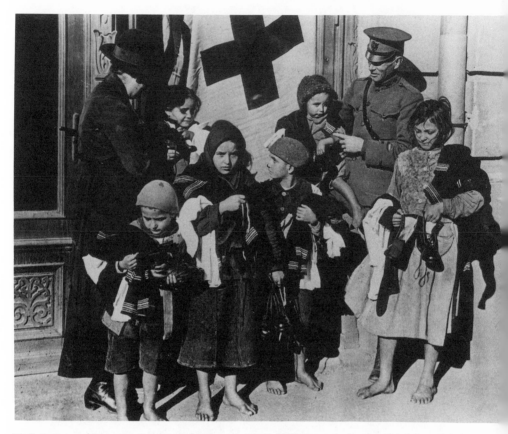

"*A.R.C. Personnel Dispensing Supplies. Serbia. December 1918.*" This is one of only a handful of photographs in which the American Red Cross workers, rather than the children themselves, symbolize the agency's good works. (Courtesy of the Library of Congress, Washington, D.C.)

August 21, 1922

Dear Lou:

I have sent you a check for $100 advance on The Craftsman Group. We shall want the Scientific Instrument done also; this will give us two fine clusters for the New Year beginning October 1st.

We shall let it stand at that, I think, and not attempt an every other month schedule as we did this past year, but shall, of course, from time to time want special things done for us such as the hatters' article. I tell you this so that on getting back you may know what you can count on from *The Survey* this year in connection with your plans.

I hope you are having a ripping time and getting sunburned so that you will look like that bruiser whose picture closes the Truckmen series. The engravings are coming out fine. Stay two weeks anyway—three if you possibly can. Meanwhile, I am sending you a bit of an additional check for that trucker-of-truck's head, which we are using on the cover.

Sincerely,
Paul

"Truckman, Truck Workers" appeared in the September 1, 1922, issue of the *Survey Graphic*. "Joy in Work," Hine's craftsmen series, appeared in its February issue.

Source: Social Welfare History Archives.

Franklin, N.Y.
August 26, 1922

Dear Paul;-

Many thanks for the advance on [the] Craftsmen series and the allowance for [the] Sept. cover, both received.

Your plan to use the Series more tentatively in the future suits me exactly. While it has been good fun to get out some of these indefinite assignments, I cannot afford to put in so much time on them and so it will be better to wait for more urgent and definite needs, keeping as close as possible to the real work portrait.

It is a real vacation. I may return more bruised than bruiser and with a headlight that will last all winter.

As ever,

Hine

Source: Social Welfare History Archives.

November 23, 1922

Dear Mr. Hine:

Mr. Lasker tells me that you have been accustomed to write captions for your photographs in the *Survey* and I am, therefore, sending the layout for the seven pages of craftsman portraits, and also your caption cards.

I am not quite sure whether they will be published this month or next, but in any case I should like to get them all ready.

Very sincerely,

Associate Editor

P.S. We have some bundles of cuts from your published photographs. Shall I hold them until you call?

The Survey Graphic had several associate editors, including Bruno Lasker, Robert Bruere, Hannah W. Catlin, Joseph Hart, Geddes Smith, Haven Emerson, M.D., and Neva Deardorff, any of whom could have written this letter.

Source: Social Welfare History Archives.

Jes' fore Christmas [1923]

Dear Old Oom;-

Your letter and check came just in time to tide over a real financial stringency and I am hoping someone will do as much for your Christmas cheer. I haven't very strong hope from the West Penn people, but you never can tell.

There ought to be some way for me to be of service to the *Graphic* through the use of some of my on-hand material, and I shall be glad to contribute some if you can arrange some way for me to go over it with

some of your people without too much waste [of] time. Also, you ought to waive your overemphasis on the virginity of such material. A good photograph should not depend too much upon the one element of novelty.

When you think of any possibilities for a "Series," let me know and I will contribute the first lot.

As ever, Hopefully-
Hine

Letterhead: Lewis W. Hine, Work Portraits, 170 Edgars Lane, Hastings-on-Hudson, N.Y.

Addressee: Paul Kellogg. The derivation of this sobriquet might be "Om," the Hindu mantra used in formal worship.

Source: Social Welfare History Archives.

April 8, 1924

Dear Paul;-

You may be interested to know that the Jury for the Art Directors Club Exhibition of Advertising Art showing at Art Centre this month gave me *the* medal for *photographs*.

It was the Engineer in the cab (P.R.R.) that you selected long ago for the Graphic Series & P.R.R. used on *menu*. Four of the other *five* they are showing are The Printer, Freight Brakeman, Mechanic & air brake, and the Heart of the Turbine, all of which you have used before they got into advertising.

Hine

Source: Social Welfare History Archives.

[April 1924]

P. U. K.;-

Two really significant aspects of my work have been recognized by this advertising award—the acceptance of the appeal of the common man (in contrast to the white collar and underwear stuff) and the value of

the realistic photography (which has for some time been displaced by the fuzzy impressionism of the day). It has taken five years of hard work to make these two tiny dents in their armor of complacency but it has been worth it.

H

The attached note is from the Art Director of the largest & most successful Adv. Agency in the country.

The addendum was missing from Kellogg's archive.

Source: Social Welfare History Archives.

October 20, 1924

Dear Paul;-

Many thanks for the extra 50. I am still in doubt about the advisability of irregular assignments for either *Survey* or me, unless the financial margin is counted on from the first.

Ready-made stuff (like the Child Labor layout) we can dicker over without much loss of time, which item is getting more valuable to me as the work settles down.

Cordially,
Lewis W. Hine

Please pass on to Miss Merrill.

Miss Merrill was a *Survey Graphic* employee.

Source: Social Welfare History Archives.

February 26, 1925

Dear Lew:

That's perfectly ripping! I thought the photograph itself was good; that the reproduction in *The Survey* was fair; but here all the values of light and shading—all your instinct for design—all your love of the beauty of the worker's hand, as well as of the art of his hand—are brought out to the full.

Did Tiffany reproduce this or was it the Aldus Printers who showed their craftsmanship? If Tiffany has never done it he is a boob.

> Sincerely,
> Paul

Source: Social Welfare History Archives.

> Hasten-on-Hudson
> March 26 [1925]

Dear Paul;-

I have sent Cooper one of the "Broadsides" & a note about the text. It was written by one of the firm, a live wire, versatile & artistic to the core, and a neighbor of mine. I feel sure that my work has been one of the influences that have brought him, an employer, to the point where he could grant that much to the worker, even in theory.

Another neighbor has suggested it might be interesting to picture the *unskilled* worker a bit. Would you be interested to consider some Hewers of Wood and Drawers of Water perhaps for June or July? If so, what basis of selection would you suggest? There might be several. I could get some as I go around on other assignments, but such a thing doesn't just happen, as you know.

> Cordially,
> Lew

Cooper has not been identified. Hine's "Portrait of a Man," which appeared in the March 1 issue of the *Survey Graphic,* was probably the broadside to which he was referring.

Source: Social Welfare History Archives.

> March 28, 1925

Dear Lew:

My impression is that Hewers of Wood and Drawers of Water would be a picture drawn by too blunt a pencil. Isn't there more drama in a particular group of workers? If common labor had never been discovered before, I think your friend's suggestion would be good. But it has.

We all have the picture in our minds. What would you say to throwing the spotlight on some little bunch in the procession—just as you threw the spotlight on those little bunches of the skilled workers in those earlier series for us?

Still I am not at all sure but what if you caught them in the act, a group of pictures under the heading "IN THE SWEAT OF THEY [sic] BROW" would have taking quality. But I rather think it is not the sort of thing you could go out and gather. You would have to simply happen on it.

We have another Health Number in embryo and it may be that within a fortnight or so a real assignment will develop out of it.

> Sincerely,
> Paul

Source: Social Welfare History Archives.

➤ ➤ ➤

> H of H-on-H
> August 31, 1925

Dear Paul;-

I'm off for 10 days on the farm, sans camera 'n everything impedimentary. Leaving the bunch of prints with Smitty.

Hope I may be able to sit in with you but my chief recommendation is to make the emphasis on the Character in the Cast, rather than on the scenery.

I think my new card is an improvement on Work Portraits.

> Cordially,
> Hiney

Smitty was Hine's darkroom assistant.

Hine's hand stamp during this period read "Interpretive Photography"; however, he may also be referring to the card's design.

Source: Social Welfare History Archives.

November 10, 1926

Dear Lew:

Congratulations on the article regarding your work in the *Brooklyn Eagle* last Sunday.

> Sincerely,
> Paul

Source: Social Welfare History Archives.

November 24, 1926

Dear Lew:

I am profoundly glad this recognition is coming to you. The *Mentor*'s reproductions are splendid. I hope it may all mean not only recognition, but mounting commissions for you.

> Sincerely,
> Paul

The Mentor featured an article on Hine entitled "He Photo Interprets Big Labor" in its September 1924 issue, pages 41–47.

Source: Social Welfare History Archives.

> ➤ ➤ ➤

September 18, 1929

Dear Paul;-

For some time I have been "interpreting" the common (middle) man (even as you and I), and the critics, even the victims themselves, have been rawther [*sic*] appreciative.

I find this line just as much fun as the previous slants on life have been and I think fully as much of a contribution to the gaiety of nations.

Perhaps some of the cogs of the *Survey* could be done, I dunno, but the main idea is to keep you a little posted on modern tendencies up our way.

Cordially-
Hine

Source: Social Welfare History Archives.

October 16, 1929

Dear P. K.;-

Mrs. A. P. K. is going over with me the material & queries that I have been wanting to see you about and she will see you (if necessary) & so I'll not need to bother you for a while. Isn't she the one I ought to keep in touch with?

Loouie

Mrs. Arthur P. (Florence Loeb) Kellogg was art editor of the *Survey Graphic*.

Source: Social Welfare History Archives.

July 22, 1930

To Whom it May Concern:

Bearer of this, Mr. Lewis W. Hine, is the official photographer for the Empire State Building and we will appreciate any courtesies extended to him. He is to be admitted to all Empire State property.

Empire State, Inc.
By Josef Israels II

Letterhead: Empire State, Inc., 500 Madison Avenue, New York. Alfred E. Smith, President.

Richard Shreve, a neighbor of Hine in Hastings-on-Hudson, was a principal in the architecture firm that designed the building and apparently recommended him for the job of photographer. During the period Hine documented its construction, his son, Corydon, assisted him.

Israels was head of the building's publicity department.

Source: Naomi and Walter Rosenblum.

[October 10, 1930]

Dear Paul;-

I was more than delighted to get another wave from you (via Manny's
article)—especially as that Series is built on those others that you "saw"
so long before others began to notice 'em much. If you can get to see
some of these new ones as practical possibilities, the expense to *Survey*
will be nominal or less.

 Could you spare a quarter (of an hour) some day along about the 15th
or 20th or 25th of Oct.? My own time is pretty full now so I shall need to
work it into your time as I can, so tell me a few alternate days or hours.

 American Magazine is doing a story about my industrial portraiture
which includes ten studies (some full-page) of the old standbys
(printer-engineer-mechanics, et al.) as "old friends" that have stood
the test of time and not yet worn out.

 Their roto-features are always exclusive stuff but they waived that
point in respect to the other qualities of the stuff. Voila!

> Cordially,
> Hiney

Source: Social Welfare History Archives.

> > >

October 25, 1930

Dear Paul;-

My hearty thanks for the cordial reception you all gave to my last effort
to surmount the inertia of age. Last Spring, I was so discouraged with
the lack of appreciation of my work that I put our house on the market
and started out to settle down in an upstate rural community where
there is more underfoot than "overhead." Then came this Empire State
job and some others that have kept the pot bubbling over. They are, all
of them, time-consuming, when one tries to do them as they ought to
be done; so, whenever it is possible for *Survey* to contribute something
for these special features, it is a little return on the extra investment of

time that I am making on such adventures. I did not press this side of it with Mrs. Kellogg but I wish you would, in some way, and I am sure that there will be many chances, during the year, for me to get you other special features for little or no cost.

Another matter—do you know how I can get in touch with the proper persons on this Housing Commission (the Al Smith one) to make sure that when they need my kind of work they will know of me? I have spoken to Mrs. Moskowitz a couple of times and am sure she will do what she can. Any hunches will be appreciated, along this or any other lines.

> Cordially-
> Lew Hine

Source: Social Welfare History Archives.

October 28, 1930

Dear Lew:

It was like old times and good times to have you with us at luncheon. And as you could see, we were all as eager as boys in an apple orchard over your pictures. And I'm sure we will not only want this skyscraper feature now, and that new bunch of work portraits later on, but may want to tap you in other directions. Only we too are as poor as Job's turkey. But at least a pin feather now and again may come your way.

As I understand it, your old friend and mine, Dr. Edward T. Devine, is the key person in that new housing commission's work. His address is Housing Commission of the City of New York, 325 East 38 Street.

> Sincerely,
> Paul

Source: Social Welfare History Archives.

➤ ➤ ➤

October 31, 1930

Dear Hine:

The release of the murals for the New School is for the December maga-
zines. (Decision yesterday.) So unless there is a slip-up, we'll hold your
sky-boys over until the January or February *Graphic*. But the check for
the use of them needn't be held over and is enclosed!

The Negro school article is in the hands of the education editor, who
is temperamental at present, in the throes of writing a long article,
and will consider it as soon as she has finished. It's to be judged on its
merits as an article with illustrations, not a spread. I'll let you know
the verdict.

I'll consult you on Empire State first page layout and captions before
I call it a day.

 Yours sincerely,
 Florence

Source: Social Welfare History Archives.

➤ ➤ ➤

 Hastings-on-Hudson, N.Y.
 November 25, 1930

Dear Paul;-

My six months of skyscraping have culminated in a few extra thrills and
finally achieving a record of the Highest Up when I was pushed and
pulled up onto the *Peak* of the Empire State, the highest point yet
reached on a man-made structure.

The day before, just before the high derrick was taken down, they
swung me out in a box from the hundredth floor (a sheer drop of nearly
a quarter of a mile) to get some shots of the tower. The Boss argued
that it had never been done and could never be done again and that,
anyway, it's safer than a ride on a Pullman or a walk in the city streets,
so he prevailed. Growing up with a building, this way, is like the
account of the strong boy (was it Hercules?) who began lifting a calf

each day and when they had both reached maturity he could shoulder the bull.

I have always avoided dare-devil exploits and do not consider these experiences, with the cooperation the men have given me, as going quite that far, but they have given a new zest of high adventure and, perhaps, a different note in my interpretation of Industry.

Please ask Florence K.—does she think it might be well to consider putting in one of these later shots in place of one of the Series decided on.

> Cordially,
> Lewis W. Hine

Source: Social Welfare History Archives.

> Homeward Bound
> Fri. P.M. [December 1930]

Dear Art;

I wonder if you could get more perspective in that Gist paragraph. I started photoing by trying to "interpret" school life at Ethical Culture over a quarter century ago. Then you steered me into Social Welfare. Then came Child Labor, Red Cross & finally Industry from a human angle.

The detective work was a mere incident that seemed necessary at the time but it ought not to overshadow the fact that I have plumbed the depths (coal mines) and scaled the heights to visualize some aspects of life for those who need to be shown.

> E- Hiney

The January 1, 1931, issue of the *Survey Graphic* featured a photo story of Hine's Empire State Building work portraits entitled "Up from City Streets" (pages 361–65). "The Gist of It" (or "Gist," as it was referred to in this letter) was essentially a brief biography of each author and a summary of his or her contributions to that issue; it appeared on the contents page.

"E" was an abbreviation for "ever."

Source: Social Welfare History Archives.

➤ ➤ ➤

December 9, 1930

Dear Art;-

The Hastings "Snooze," the livest paper around here, wants to print something about the forthcoming *Graphic* spread of Hine-o-graphs, and they go to press next week before *Graphic* appears. Have you any copy of the Blurb and mayhap the Gist, that they could make up from?

If you have anything like a Dummy, of the cuts too, I might be able to show it to Israels and perhaps prepare his mind for whatever presentation may come from your office about the magazines I think he might buy.

> Cordially-
> Hiney-

Hine's word play is reflected in this obvious reference to *The Hastings News*.

Source: Social Welfare History Archives.

➤ ➤ ➤

December 11, 1930

Dear Hiney:

We are having trouble with that fancy first page of the art feature. I'll send you proof as soon as it is in presentable shape—proof of that and the pages following.

I left off the sublines which you were for inserting on the full-page cuts, on the ground that they took away from the strength of the thing.

In the Gist I let you down to the bottom of the deepest coal mine, but I had to leave out the almost prehistorical Ethical Culture episode. If you keep on going backward this way, you'll turn up somewhere in the Book of Genesis, snapping up the animals while God named them!

> Sincerely,
> Arthur

Source: Social Welfare History Archives.

January 1, 1931

Friend Florence:-

Happy New Year and Congratulations on the results of *our* efforts! Have had many bouquets.

If the colored photos are not usable, please mail 'em.

Did I ever show you the Montclair Library studies? Some way, somehow, something ought to be salvaged from that series. They have a publicity woman who could get you up something in the way of an article.

Cordially-

Hiney-

Many thanks for all your sympathy, patience and encouragement. Even skyscrapers have their basements and skyscraping has its rebounds & depressions.

H

Addressee: Florence Kellogg.

Source: Social Welfare History Archives.

February 7, 1931

Dear Paul and Arthur;-

Red Cross accepted my "propolition" at two hundred a week for short orders. *World's Work* has just waked up to my existence and is using special stuff and wants more. A raft of lesser lights are [sic] using the skyboys and altogether a little stream of shekels trickles in and the applecart job seems more remote.

I want to tell you that I shall always remember what a factor you two and *Survey* have been in putting my stuff on the map, to say nothing of what your appreciation and encouragement have meant all through the first quarter century of Hineography. The other three quarters ought to be that much easier. I am convinced that had the Paul-Art cooperation failed to synchronize at various critical periods I might still be polish-

ing brains at the Ethical Informary so, please, for them and for me accept my heartfelt thanks.

Cordially-

Hiney

With Corydon as his assistant, Hine documented drought conditions in rural communities in Kentucky and Arkansas for the American Red Cross.

Source: Social Welfare History Archives.

February 10, 1931

Dear Hiney:

Thank you a lot for the Paul-Art letter. Anything that either of us has ever done to help you along has been paid back at least a thousand times, both personally and to the *Survey*.

Sincerely yours,

Arthur

Source: Social Welfare History Archives.

February 11, 1931

Dear Lew:

I am ever so glad you are taking that Red Cross commission on.

Sincerely,

Paul

Source: Social Welfare History Archives.

March 1, 1931

Dear Paul-Art;-

I opened *Survey Graphic* in the midst of printing up the wad o' stuff that the Red X trip yielded, and need I tell you that I nearly lost my mind

when I compared the drought illustrations with the Hineographs you might have had if only they had sent me a few weeks earlier. I am really a bit proud of what I got in a couple o' weeks time—they are worthy of *Survey,* and you, and me. Some day, lemme show yu.

It was only a year ago, come St. Patricks' (the birthday of Al's Big Shanty), that I decided to move out into the open spaces where there is less overhead and more under foot, for I thought I had shot my best bolts and was ready for the armchair by the fire. Some subquentials would indicate that there is a lot of wallop in the old Model T, if only the supply of gas and oil holds out. There is nothing to brag about but a deal to be thankful for.

<div style="text-align:center">Confidentially and gratefully-
L. W. Hine</div>

"Al's Big Shanty" is Hine's ironic reference to the Empire State Building, erected under Alfred E. Smith's aegis. Built during the Depression as a symbol of New York's economic prowess, it was the focus of much controversy because of rising unemployment and the bank panic throughout the United States. Smith, who was president of the corporation that financed the building's construction, had been governor of New York for four terms, from 1919 to 1920 and from 1923 to 1928.

Source: Social Welfare History Archives.

<div style="text-align:center">[March or April 1931]</div>

Paul;-

Some time, tell me the inwardness of my Red X assignment. Griesemer has been very liberal & patient thro it all but I feel that you & Fieser (perhaps) were the motivation. I have a feeling that G. has little picture sense.

<div style="text-align:center">Hine</div>

Apparently, Kellogg had referred Hine to Griesemer and Fieser, two American Red Cross staff members Hine worked with on the assignment in Kentucky and Arkansas.

Source: Social Welfare History Archives.

➤ ➤ ➤

Hastening-up-the-Hudson, New York

April 12, 1931

Dear Art;-

If you fellers have the old-time luncheon on Thursday, 4/30, and have room for two, I would like to bring in our old friend Frank Manny, of Boston, who expects to be around for a coupla days then. He is the maker of "Findings," and has a lot of contacts you-all would be interested in if you are not too much involved on that day.

Been having the biggest showing I ever had of my "quarter-century of work," at the Yonkers Art Museum, recently, with a lot of good newspaper appreciation. *American Magazine* is planning to run a story with a bunch of old favorites soon. See you "subsequently."

Cordially-

Hiney

P.S. Please ask Friend Florence to let me know if and when they can decide on that Montclair Library stuff.

Source: Social Welfare History Archives.

➤ ➤ ➤

August 22, 1931

Friend Florence;-

The *American Mag.* folk are holding the old write-up, called "Faces we like to look at," to use as soon as space opens up, and I have not been able to pry up any more openings for my super-mech's.

Would it be okay if I wrote Paul a tiny billet to tell him that I have this stuff on hand in case he hasn't enough pitchers [sic] for his fall number? I am sure it is the kind of stuff he would like.

Cordiallically-

Hiney-

Source: Social Welfare History Archives.

➤ ➤ ➤

November 24, 1931

Dear Paul;-

No special hurry about that Super-mechanic layout, but don't let it get
snowed under too far, S.V.P. I will accept any contribution you feel
budget will allow. Have lots of work but not very many oodles of shek-
els coming in, but am having "lots of fun."

> Cordially-
> Hiney

Source: Social Welfare History Archives.

➤ ➤ ➤

January 5, 1932

Dear Paul;-

A Happy New Year and a new problem. *Who's Who in America* shelved
me in the last issue. A number of prominent persons have told me they
wrote to Marquis Co., protesting the move. Our old friend Manny
seems to be the only one they sassed back. He still thinks they are in
error—if you do, please tell them your reasons, if there is still time to
make the change for the coming issue. Personally, of course, I think
my contribution was unique and the last two years have held the cream
of it all.

 Thank you, as always, and I want to meet the P.M. tea-drinkers some
time with some new personal portraits.

> Cordiallically-
> Lew-

P.S. What hours and days do the above tea parties function? Naturally,
I do not think the above is a question for them to discuss, as I know
some of them, including Florence K., think my stuff is not modern
enough. I do find, however, that my old-fashioned studies go on being
used and appreciated years after the fads die out. However, use your
judgment.

Source: Social Welfare History Archives.

January 27, 1932

Dear B.A.;-

Who is in charge of Publicity up at Gen. Electric now? I may want to write him. Could you use any of my studies?

Cordially-
Hine

Addressee: Beulah Amidon, an associate editor of the *Survey Graphic*.

Source: Social Welfare History Archives.

February 3, 1932

Dear Hine:

The story of this condemned March *Graphic* and its twelve articles is like the story of the Five Little Peppers and How They Grew. Those twelve little articles are with difficulty getting squeezed into a 96-page issue. Result, we could use only three of your photographs—one as a full page and two in the text.

Paul asks me to send you the enclosed check. I know it is no shower of gold but we had to have a few pages drawn to order for this issue and are feeling our eternal poverty.

Those beautiful G.E. pictures didn't fit the article at all. Nothing fitted anything in this blooming number.

I am holding your black portfolio so as to be sure you come in to see us soon again.

Sincerely yours,
Florence

Source: Social Welfare History Archives.

➤ ➤ ➤

March 8, 1932

Dear Lew:

May I add a postscript to the check which went off to you and tell you
how glad I am that we could handle those three work portraits of yours
in our Economic Planning Number. It's like old times to have you in
the thick of a special project like that. Or rather the thin, because while
we added two forms to the issue, the ground to be covered was such
that we had to cut down on text and pictures, yours among them.

Several people have already spoken to me of the charm and calibre of
the three pictures we did handle.

With genuine appreciation,

Sincerely,

Paul

Source: Social Welfare History Archives.

➤ ➤ ➤

May 4, 1932

Dear Lew:

I find your clipping and notation on getting back to my desk. And
alongside it is a copy of the *Missionary Voice,* or the *World Outlook* as it is
now called. I met the editor at Atlanta recently and she is a peach. It
was ever so good to find their first issue under the new name glorified
with a bunch of your work portraits.

That picture of me was one that Christina Merriman came into the
office and snapped one fine day. Do you remember her? Later she spe-
cialized in photography before her death and did some very rare things.
This is perhaps not one of them. Some day when you are around here
with your camera I will be glad to be the victim.

Sincerely,

Paul

My introduction to Hine's work occurred during the two-year period I was employed by the
United Methodist Church as director of preservation and research of its historical photographic

collection, an archive of 200,000 secular and religious photographs. Among this material are 1,000 photographs Hine provided for church publications and lantern slide programs. In 1920, for example, he conducted special investigations for the Interchurch World Movement on "Life & Labor of Colored People, North and South." So careful was Hine vis-à-vis reproduction of the images that many of them have this statement stamped on the face of the print: "For lantern slide use, not for reproduction."

The United Methodist archive is now housed at Drew University. Included are 300 European photographs Hine made for the American Red Cross. These provided the impetus for my first book, *Lewis Hine in Europe: The "Lost" Photographs*. *The World Outlook* is today called *The New World Outlook*.

Source: Social Welfare History Archives.

May 6, 1932

Dear Lew:

Mrs. Larson of our staff ran across this paragraph in H. G. Wells's new book, opposite which is a photograph of one of your Empire State Building pictures.

> Sincerely,
> Paul

A portrait of an Empire State Building sky-boy, "Icarus," appeared in Wells's *The Work, Wealth and Happiness of Mankind*, vol. 1 (New York: Doubleday, Doran & Company, 1931), opposite page 274, along with photographs by Margaret Bourke-White and William Rittase.

Source: Social Welfare History Archives.

May 11, 1932

Dear Paul;-

For some quarter of a century I have had a growing conviction that a good photo-portrait could be made of you. For a short time past, I have felt sure that I am man enough to do it. Therefore, I'm not giving up the battle just because of the unfavorable situation at the office.

We frequently go Croton way on a (Sat. preferably) or Sunday and would be glad to stop for an hour in midmorning, en route, if you

could let me know a few days ahead. An hour will be ample for the ordeal.

Now, it's your move!

> Cordially,
>
> Lew

Hine was alluding to his continuing professional differences with Florence Loeb Kellogg, who increasingly found his work "old-fashioned" and opted for the work of more contemporary photographers. From 1935 on, for example, she turned to Roy Stryker and the F.S.A. photographers for illustration materials.

Source: Social Welfare History Archives.

September 8, 1932

Dear Paul;-

Please look over the BOOK and see what you can find. If you can, I wish you would review it for the *Graphic*.

It was built as a picture book for children, from the adolescent up, and even we blasé adults can get a good deal from it, I hope. Many of the studies are old friends to some but to many they will come with a fresh message. The Introductory statement is something of a Credo.

Any suggestions as to uses and outlets will be appreciated.

> Cordially-
>
> Lew-

It is out—Sept. 13th.

Hine's work portraits were featured in *Men at Work: Photographic Studies of Men and Machines*, a handsomely designed book originally published by Macmillan Company, New York, in 1932 and reprinted by Dover Publications, New York, in 1977 with eighteen additional prints. The book featured Hine's photographs and captions and a dynamic layout designed by him. It was marketed to adolescents.

Source: Social Welfare History Archives.

➤ ➤ ➤

June 13, 1932

Dear Lew:

I'll let you know the first chance. Art is long and time is fleeting, but
you'll overtake them yet!

 Sincerely,

 Paul

Source: Social Welfare History Archives.

➤ ➤ ➤

February 17, 1933

Dear Florence Kellogg;-

I am glad you raised the question of the value of human values in
photography beyond mere illustration.

 Just now I think it is a very important offset to some misconceptions
about industry. One is that many of our material assets, fabrics, photo-
graphs, motors, airplanes and whatnot "just happen," as the product of
a bunch of impersonal machines under the direction, perhaps, of a few
human robots. You and I may know that it isn't so, but many are just
plain ignorant of the sweat and service that go into all these products of
the machine.

 It is for the sake of emphasis, not exaggeration, that I select the
more pictorial personalities when I do the industrial portrait, for it is
only in this way that I can illustrate my thesis that the human spirit is
the big thing after all. With regard to this emphasis, I think we should
apply the same standard of veracity for the photograph that we do for
the written work. Even in art, poetic license shouldn't slop over into
yellow journalism.

 One more "thought"—I have a conviction that the design, regis-
tered in the human face thro years of life and work, is more vital for

purposes of permanent record, tho it is more subtle perhaps, than the geometric pattern of lights and shadows that passes in the taking, and serves (so often) as mere photographic jazz.

 Cordially-

 Lewis W. Hine

Source: Naomi and Walter Rosenblum.

4.
Hine at Work: Editorial, Corporate, and W.P.A. Assignments, 1933–35

After the publication of *Men at Work,* Hine's picture book for adolescents, the demand for his camera picked up pace again. He pursued Florence Loeb Kellogg, the *Survey Graphic*'s recalcitrant art editor, for additional assignments and was introduced to Sidney Blumenthal, president of Shelton Looms.

Hine's relationship with Blumenthal, writes Jonathan Doherty in *Women at Work,* "was one of the most valuable and productive associations with private industry that he developed. Blumenthal was considered by Hine to be one of the more progressive leaders in industry management. In a 1917 article he had advocated company provided disability compensation, life insurance, and pensions" (page 41).

In 1933 Hine photographed all aspects of the manufacture of fine fabrics at the Shelton Looms. *Through the Threads of the Shelton Looms,* a portfolio of twenty photographs with text, was published that year. This publication opened doors leading to Dr. Arthur Morgan, director of the Work Progress Administration and the Tennessee Valley Authority, and numerous museum curators. For Hine, the Shelton Looms assignment was an artistic and commercial success.

April 17, 1933

Dear Paul;-

I often feel that bread cast upon *Survey* waters brings in rather more returns than most anything else scattered elsewhere.

For instance, "Through the Threads" brought to Sidney Blumenthal a request from School of Business, Harvard U., for prints for special use there, and started Mr. B. off on a campaign of sending such material out to schools, etc., which is giving me a deal of work. This same "spread" was the immediate cause, I happen to know, of the letter you received from Frank A. Manny, and when I read to Mr. Blumenthal the copy of that letter that you sent me, it helped start off some more things including the probability of having me help in the preparation of the exhibit for [the] World's Fair, and possibly a book to follow the lead of *Men at Work*.

Sidney Blumenthal is a man you would admire, both for what he has done and for what he will do. Also, I think he ought to be helping you when finances loosen up. I think I see a way for you to get in touch with him through a suggestion of Manny's in which S. B. seemed interested. This I will talk over with you when we both have time at the same time.

Meanwhile, thank you most heartily for what you have done.

> Cordially-
> Lew

Hine's photo story "Through the Threads" appeared in the April 22, 1933, issue of the *Survey Graphic,* pages 210–11.

Source: Social Welfare History Archives.

June 14, 1933

Dear Paul;-

Florence K. seems to think that Mr. Fels might be interested to know about the ways I have cooperated with Sidney Blumenthal on his Shelton

Looms situation. Can you think of a way that it might be brought to his attention and open the way for an interview? We ought to understand each other and God knows I need more under-standing and less over-head, or something.

Am still working on that series of farm workers that you may recall was suggested by the head of Dept. of Agri. (was it?) back in the good old days of Railroaders, et al. It is slow and hard sledding, even more difficult than the other lines have been, and takes time and expense. Hope I live to see it through.

> Cordially-
> Lew

Samuel Fels was a partner in the soap manufacturing firm of Fels & Co. A generous contributor to Survey Associates, he maintained progressive corporate policies that included profit-sharing programs for employees and workers councils to help determine shop policies.

Source: Social Welfare History Archives.

➤ ➤ ➤

June 15, 1933

Dear Lew-

If you make up a portfolio of the Shelton Looms—say half a dozen of the best—I'll put it in Mr. Fels's hands with the warmest sort of recommendation I know how. I think his feeling is that a soap works does not lend itself to so arresting a pictorial treatment; but he is wrong there of course.

At a later stage—and perhaps even now is not too soon to lay lines— there might very well be something growing out of these new governmental operations in the industrial field which would open up for you.

For example, there will be excellent progress photographs and pictorial records of the mechanical treatment of the Tennessee region. Why would it not be possible to interest President Morgan in having a human record to parallel that? Make up another portfolio with about a dozen pictures, not limited to the looms, but showing some of your Empire

State and other work; and I will be glad to send that to Mr. Morgan with the suggestion—unless you have a better contact.

> Sincerely,
> Paul

Source: Social Welfare History Archives.

July 24, 1933

Dear Mr. Blumenthal;-

I am, indeed, grateful to you for the very comprehensive statement sent to Mr. Arthur E. Morgan and feel that it ought to register and yield results, if anything can.

I attach a note from Dr. Tugwell and a brief list of prominent persons with whom I have worked in the past and who would appreciate a copy of the Portfolio. I suggest sending it with a personal note and later following it up with a copy of the new brochure, when it is finished. This gives an excuse for two contacts.

If you have time to hear the enclosed letters to Commissioner Perkins and Miss Jane Addams, both of whom have been personal friends of mine in the past, please make any suggestions that you think will make them more effective.

The Newark Museum has been suggested as a possible use for our material. If you think it is, please suggest the proper persons to see— I might run out there.

Would a brief note from you be a help?

> Very sincerely yours,
> Lewis W. Hine

Prof. Richards will try to see me this week.

Jane Addams was the founder of Hull House, Chicago, the first settlement house in the United States. She was also an ardent peace activist and a member of the *Survey Graphic* advisory board. While in Chicago doing fieldwork for the National Child Labor Committee in 1909, Hine photographed immigrants at Hull House.

Frances Perkins was a prominent New Dealer who served in state government.

Source: International Museum of Photography at George Eastman House.

> > >

August 28, 1933

Dear Mr. Hine:-

Most any day this week or next will be satisfactory for you to come to the mill as I expect to be here all of the time. Of course, the mill is closed on Saturdays and will be closed Labor Day.

There is always a possibility of my going to New York for a day, and, if you will kindly wire me the day before you intend coming I will send you a return wire to let you know whether I will be here.

When anyone knows their business as well as you do yours it is always a pleasure to work with them, and I will look forward to your coming some day this week or next.

> Yours very truly,
> A. G. Holland

Letterhead: The Shelton Looms, Owned and operated by Sidney Blumenthal & Co.Inc., Manufacturers of Pile Fabrics, Shelton, Conn.

Holland was manager of Sidney Blumenthal & Co.

Source: International Museum of Photography at George Eastman House.

> > >

[August 1933]

My dear Dr. Tugwell;-

I have been getting so many echoes from your Industrial Discipline that I venture to send you a recent visualization of some human elements in the textile industry. You will recall my help in illustrating your economics book in the old Columbia days.

In passing, I wish to express my appreciation of the high moral plane on which Mr. Sidney Blumenthal, President of the Shelton Looms, is conducting the company program as he has for many years past. In the

Introduction to this Portfolio Mr. Blumenthal expresses his credo and I
am sure you will see that it accords with yours and mine.

> Very sincerely yours,
> Lewis W. Hine

Addressee: Rexford Tugwell, chairman of the Planning Department of the New York City Plan-
ning Commission.

Hine revised the phrase "high moral plane on" to read "enlightened outlook upon social *indus.*
with."

Source: International Museum of Photography at George Eastman House.

[August 1933]

My dear Miss Addams;-

I think you will recall my photographic and publicity activities in the
various social welfare fields—Child Labor, Red Cross, Tuberculosis,
Recreation, etc.—a few years back. Since then, I have been doing some
interesting work in Industry, trying to interpret to the outsider what I
consider to be the human basis of industry.

Mr. Sidney Blumenthal, President of The Shelton Looms, has re-
cently brought out a portfolio of my photo-studies, which, at the same
time, shows the very progressive attitude that his company has been
taking for a long time.

I am sending you a copy of this portfolio for I know you will appreci-
ate it and I hope you will note, especially, the introductory card which
gives the essence of his industrial idealism.

With best wishes and hopes that the Summer will prove a restful one
for you, I am,

> Very sincerely yours,
> H-sign

Addressee: Jane Addams.

Source: International Museum of Photography at George Eastman House.

After the completion of the Shelton Looms portfolio, Hine embarked on a letter-writing campaign. The original letter to Jane Addams, for example, was a draft that Hine showed to Blumenthal for his comments and suggestions. Blumenthal added a postscript that appears in another typeface in the original:

"Mr. Hine: Suggest that you draw attention to the fact that in Pavilion No. 5 of the General Exhibits Building at the [World's] Fair they will find an interesting display of the originals of these photographs in somewhat larger size, in connection with the exhibit of our Company."

This information was modified by Hine and incorporated into the final version, then typed on the Shelton Looms stationery, as were the other letters that follow.

August 3, 1933

My dear Mr. Blumenthal;-

I sent to a friend who knows President Morgan from several angles the letters written by you and Paul Kellogg to him. This is the comment I received.—"Paul's letter is good but Mr. Blumenthal's could not be better if he had made a special study of the type of letter most effective with Mr. Morgan."

I feel very deeply indebted to you for this letter and for your understanding of what I am trying to do.

Mr. MacFadden has spoken to me at various times in the past about using my photo-studies in his talks, etc. Last week he gave me some more definite suggestions of what other studies would be of value in his presentations. I will outline those suggestions and bring them to you within a day or two.

> Sincerely yours,
> Lewis W. Hine

Mr. Blumenthal;-

May we send a copy of [the] Portfolio to the following who are on a previous list coming from *Survey* magazine people?

> Mr. H. B. Bergen, Director of Industrial Relations Dept.,
> Proctor & Gamble Co., Ivorydale, Cincinnati, O.

The Curator, Benjamin Franklin Museum, Philadelphia, Pa.

The Curator, Cleveland Museum, Cleveland, O.

Dr. Walter Bingham, Director of The Personnel Research Federation, 29 West 39th St., N. Y. City

Mr. Alfred K. Stern, Director of Special Activities, Julius Rosenwald Fund, 4901 Ellis Ave., Chicago, Ill.

Also 2 cop. to Miss Coffey, Curator, Newark Museum.

MacFadden has not been identified.

Hine's interest in sending portfolios to the parties mentioned in this letter was a way of both publicizing his project for the Shelton Looms and making inquiries about other assignments. At this stage he was hopeful also of placing the material in museums. Little, if anything, came of these queries.

Source: International Museum of Photography at George Eastman House.

January 22, 1934

Dear Sir;-

Referring to the photo-studies of workers from the Shelton Looms, used in the Century of Progress Exposition and sent to your Museum a while ago, Mr. Blumenthal has asked me to tell you that we have, since, assembled a number of new studies that show more of the mechanical aspect of the creation of beautiful fabrics. These additional studies have purposely omitted the human element that is so evident in the first series.

I enclose a list of descriptions for a new series that has been made up, and you will find fifteen of these marked with an "X" to show you the phases of manufacture treated by the new studies.

Mr. Blumenthal asks if you will please look these over and let me know if you think that ten or fifteen of these new studies, made up to match those you have on hand, would be of any real use to your exhibit. It may not be possible for us to frame these as the others were. They were done in Chicago. Perhaps we would send you the prints mounted and ready to frame as you see fit.

Please return the list of descriptions and oblige,

> Yours very truly,
> Lewis W. Hine
> Staff Photographer
> Sidney Blumenthal & Co.

Addressee: O. T. Kreusser, director of the Museum of Science and Industry, Chicago.

Source: International Museum of Photography at George Eastman House.

February 16, 1934

Dear Mr. Blumenthal;-

The following requests for mounted enlargements of the Shelton Looms material have come to me during the past several months and have been waiting until the last series of 8 × 10 inch prints were mounted and labelled. They have been finished and ready to send.

1. Miss Gertrude Underhill, Curator in charge of textiles, Cleveland Museum of Art, Cleveland, O.
2. Mr. George F. Bowerman, Librarian, The Public Library of the District of Columbia, Washington, D.C.
3. Miss Ramona Javitz, Librarian in charge of the Picture Collection, New York Public Library, Fifth Ave. & 42nd St., N.Y. City
4. Mr. C. G. Leland, Supt. of Libraries, Board of Education, N.Y. City, 215 East 41st St., writes that there are six of the largest schools that can make real use of these sets and asks if he may have at least two more sets.

These are the high spots in the various requests that have reached me and I think they will be good investments.

> Sincerely yours,
> Lewis W. Hine.

P.S. I think a personal note should accompany these, either from Mr. Mathews or myself.

Source: International Museum of Photography at George Eastman House.

According to Naomi Rosenblum, Hine's Through the Threads *portfolio was also sent to Ansel Adams, "who offered suggestions for the use of the Loom photographs . . . [and wrote] about Hine to Dr. Arthur Morgan" (*America and Lewis Hine, *page 23). Kellogg's support was also enlisted, and he sent Morgan a lengthy letter outlining Hine's contributions to the magazine.*

In October 1933 Hine received a month-long assignment at Morgan's Tennessee Valley Authority project to photograph the Wilson and Muscle Shoals dam site, for which he was paid $1,000. Although he felt "glorious" at first, Hine became more and more frustrated with Morgan's inability to recognize the value of photography to publicize the T.V.A. Instead of using photography to stimulate public interest, Morgan insisted on using it to duplicate blueprints and charts. In addition, Morgan reproduced Hine's photographs without a by-line or credit. With this final blow Hine terminated his relationship with the agency.

➤ ➤ ➤

July 10, 1933

Dear Mr. Morgan:

From their blueprints on, your engineers and draftsmen will be making an exact record of the physical progress of your Tennessee project.

But along with the surveys and framework of the plan in terms of mechanics and mathematics goes the whole epic story of the men on the job, from shovelers and sandhogs up through to the technicians; there is the drama of team play, and the social changes that the project will bring to the region.

When we launched the *Pittsburgh Survey* back in 1907–8, we broke with the old stereotypes of social and economic investigations. We reinforced our text with things that spoke to the eye—drawing in charts, graphs, maps and designs from the engineers—and employed not only photographs but pastels and even sculpture, using Rodin's *Puddler,* for example, to visualize the meager payments made for the loss of an eye, an arm, a leg, in the industrial accidents of the steel mills.

In our Coal and Power Numbers in recent years we have gone further—with relief maps, aerial photos and the like. And we turned to Lewis W. Hine, whose *work portraits* had been a feature of our *Pittsburgh*

Survey, to give us the *cast of characters* of the electric industry from line men up to superintendents.

Hine is the pioneer in social photography of this sort, assisting with his camera the early work of the National Child Labor Committee in bringing out the human appeal of immature wage earning. More recently he has done some excellent work in visualizing railroad labor, in his pictorial record of the work that went into the Empire State building (under Governor Smith), and in his assignment for the Shelton Looms.

It occurred to me that your imagination might warm to a similar sort of treatment of the Tennessee Valley project. The Russians have, of course, resorted to such pictorialization in their major engineering projects, in getting the whole people to know of them; and our friend Herr Muller has long employed photography to reinforce his three-dimension exhibits at the Munich Industrial Museum.

So I told Mr. Hine that I should be very glad to call his work to your attention. He has given me an album which illustrates it, and which I am sending under separate cover. His charges are very reasonable; it is really the love of the thing that has kept him at his creative last all these years. His address is: Lewis W. Hine, Hastings-on-Hudson, New York.

> Sincerely,
> Paul U. Kellogg

Addressee: Arthur E. Morgan, director of the Tennessee Valley Authority project.

Source: Social Welfare History Archives.

October 14, 1933

Dear Paul & Co.;-

Dr. M. called me down to Washington to confer—now I am starting Tuesday to put in a preliminary month in the T. Val. Anyway, it feels good to get into action. Many thanks for everything to everybody.

> Cordially-
> Lew

Source: Social Welfare History Archives.

> > >

H-on-H-
December 15, 1933

Dear Paul;-

You could send this list on as it is. If you see any way you could put in
one of the old-fashioned bouquets, along with this January series, it
might be of more value now than to wait until you have to send a floral
wreath or a lily. It is not a matter of personal satisfaction (great though
that is when you or Art or Florence give an introductory flourish), but
I am sure that somehow we have to get in our hyperdermic before they
go to sleep, for I *know* I can help them if I get half a chance.

Hopefully-
Lew

Hine's typewritten date, "12/15/33," was a typographical error; the letter should have been dated
November 15, 1933.

Hine's disengagement from the then-popular fascination with and idealization of machine tech-
nology caused Florence Kellogg gradually to discontinue using his photographs in the *Survey
Graphic*. In this letter he is discussing photographs of his reproduced in connection with a serial
T.V.A. piece entitled "Bench Marks in the Tennessee Valley," *Survey Graphic*, January 1934, pages
6–7, 9, and 10.

In this letter Hine uses various flower symbols and references to describe politely his professional
differences with Florence Kellogg and Arthur Morgan. By "old-fashioned bouquets" he was refer-
ring to his photographs, which he knew Florence found out of date; by "floral wreath" and "lily"
he was alluding to the imminent death of his association with the magazine because of deteriorat-
ing relations with the art director; and by "hyperdermic" he was describing the infusion of new
ideas that Morgan and his associates at the T.V.A. required. Paul Kellogg's efforts at mediating
the conflict between Florence and Hine in the end resulted in a reconciliation.

Source: Social Welfare History Archives.

> > >

Knoxville, Tenn.
November 25, 1933

Dear Paul;-

Have had a glorious month with T.V.A. It is a large order they have
started and it is all in the first stage. The visual part of it has not been

worked out yet and, altho I have given them a good demonstration, some feel that I could accomplish more later.

> Lew
>
> En route to H-on-H
> November 27, 1933

P.S. Decided to call it a month & review operations later.

Have tried to round up some pictorial material for you but Publicity is in a jam. I think it could be arranged thro Dr. Morgan & I have a good hunch for a layout whenever you have time to see me.

Hastings-on-Hudson now.

> Lew

Source: Social Welfare History Archives.

> November 28, 1933

Dear Lew:

I shall be eager to see your pictures. And we shall be handling developments in the Tennessee Valley in ways that would make them a real windfall in our plans for the new year. Meanwhile, again congratulations on this new piece of scouting with your camera eye in the most interesting laboratory in America.

> Sincerely,
> Paul

Source: Social Welfare History Archives.

> H-on-H
> December 2, 1933

Dear Paul;-

I'll be seein' you at 3 P.M. Monday. It will take you some time to thaw

out some coagulated situations down there, so I shall be glad to start you soon. Big things move slowly.

> Cordially,
> L. W. Hine

By "coagulated situations down there" Hine was alluding to the mounting tensions with Florence Kellogg.

Source: Social Welfare History Archives.

December 11, 1933

Dear Mr. Blumenthal,

I am back in Hastings, for the time being, until the activities in Tennessee can progress to the visual stage.

Meantime, I will submit to you what data I have on hand relative to the requests for the sets of enlargements for Museum and School use. Most of these requests I have suggested to you some time in the past, and I have not been able to check up on what Mr. Matthews has done.

(1). The special set for Professor Richards has been sent to him.

(2). The set for the Lending Collection of the Metropolitan Museum of Art (via Dr. Richard F. Bach) has been sent, I think.

(3). Miss Hutchinson, Librarian at the Brooklyn Museum, will be glad to have her set soon.

(4). Dr. Dooley, Principal of the Textile High School, New York City, through his librarian, Miss Nellis, can make good use of a set.

There are six other possibilities that I would like to speak to you about before going further into them. I am in the City from time to time.

> Sincerely yours,
> Lewis W. Hine

Source: International Museum of Photography at George Eastman House.

December 13, 1933

Dear Lew:

Enclosed are proofs of the first T.V.A. article with your pictures that Mr. Morgan let me have.

The next article will deal with transmission, distribution, the new towns, forestation, the educational plans, etc., I think. Here is the memo. you left with me. Will any of these fit? I am not sure whether these enlargements would be the right ones? If you could send us numbers that would fit article number 2, and then some that will give types of workers, farmers, townsfolk, etc., I think that would be about right?

Are we to pay you for the pictures, or make our dicker with the T.V.A.?

Sincerely,

Paul

"Bench Marks in the Tennessee Valley" appeared in the January 1934 and March 1934 issues of *Survey Graphic*.
Source: Social Welfare History Archives.

December 14, 1933

Dear Dr. Morgan:

Recently we learned with considerable interest that Mr. Lewis W. Hine, interpretive photographer, is to do some human-interest photography for you in the Valley territory.

In our work with economic exhibits, including the work in land economics under Dr. L. C. Gray, we have felt handicapped by a lack of striking human elements to give point to our basic material. This was especially true this year in connection with the Century of Progress. If in Mr. Hine's work he secures photographs that illustrate farm labor or effort (not merely pictorial effects) such as he was able to get in his *Men at Work,* or if he gets native rural handicraft pictures of people at work, or, in fact, any arresting pictures that can be related to our economic

efforts on behalf of agriculture, I shall appreciate it if you will call my attention to such photographs.

Assuming that you could release them for such use, we shall need something of the sort as soon as we begin revising our Century of Progress exhibit this spring.

Sincerely yours,

J. Clyde Marquis

➤ ➤ ➤

December 15, 1933

Dear Paul;- P.S.

Just received these two copies of letters that bear on our immediate problem. Others have told me they could use this kind of visual stuff in various kinds of educational work and I discussed this phase with Dr. Morgan. He seemed interested at the time.

Lew H.

Letterhead: United States Department of Agriculture, Bureau of Agriculture, Bureau of Agricultural Economics, Washington, D.C.

Marquis was director of information, U.S. Department of Agriculture.

Source: Social Welfare History Archives.

➤ ➤ ➤

February 5, 1934

Dear Paul;-

Thank you again, as ever, for the helping hand, and I'll do as much for you-all when my turn comes. I would not think of bothering you if I did not feel sure your bread-casting would return to you some time, but the real drawback in all this slow motion on the part of those who ought to be realizing on my help is that one cannot do this kind of visualizing from a wheelchair nearly as well as he can before old age advances.

Cordially-

Lew

Source: Social Welfare History Archives.

➤ ➤ ➤

October 29, 1934

Dear F. K. and P. K.;-

I'd expect Morgan and His Men to be unwilling to acknowledge that those five studies were mine but I am surprised that some *Survey* keen eye did not notice that there was considerable Hine accent about them.

T.V.A. runs true to form and formula, as do all the Alphabetics I have contacted, and the accumulation of straws finally cave[d] me in.

L. W. H.

Hine was referring to the third installment of "Bench Marks in the Tennessee Valley," which appeared in the November 1934 issue of the *Survey Graphic,* pages 549–51.

Source: Social Welfare History Archives.

➤ ➤ ➤

November 7, 1934

Dear Lew:

I'm sorry that we failed to carry credit lines under those pictures of yours in the November *Survey Graphic.* We'll watch our step hereafter.

But while I see how it upset you, I think you read more into it than was there.

I imagine that at the overworked T.V.A. headquarters they simply drew on their stock, and sent the ones on to us, without the thing being handled by someone who knew their sources. Why not drop them a line, asking them to label yours?

At our end, Arthur's death ripped out the very hub of our working scheme. He would have caught yours, I know; or Florence, had she been handling the issues, which was not the case.

So don't cave in, old man. Here's to you and yours.

Sincerely,
Paul

Florence Kellogg's marginalia next to the fourth paragraph is worth noting: "Not necessarily. It's up to the Morgan publicity people. They don't seem to give credit to their paid photographers. FLK."

In July 1934 Arthur died suddenly of a heart attack. According to Clarke Chambers, author of *Paul U. Kellogg and the Survey,* his death left "a hole in Paul's life and in the *Survey* neither of which

could ever be filled . . . [and] required a major overhauling of the *Survey* staff and of its entire operation" (page 135).

At the same time Paul, after twenty-five years of marriage, divorced his wife, Marion. The following year he married Helen Hall, a settlement house leader who succeeded Lillian Wald at the Henry Street Settlement.

Source: Social Welfare History Archives.

[May or June 1935]

Dear Paul;-

My emphasis has always been, when making new contacts, not my need but *their opportunity,* for I feel sure they need me more than I need them. I hope the results will justify all the bloodshed, and I do thank you again, as ever.

Lew Hine

"Bloodshed" is a term that Hine began to use often with regard to his battles with Florence Kellogg.

Source: Social Welfare History Archives.

[c. June 25, 1935]

Dear Paul;-

W. Frank Persons suggested my writing to Fechner who takes a rather self-satisfied attitude (see attached).

The Hopkins and Tugwell setups seem to be planning to do some self-directed publicity but have not gone very far,

Hopefully,
Lew

Please return letter some time.

The attachment to this letter was not among Kellogg's papers.

Persons and Fechner have not been identified.

According to Maren Stange, when Tugwell left Columbia University in 1933 to become assistant secretary of agriculture, he hired Roy Stryker to work temporarily in the Information Division of

the Agriculture Adjustment Administration in the summer of 1934. Stange has written, "In May, 1935, when Tugwell became administrator of the Resettlement Administration (RA), which, sans Tugwell, became the F.S.A. in 1937, he called Stryker back to direct the Historical Section-Photographic of the RA's Information Division" (*Symbols of Ideal Life,* page 105).

Since Kellogg was aware of Hine's need for additional work, he no doubt alerted Hine to Stryker's newly created photographs department.

Source: Social Welfare History Archives.

[c. June 26, 1935]

Dear Lew,

Sounds like what I've been told by Fechner.

Here's hoping on Hopkins & Tugwell to keep me abreast.

P. U. K.

Source: Social Welfare History Archives.

October 3, 1935

Dear Lew:

Homer Borst told Gertrude Springer that you were doing some fine photographs for his Chest organizations in New Haven. And that you were backing and forthing between there and your home. Won't you let me see some of the things you have been doing the next time you are coming in to New York?

Sincerely,
Florence

Homer Borst directed the Community Chest organization, a social relief agency based in New Haven, Connecticut.

Gertrude Springer was managing editor of *The Midmonthly,* a journal specializing in practical advice for the fledgling social worker; she also served as a member of the *Survey Graphic*'s advisory board.

Source: Social Welfare History Archives.

➤ ➤ ➤

H-on-H-
October 10, 1935

Dear Florence;-

Borst, and others, seem to like the New Haven stuff—it is only the old-fashioned Hine-ography which you have not had much use for lately. Have been putting in some time for Morris Cooke's Rural Elec. Admin.—in Ohio, Penn, etc.

It does keep me bouncing around a bit. See you sometime.

Cordially-
H

Source: Social Welfare History Archives.

➤ ➤ ➤

October 15, 1935

Dear Paul;-

As a sort of compensation for previous neglect, some of my old clients are runnin' me ragged on some special jobs that bid fair to add new chapters to Hineography.

Am alternating weeks, now, between a photo-survey of Borst's Community Chest up in New Haven and Cooke's R.E.A in Ohio & Penn. Sam Board thinks the Resettlementers may need something done also.

Anyway, it's "looking up not down," etc.

Cordially,
Lew

P.S. Borst is full of good ideas—note enclosed. A lovely reproduction.

The "Resettlementers" were Roy Stryker and the Resettlement Administration.

Sam Board cannot be identified.

Source: Social Welfare History Archives.

➤ ➤ ➤

October 21, 1935

Dear Lew:

Just the same Gertrude Springer and I are hankering to see what you
are doing for Homer Borst! Not for any immediate definite use but as a
possibility. So won't you let us look at the photographs sometime when
it is convenient for you?

Beulah Amidon is in Washington this week seeing Morris Cooke
about a story on the R.E.A. and following other leads. So your R.E.A.
pictures excite us mightily.

We are all very glad that people are beating a track to your doorstep
again.

Sincerely yours,
Florence

Morris Cooke directed projects for the Rural Electrification Administration (R.E.A.) in Ohio and
Pennsylvania. With this federal agency, as with the T.V.A., Hine fought for control of his
negatives.

Source: Social Welfare History Archives.

5.
The Politics of Documentary Photography, 1935–38

Disillusioned with the inability of "the alphabetics" (federally sponsored public service agencies) to perceive how his social photographs could serve their publicity purposes, Hine nevertheless approached the Resettlement Administration, which later became the Farm Security Administration, for work. His letters to Roy E. Stryker, director of its historical section, pertain to this exchange.

Years earlier, Stryker had used Hine's photographs to illustrate Tugwell and Munro's textbook *American Economic Life,* which was published in 1926. Although his images constituted the bulk of illustrations for the book, they were altered and cropped and usually appeared without the caption that Hine formulated. Maren Stange writes that Hine wanted to show "the meaning of the worker's task, its effects upon him and the character of his relation to the industry by which he earns a living . . . [whereas] Stryker, Tugwell, and Munro were interested in portraying the benefits of the new management sciences" (*Symbols of Ideal Life,* pages 92–93).

Scholars have speculated that Hine's age and insistence on pictorial control were factors in Stryker's not hiring him; indeed, perhaps it was Hine's reluctance to give Stryker carte-blanche with his negatives that made Stryker wary of hiring him for Resettlement Administration projects. While Stryker repeatedly stated his admiration for and debt to Hine, no work was forthcoming.

➤ ➤ ➤

November 14, 1935

Dear Mr. Hine:

I am looking forward with a great deal of interest to seeing the pictures which you took for the R.E.A. Whenever you are ready to turn over the negatives to us, we shall surely be in a position by that time to give them careful work on future enlargements. I think for the present your idea is excellent—by all means keep the negatives in your possession.

As things are now, I do not believe that you can expect anything to open up where we could use your services. Perhaps in the spring our finances might make it possible for us to work out some proposition with you. I certainly would very much like to, as I have no questions whatever but what you could put out a good job.

When you are down in Washington again, by all means give me a ring as I am always very glad to see you. Perhaps, we can have lunch together.

<div align="right">Very truly yours,
Roy E. Stryker</div>

Source: University of Louisville.

➤ ➤ ➤

December 27, 1935

Dear R. E. S;-

Before I forget it, you may be interested to know that you have registered a "high" with the little lady at the *Survey* who is Art Editor (Mrs. Kellogg). I happened in yesterday to talk over some things and she was very appreciative of what you are doing down there. She suggested that I talk over a little question of policy that is still unsettled with the R.E.A. I have finished up with them so I feel that I am divulging no professional secrets—at the same time, please consider this as man to man and try to decide it as you might "if you were I."

It's this way. When Cooke called me in to do a special job for him,

he stated (in a letter) that all he wanted was "one hundred good photo-studies," and that was the basis of my agreement with R.E.A. Some time before I finished up, I went over with the head of Publicity Dept. the alternative of my putting in my remaining time getting extra negatives instead of extra prints and he decided on the negatives. I have given them several hundred prints and have told them I will furnish more at a reasonable rate, which I gave them.

When I was in Washington last, I looked up as many of the possibilities for their getting prints made as I could and wrote them, some time ago, that, in order to protect their equity in the negatives as well as my own reputation, I had decided to exercise my photographer's prerogative and supervise the prints made from these negatives. This is a legal right that a photographer has and it is only just. In every case where I have waived that right, I have had good reason to regret it whenever I saw the results that were put out.

Ignoring my arguments, different R.E.A. officials continue to ask me, on different pretexts, to send down the negatives. I have good reason to believe that their only reason for wanting them is to economize on the printing.

Without boasting at all, I want to assure you that I have gathered, in those negatives, a wealth of visual material and, if they continue in this penny-wise policy, a good part of the real value of it all will be lost.

Now I wonder if you can take your mind outside the office walls and try to imagine what you would do in my place. I am sure that the proposition was just one of Cooke's trial balloons and that there is nothing more for me with R.E.A. Incidentally, I covered over 2,000 miles in my auto with my Associate—Ohio, Penn., & N.Y.—and the actual expenses cut a deep gash in the amount they paid me. I hope I am not intruding too far on your good nature and passing interest in my work.

> Sincerely yours,
> Lewis W. Hine

Addressee: Roy E. Stryker.

Source: University of Louisville.

> > >

[December 1935 or January 1936]

Dear Mr. Hine:

I am sorry that I have not been able to answer your letter sooner, but I have been delayed in getting to my correspondence.

I very much appreciate your feelings in regard to the use of your negatives. A photographer like yourself, who puts as much effort into the pictures as you do, has every right to see that the pictures from these negatives are of the best. Unfortunately, there are too many people in Government service who do not have proper respect for either the negative or the print.

I am so much in sympathy with the good photographer's desire to care for his films that we started out here with the intention of letting each man do his own printing. That, however, has proved impossible, so we now have a laboratory set up to take care of the printing. We have done our best, however, to compensate for this situation by being hard-boiled with the laboratory people. We are demanding extreme care from them in handling the negatives, and I might say that we are getting very excellent work from the men in the laboratory.

I have a special problem, however, which is so much similar to the one that you raise. Miss Dorothea Lange, who is one of our photographers, is stationed on the Pacific coast. She is most desirous of keeping her negatives there, but to date we do not seem to be able to work out a very satisfactory arrangement for her to do her own printing in Berkeley. It either means that we shall have to contract to have the prints made by a commercial dealer, or keep her away from her fieldwork if we are to get prints made from the negatives there. I have tried to figure out some way of making it work and let her keep her negatives, but I fear that we are going to have to request her to send the negatives on to our files. I know just how much she hates to do it, yet I am under pressure at all times to obtain prints from her negatives and find it much too long a job to write a letter out there and then have to wait for the copies to come through.

I hardly know what to advise you. I suppose in the end the Government is the owner of the film unless the contract is otherwise stated. You have presented to them the advantage of letting you do the prints,

but this has apparently been of little avail. I presume that the people involved there are of the type mentioned above, who think that any kind of print is a satisfactory one. If I were in their place, I would be so anxious to get the best possible use of the negatives that I would go to some length to have good prints made. Unfortunately, I have nothing to do with it so I can offer you little in the way of suggestion as to the best way of handling it.

I have been very anxious to see the work which you did on this trip. Would it be all right to go over there at the R.E.A. and ask whether or not they have pictures, and if so could I look at them if I did not mention the fact that I am a friend of yours.

I am terribly upset about the mix-up you are in about these negatives because we are in mutual accord about the importance and value of the negative. If there is any possible way in which I could be of service in clearing this up, let me know. Unfortunately, I am not acquainted with anyone in the R.E.A. and so cannot offer assistance in this way.

We are extremely busy here at the present time trying to get our prints filed and the negatives properly taken care of. This important work is interfered with by this or that job that has to be sent out.

I had hopes that something might open up later in the summer, and we might be able to use your services then. With the recent Court decision, however, I suppose I can hope for little more than I am getting in my budget at the present time.

Accept my best wishes for a satisfactory solution of this difficulty.

Very sincerely yours,
Roy E. Stryker

The court decision to which Stryker is referring is uncertain, but he was clearly alluding to cutbacks in his budget and the agency's reorganization as the Farm Security Administration (F.S.A.).
Source: University of Louisville.

July 24, 1936

Dear Mr. Hine:
I found your letter of July 1 on my desk when I arrived back from my vacation yesterday. I was very glad to hear from you again.

I am keeping you very much in mind for any job which might develop here where I could use your services. However, we have had to curtail our staff rather than enlarge it, and I don't see much possibility of taking any additional people on unless things open up more than they are now.

Walker Evans is doing work in the South, at the present time, on sharecroppers and tenants. Miss Dorothea Lange, who has been working for us in California, is now in the East. She just made a trip down through the South, taking pictures of agricultural labor. Our other two men are in the middle West, taking pictures of drought conditions.

I do not believe it is necessary for you to send any samples of your work. I am already very familiar with it and do not need samples to convince me of the value of taking you on our staff, provided that we were financially able to do so. I do hope, however, that some work will come your way, either with us or with some other agency. It is so important that we recognize the value of a graphic portrayal of our life. When I search now for pictures of any phase of American life, even as late as 1900–1910, I realize very keenly the value of the camera as a device to record history.

If you are in Washington, please, by all means, look me up, as I am always glad to see you. If I hear of any opening, I will be very happy to suggest your name. Thank you for your letter.

> Sincerely yours,
> Roy E. Stryker

Source: University of Louisville.

August 14, 1937

Dear Roy Stryker:

A lot of good work has gone through since I saw you last. Now I am pounding the cobblestones of the Big City making new contacts; some of them look mighty promising too.

Incidentally, I am working with the New York Public Library—Javitz and Lydenberg—on the question of making the best of my collection of negatives available to the public through them and with the

possible assistance of the Carnegie Corporation. (The last is *very confidential* as it is still in the tentative stage.)

I wonder if you know anything about what the Library of Congress is doing with collections of negatives that are along this line. I have heard that they are in charge of a series of photo-records of old historic homes, etc. If the N.Y.P.L. is unable to handle my stuff, I'd be glad to know about the L. of C.

Above all, I do not want to lose touch with you—there are so many things with which we can be of mutual help, I am sure.

> Cordially,
> Louis [*sic*] W. Hine

This material is now part of the New York Public Library's Local History and Genealogy Collection and may be found under the heading "Studies of American Life and Labor, Lewis W. Hine."

Ramona Javitz was librarian in charge of the Picture Collection at the New York Public Library.

Henry Miller Lydenberg, assistant director of the library and its chief reference librarian, was responsible for building collections.

The letter was retyped by an unidentified person, who misspelled Hine's first name in the closure.

Source: University of Louisville.

September 29, 1937

Dear Mr. Hine:

Your letter of August 14 was acknowledged by my assistant, and a copy sent to me in Vermont. I am sorry that this is the first opportunity I have had to get a reply to you.

I expect to be back and forth to New York often in the course of the next few months, and I wonder if you and I could arrange to get together and talk over the problems you mentioned in your letter. Also, there are many other things I have in mind.

I am wondering what luck you have had to date in the placing of your films in the Public Library.

I might be of help in the disposition of your films. Please let me know how I can reach you so that on my first trip up I will be able to talk these things over with you.

I suggest that in the future you address me at my home, since the official mails sometimes become so involved.

Best regards.

Sincerely yours,

Roy E. Stryker

Letterhead: Farm Security Administration.

Source: University of Louisville.

From the Stryker correspondence we go back a year to an important series of letters between Hine and Kellogg addressing the picture press's expansion from 1936 to 1937. Nearly thirty years after the Pittsburgh Survey, *Stryker and* Life *magazine fully employed the power of photographic communication. But just as Stryker created his own roster of photographers, so did* Life. *With* Look *magazine's debut in 1937, contemporary documentary photographers now had several vehicles for their work.*

September 15, 1936

Dear Lew:

I have just heard of two new journalistic projects that are up your street.

One is that *Time* is going to bring out an illustrated picture weekly; and if they put the sort of imagination into it that they put into *Fortune* it ought to go far.

Another is that the *Times Mid-Week Pictorial* has been sold and a new crowd is burgeoning into the journalistic game with an initial edition of half a million. I don't know the people in either of these projects but felt they ought to know about you. Do enlighten them.

Sincerely,

Paul

Hine's photo essay "A Railroad Fireman" was published by *Fortune* in June 1939. For a comparison of Hine's photo stories with those published by *Time* and *Life*, see my "Lewis Hine's Photo Stories: The Fetish of Having a Unified Thread," *Exposure*, 27, no. 2, 1990, pages 9–20.

Source: Social Welfare History Archives.

September 16, 1936

Dear Paul;-

Thank you for your thoughtful suggestion which I shall follow up immediately.

I have on hand four of the *Pittsburgh Survey* volumes that you sent me long ago. Probably you know someone who could make more use of them than I can—also, I need the room. Be glad to tote 'em in to your office some time if they might be usable.

> Cordially-
> Lew

Since the *Pittsburgh Survey* volumes are not unusually large, Hine's letter takes on an uncharacteristically specious tone. Perhaps this was Hine's way of reminding Paul of their halcyon survey days. Perhaps it also represented an attempt to arrange a meeting with Paul and receive a much-needed pep talk.

Paul's response to the "bloodshed" between Hine and Florence was to find Hine additional assignments for other agencies. Hine would be paid by that agency and then bring the photographs to the *Survey*, which would then publish them. Once the work came into the office, Paul would mediate whatever differences emerged between Hine and Florence (cf. Paul's letter of March 4, 1937). He did not abandon Hine.

Source: Social Welfare History Archives.

September 22, 1936

Dear Lew-

It's good of you to offer the return of those *Pittsburgh Survey* volumes. Of course I'd be glad to have them to place elsewhere; or fill up a new set (for no new sets can be obtained). But are they extras? If not, then it seems to me as your work is shot through them, I'd hate to take them unless you are altogether sure you need the room.

> Sincerely,
> Paul

Source: Social Welfare History Archives.

➤ ➤ ➤
H-on-H-
November 22, 1936

Dear Paul;-

I certainly appreciate your many efforts to keep the Work Portraits idea alive—I often feel the results do not justify all the bloodshed. It is about time, anyhow, to turn it all over to the new generation with their modern efficiency, but every few years I find the procession has gone around the block and is again catching up with the old-timers and their persistent emphasis upon some of the old fundamentals.

Again, I thank you and Miss Sabloff as well.

Cordially-

Lew

P.S. It was Arthur who coined the nickname "Work Portraits" and it was he who gave me the first mental hypos that started me on the quest for visual documents in life and labor.

Miss Sabloff was a member of the *Survey Graphic* staff.

This letter was written on the day *Life* magazine's premiere issue appeared—hence, Hine's mention of "the new generation." As Kellogg later wrote, it featured the "hieroglyphics" he and Hine had pioneered more than thirty years earlier.

In photographic chemistry hypo, or sodium thiosulfate, is a fixing agent. Hine appropriated this term to describe how he immortalized the immigrant and laborer in his photographs.

Source: Social Welfare History Archives.

In 1936, after years of exasperation that followed the success of the Empire State Building assignment, Hine was appointed chief photographer for the National Research Project of the Works Progress Administration (W.P.A.). His first assignment was to chronicle recent changes in industrial techniques with supervisor Laura Beam. Hine was ecstatic about the assignment, referring to his colleagues as "kindred souls" and the project itself as "the most glorious visual joyride I've had since the old days of Child Laboring and Red Crossing." The project was never completed, however, although Hine was the coauthor of a 17-page booklet with project director David Weintraub entitled Technological Change *(Philadelphia: Works Progress Administration, 1937), which included several of his photographs.*

Later, Hine would express dissatisfaction with his experiences and denigrate Weintraub's lack of picture sense. In his letter of March 2, 1937, Hine stated his philosophy: He was "not a bit satisfied to sacrifice pictorial value to the fetish of having a unified thread running through the series." The National Research Project assignment and his frustration with Weintraub occurred while Hine was conducting his tip-toe correspondence with Stryker.

➤ ➤ ➤

November 25, 1936

Dear Mr. Kellogg:

Mr. Gill's office has forwarded to me your letters of November 18 and November 24 concerning Mr. Lewis W. Hine. I am very much interested in the possibility of Mr. Hine's doing some work with us, and would appreciate it if you could arrange for a meeting between Mr. Hine and myself, preferably in Philadelphia.

> Sincerely yours,
> David Weintraub

Letterhead: Works Progress Administration, Harry L. Hopkins, Administrator, National Research Project on Reemployment Opportunities and Recent Changes in Industrial Techniques, 12 South Twelfth Street, Philadelphia, Pennsylvania.

Source: Social Welfare History Archives.

➤ ➤ ➤

En route—N.Y. to H-on-H
December 10 [1936]

Dear Paul;-

Already in the thick of it—your spark touched off what may be quite a detonation. They seem to need just what I can give them and it is a bunch of kindred souls, enthusiastic and sympathetic. Again, "I thank you." (You too, Miss Sabloff.)

> More anon,
> Lew

Source: Social Welfare History Archives.

> > >

Philadelphia
December 29 [1936]

Oom Paul;-

Thus far it has been just one adventure after another, and the beginning of what seems to be the most glorious visual joyride I've had since the old days of Child Laboring and Red Crossing. In many ways it may be more really worthwhile than they were.

I hope some of the results may prove of value & use to you when the time comes.

Also, that the New Year will bring you many of the things you have so thoroughly earned.

Lew-

Source: Social Welfare History Archives.

> > >

January 4, 1937

Dear Lew-

Some checks that help us clear '36 and start '37 have meant a lot in my New Year's mail.

But I count your letter right up at the top. You don't know how glad I am. And of course we shall be eager to tap your treasure trove when the time comes.

You'll be interested in this letter from Louis Resnick.

Sincerely,
Paul

Resnick may have been a social worker or journalist.
Source: Social Welfare History Archives.

> > >

Somewhere in Penn.
February 5, 1937

Mine Paul;

En-routing from New England to Carolina, W. Va., and points west.

Imagine my delight to find me dropped, right side up, in the midst of the grandest bunch of guys since the old *Pgh. Survey,* Child Labor & Real Red Cross days!

One test of a *real guy* being the ability to sense the usability of the products of the House of Hine. It takes both of us to do the job right now.

For a time I tried to carry the job alone but we all realized it was poor economy so they added my son and auto to the setup in spite of the rule that two birds of a feather may not flock under the banner of W.P.A. (except—).

Weintraub, Kaplan, H. Paul Douglass, Tom Tippett—some of whom you ought to know better.

There seems to be a-plenty to do before the reports are finished, and we are adding our mite. The range of their needs is great and I have in the past delved into about every kind of thing they are calling for, from industrial technics to social welfare.

I get the urge, from time to time, to share the good news with you.

Lew

Hine was assisted by his son, Corydon, during this period.

Source: Social Welfare History Archives.

➤ ➤ ➤

February 11, 1937

Dear Lew-

You're a peach to keep me posted. And of course I am delighted that Hine & Son—and auto!—are so happily and usefully engaged.

Here's hoping it leads on and on.

Sincerely,
Paul

Source: Social Welfare History Archives.

Photographic Department
National Research Project, W.P.A.
Hastings-on-Hudson, N.Y.

February 20, 1937

Dear Paul;-

I have written Weintraub that we are assembling some visual material this week subject to his approval and that if he can meet us, as you suggested, for dinner at Henry Street Settlement (Thursday, the 25th) to let you know.

Meantime, I am planning to call in on Florence K. and Victor Weybright, *Wednesday* afternoon, the 24th, and get the stuff together. Please ask her to write me early Tuesday, Special Delivery, or phone me, if it is or is not satisfactory. Also, what part of the afternoon suits them best.

Cordially-
lewhine
Chief Photographer

Victor Weybright was managing editor of the *Survey Graphic*.
Source: Social Welfare History Archives.

March 2, 1937

Dear Paul;-

I expect to be going through N.Y. City Monday morning, en route to Phila. Could you & Florence spare me just a wee bit o' time to see how far we have advanced with the first layout? If so, please make it fairly early & let me know at Hastings-on-Hudson.

I am not a bit satisfied to sacrifice pictorial value to the fetish of having a "unified thread running through the series" as D. W. & B. A. advocated. (The weekly magazines do that so beautifully.)

I still feel that if we can suggest things that are really pictorial on the topic I suggested, MANPOWER-SKILLS-CHANGE, it will illuminate the

Foreword better than to confine the studies entirely to change, but I would rely upon your judgment & Florence's.

Also, the much hacked article on Scotts Run, if it ever is published, cannot possibly be anything like what Tom T. would dramatize for you. Also it has the most dramatic possibilities of all the projected reports in text & photos so I hope you will still consider it as [a] possibility.

> Cordially
> -lewhine-

D. W. refers to project director David Weintraub; B. A. may have been Beulah Amidon.

Tom T. is Tom Tippett, the writer with whom Hine worked on the National Research Project. The article and photographs eventually did appear in the May 1937 issue of the *Survey Graphic* under the title "Manpower Skills."

Source: Social Welfare History Archives.

March 4, 1937

Dear Lew-

My feelings are on the side of you as the artist in handling the pictures of your choice; but my instinct as an editor is, as I told you from the first, that the arresting thing to make the most of in your new work is to have enough plot in the cluster of pictures so that it will strike people's imaginations on a fresh side. This would not mean that it would be necessary to have all of the pictures of all of the pages of that sort. And I agree with you in being against lumbering up the art spread with a lot of running type.

As I understand it, the way our conference left things was that Dr. Weintraub was going to write a brief article illuminating the work as a whole; and that adjoining it we would publish this art feature of your pictures. He felt strongly that there should be additional pictures both to emphasize the theme and to be more representative of the different industries covered. And you and he, as I understood it, were going to arrange for those pictures and have the whole in hand by March 20.

Florence and I will be glad to see you Monday if you care to come in.

But I don't know that we could get very far until the other pictures are in hand. You decide.

You left a portfolio of pictures with Douglas Lockwood at Henry Street the other day. They were much appreciated. I will have them here for you to pick up when you come in Monday.

You may be running across Tom T. in the next few days and we should be ever so glad if you would try him out on the idea of an article for us that would dramatize Scotts Run up to the hilt.

> Sincerely,
> Paul

Source: Social Welfare History Archives.

March 18, 1937

Dear Paul:

I expect to be going through New York Friday morning, late or early afternoon. Shall have the layout, roughed out, and hope I may be able to turn it over to Florence or you or both. There are some final editorial changes that you should know about. The text Weintraub promised you for the 20th will be forthcoming.

> Cordially,
> Lewis W. Hine

Source: Social Welfare History Archives.

May 12, 1937

Dear Florence;-

I missed you on the only chance I've had to stop for a long time.

Wanted to congratulate you on the corking result of all the bloodshed. Have heard a lot of appreciation from many different quarters.

If you haven't returned the photo-prints, you might send 'em to Mr. Weintraub, 12 S. 12 St., Phila.

He was bothered by the slips in text, as he has probably written. Doesn't bother me so much.

Tom Tippett wants a delay of a month on his effort.

> Cordially
> Lewis W. Hine

P.S. D. W. told me he wanted to get some reprints (with corrections). If you can spare five more copies of May I can place them to good advantage.

Letterhead: The Y.M.C.A. of Philadelphia, Central Branch, 1421 Arch Street. Rooms at Reasonable Rates. Men—Women—*Married Couples, Transient or Permanent* (italics Hine's).

Source: Social Welfare History Archives.

> May 14, 1937

Dear Lew:

I've sent all your photographs to Mr. Weintraub and here are five extra copies of the May *Graphic* for you. Glad my agony to do your spread as you wanted it produced the desired results.

Tom Tippett has written to Beulah Amidon about the delay on his stuff.

How liberal the Y's becoming, with its leniency to transient married!

> Sincerely,
> Florence Loeb Kellogg

Source: Social Welfare History Archives.

> July 21, 1937

Dear Lew-

There's a possibility I may be out of the office on Friday. How about coming in on Tuesday at eleven-thirty?

> Sincerely,
> Paul

Source: Social Welfare History Archives.

During the period 1937–38 Hine began to elaborate plans for a study of craftspeople and made contact with the Carnegie Corporation. With Kellogg's help he wrote to curatorial and administrative staff at various museums and libraries to develop this idea and, when possible, to place his older studies of immigrants and child laborers.

Wed. Morn—July 21 [1937]

What-a-man, What A Man, WHAT A MAN our Oom Paul is.

Your little bundle of sparklers just arrived. I will follow up your man Youtz and see 'im anytime-anyplace-anyhow. Fortunately my time is flexible now.

I have written Helen Ferris (another of my old, patient appreciators who almost got my *Men at Work* put out by the Junior Lit. Guild), asking if she could give us a little time after her vacation, checking & giving suggestions. She might want to publish something.

I have to be in N.Y. Thursday, so I made a tentative date with Sabloff for some time after eleven A.M., if convenient for you. Will call up so you can adjust me to your other duties.

> Ever hopefully-
> lewhine

P.S. Will bring the Project studies that you asked for.

Philip Youtz was president of the American Federation of Arts in New York and director of the Brooklyn Museum.

Source: Social Welfare History Archives.

July 21, 1937

Dear Helen Ferris;-

I want to tell you, very confidentially, that I am working on a very alluring proposition in connection with the Carnegie Corporation. They are considering the question of helping me finance some work that would round out my collection of negatives and put the results of

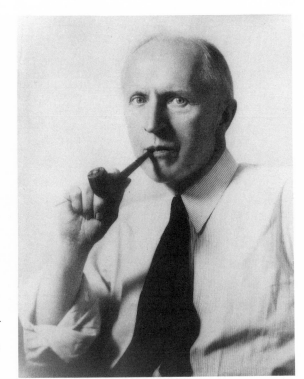

Paul Underwood Kellogg, about 1925, by Lewis W. Hine. Kellogg, *a prominent figure in the social welfare community and editor of* Charities and the Commons, *which later changed its name to* The Survey *and* Survey Graphic, *was Hine's lifelong collaborator and champion.*
(Courtesy of Social Welfare History Archives, University of Minnesota, Minneapolis, Minnesota)

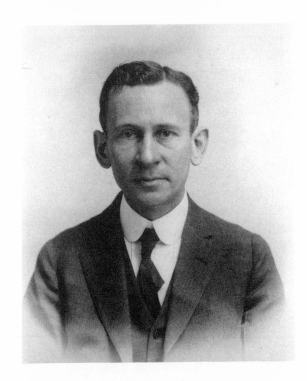

Lewis W. Hine, about 1925.
(Courtesy of Lewis W. Hine Collection, United States History, Local History and Genealogy Division, The New York Public Library, Astor, Lenox and Tilden Foundations)

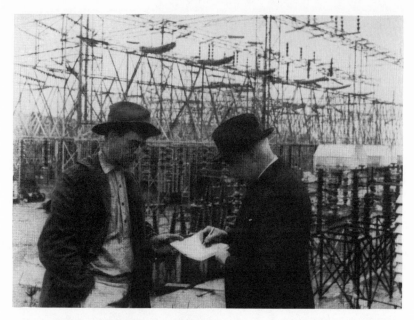

This was one of several images to appear in a photo essay entitled "Giant Power," published in the March 1, 1924, issue of the Survey Graphic. *The industrial and labor-oriented direction Hine's work took after he returned to the United States is epitomized in a number of photo stories that appeared in the* Survey Graphic. (Courtesy of Social Welfare History Archives, University of Minnesota, Minneapolis, Minnesota)

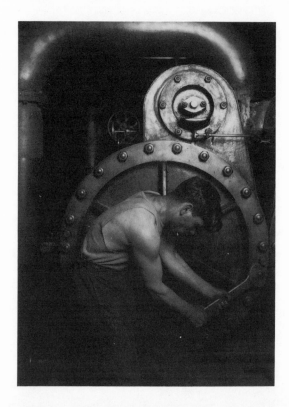

"Power House Mechanic." Made in 1925, this is one of Hine's most iconographic and widely reproduced images. (Courtesy of Fotomann, Inc.)

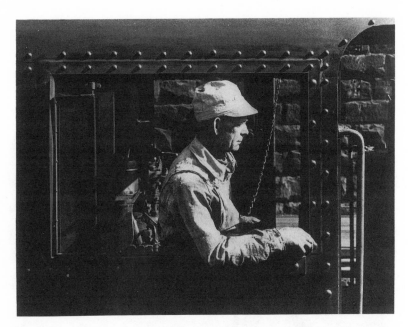

"*Railroad Engineer, 1930.*" *In the 1920s Hine coined the term "Work Portraits" to describe his documents of American labor. His work portraits of railroad engineers were reproduced in both socially oriented and corporate publications, such as the* Survey Graphic *and* Fortune. (Courtesy of private collection)

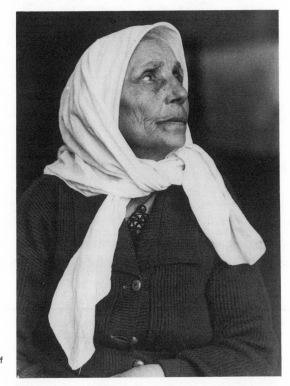

"*Syrian Grandmother, Ellis Island, 1926.*" *Hine returned to Ellis Island in 1926 to photograph immigrants after quotas were reinstituted.* (Courtesy of private collection)

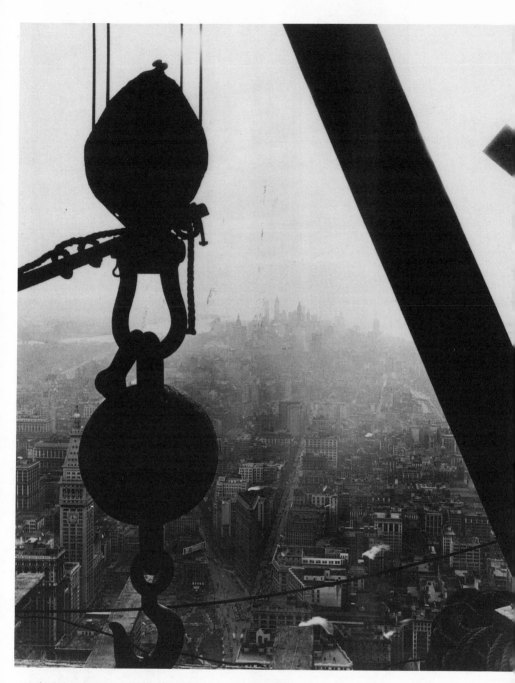

"Looking out on Lower Manhattan from the Empire State Building." The apotheosis of Hine's work portrait methodology was his series of images of workers constructing the Empire State Building. Hine, age 54, was suspended in a cherry picker and elevated to upper-story girders to make his majestic views. (Courtesy of Avery Architectural and Fine Arts Library, Columbia University in the City of New York)

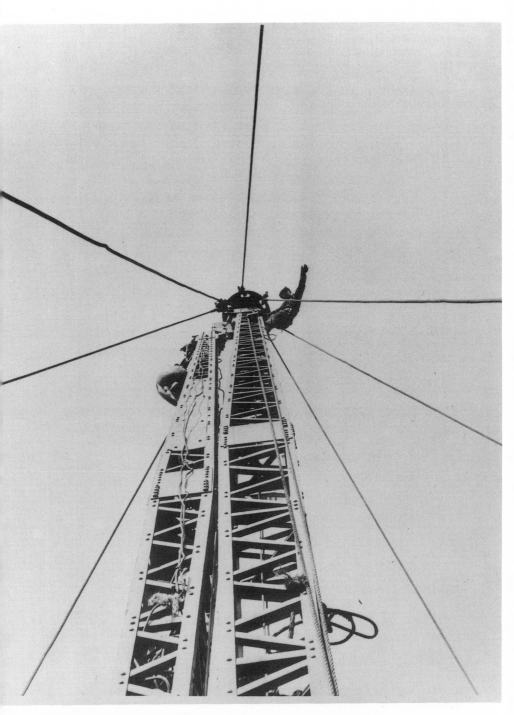

"Placing the Derrick." *The graphic and humanistic nature of the Empire State Building images led to the publication of a book that Hine designed for adolescents entitled* Men at Work. (Courtesy of Avery Architectural and Fine Arts Library, Columbia University in the City of New York)

"A Connector Goes Aloft." In the 1930s 35-millimeter cameras were introduced, giving the photographer more flexibility in the picture-making process. Nevertheless, throughout this six-month assignment Hine continued to use the cumbersome Graflex camera, which used 4 by 5 and 5 by 7 inch negatives. (Courtesy of Avery Architectural and Fine Arts Library, Columbia University in the City of New York)

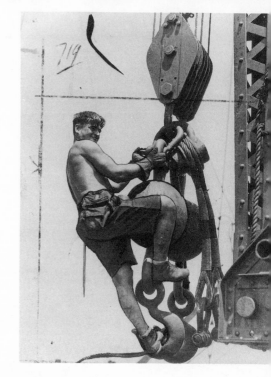

"The hoisting gang attach the great cables to the beams, steer and shift them into place, and wave their signals to the bellman. Careful teamwork is necessary; every man is alert at every minute to do his part." The cover photograph for Men at Work. (Courtesy of Avery Architectural and Fine Arts Library, Columbia University in the City of New York)

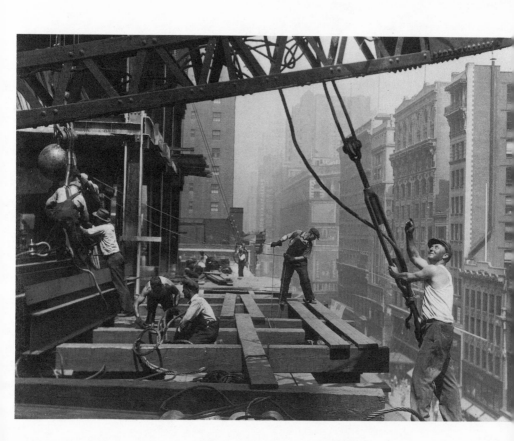

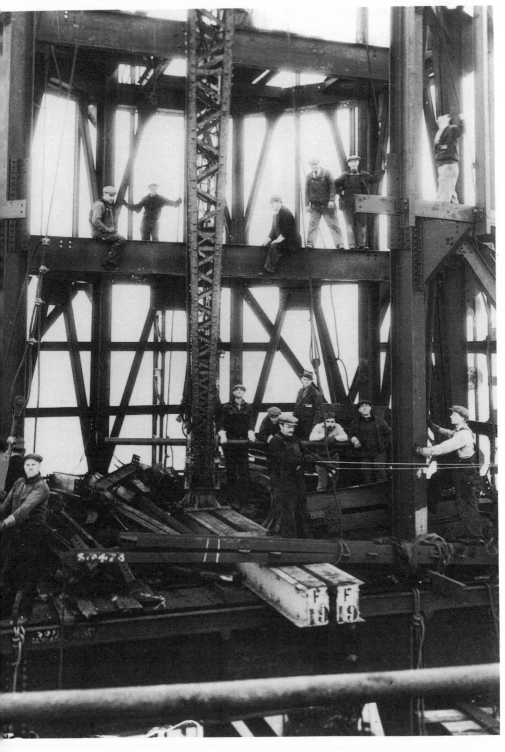

Unlike Hine's earlier industrial studies, which seem static because of his tight framing, the Empire State Building images are candid and kinetic. (Courtesy of Avery Architectural and Fine Arts Library, Columbia University in the City of New York)

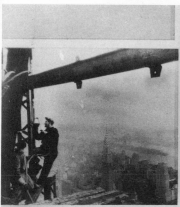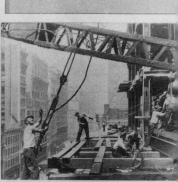

MEN AT WORK

Not in clanging fights and desperate marches only is heroism to be looked for
But on every bridge and building that is going up to-day.
On freight-trains, on vessels and lumber-rafts, in mines, among the firemen and policemen.
The demand for courage is incessant and the supply never fails.
These are our soldiers, our sustainers, the very parents of our life.

William James

Hine's work portrait triptych recalls the time exposures—montage-like combinations of multiple pictures and text—he first designed for The Survey *in 1914 and 1915.* (Courtesy of Avery Architectural and Fine Arts Library, Columbia University in the City of New York)

all my years of work on a permanent basis. It is, however, in the very early stages of development.

The first line of work would be to make some new series of negatives that would show the old handcrafts—spinning, weaving, etc.—as they are still being carried on in parts of New England, on the Appalachian Highland, among the Pennsylvania Dutch and elsewhere. Also the old methods of mining coal, blowing glass, making furniture, etc. I have done, during the past eight months, a lovely series of studies showing many techniques of modern industry that would fill out the story of technological change.

Some other significant series could follow, but the reason I am bothering you now is that the Corporation suggests that I get several persons, like you, Paul Kellogg, et al., to help me organize the work to be done. Incidentally, some of it might easily be grist for your mill, but, even tho it were not, could you spare just a little time, after return from your vacation, to advise with me? It is, I am convinced, the biggest opening I have ever had and I need some help.

> Cordially and gratefully,
> Lewis W. Hine

Source: International Museum of Photography at George Eastman House.

➤ ➤ ➤

July 25, 1937

Dear Paul;-

It may be afternoon, Wednesday, before I reach New York. If you are full up, I'll see you another day. Would like to begin shaping up the Nat. Research stuff soon.

Helen Ferris, Junior Lit. Guild, has long been a very stimulating cooperator and helpful, so I wrote her about the setup. She comes back with a hearty promise to help in any way she can when back from vacation. This is Carnegie, of course.

Miss Javitz, Picture Collection, N.Y. Pub. Library, has been telling me all along that her boss, H. M. Lydenburg, Director, N.Y. Pub. Lib., might appreciate a chance to play with us. She knows Philip Youtz and thinks he should be *great help*.

After a while, our old friend, Sidney Blumenthal, might be useful and furnish the opportunity for you to meet up with him, an old dream of mine, you'll recall.

Also, I have a coupla friends at court up at the Met. Art Museum, now on vacation.

Ever-

lew-

Source: Social Welfare History Archives.

August 14, 1937

Dear Paul;

I *must* tell you a coupla things—first, your Philip Youtz is all you pictured, *many times over,* and he seems much interested and willing to help; thinks it would be well to try to enlist the backing of the Amer. Feder. of Arts, of which he is President, as well as the N.Y. Pub. Lib., which he thinks is good for help too.

Also, I have contacted Allen Eaton who has just finished a grand book on the Crafts of the Southern Highland, knows the whole situation intimately as well as the New Hampshire setup, and, moreover, is *very enthusiastic* over both sections of my enterprise: (1) making the old negatives available for much wider use, (2) gathering new ones on the passing crafts and the present activities that are carrying over the essentials of the old crafts for the benefit of the present generation. He will be invaluable as [an] advisor.

It seems to me desirable to amplify the aim of the second section above to include visual records of enough of the life of these crafts-people to make a suitable background for the study as a whole, with as much data as I can get that will be pertinent. In the early days of my Child Labor activities I was an investigator with a camera attachment,

but the emphasis became reversed until the camera stole the show. Maybe it's time to back up a bit.

> Cordially
> lewhine

P.S. I'll be briefer hereafter.

Source: Social Welfare History Archives.

August 20, 1937

Dear Sir:

I had a talk today with Miss Alice Felton about the possibility of my making an interpretive photograph survey of our American craftspeople and the adaptation of their crafts to present-day needs. It is, partly, an outgrowth of some suggestions she made to me several years ago.

If you have time to see a little of my work, I feel sure the project would appeal to you as one object of the enterprise is to make these records available for the use of museums and libraries. I am in the City several times a week.

When I presented the matter to Paul Kellogg, editor of *Survey Graphic,* he felt it was of sufficient importance to warrant the formation of an informal advisory committee for suggestion and supervision and I have already enlisted the cooperation of the following—Paul U. Kellogg, *Survey;* H. M. Lydenberg, Director, New York Public Library; Philip Youtz, Director, Brooklyn Museum; Allen Eaton, Associate, Russell Sage Foundation; with a probability of having, also, Horace H. F. Jayne, Director, American Federation of Arts.

It would be a great help if you would consider yourself a member of this very flexible group.

I have already made overtures to the Carnegie Corporation of New York and have been asked to make them a formal outline and proposition for their first meeting of directors in October.

The members of the committee agree with me that this is not a

personal matter but is one that could have a deep, social significance as a means of education for the present and future generations.

> Very sincerely yours,
> Lewis W. Hine

Addressee: Henry W. Kent, secretary of the Metropolitan Museum of Art.

Hine's handwritten notations after the first sentence read "educ. & voc. not coml.," which I would transcribe as "educational and vocational, not commercial." These apparently were personal notes and did not appear in the letter itself.

Source: International Museum of Photography at George Eastman House.

August 26, 1937

Dear Paul;

The enclosed tells a little of how our snowball is growing. Youtz wrote a very helpful suggestion about getting the Director of the Amer. Feder. of Arts to sponsor the enterprise and I have a date to see him in Philadelphia next week.

If I get the Metropolitan Museum of Art dotted up, there will be standing room only. Youtz suggested getting the help of the Museum of Modern Art, possibly.

Please don't feel you have to answer all my babblings but I want to keep you posted.

> Ever-
> lew

Source: Social Welfare History Archives.

September 3, 1937

Paul, m'dear;

Lady Luck continues to grin—Jayne, director of [the] American Federation of Art, cheerfully signs up for our advisory committee, agrees to sponsor the "Photographic Interpretation of some phases of Ameri-

can Craftsmanship" (for the A. F. of A.), and wants to have a chance at some of the results for their new *Magazine of Art.*

When you are ready to talk about the possible layout of Hineographs for Dec. No. of *Graphic,* I can drop in s'm time. After I get my new plans worked out, you'll have a chance at it. Final draft should go in Oct. 1st.

> Hopefully-
> lew

Source: Social Welfare History Archives.

> Hastings-on-Hudson
> September 15, 1937

Dear Miss Sabloff;

Please try to make a date for me to see Paul Monday, the 20th (A.M. preferred) and drop me a line Friday to reach me Sat A.M.

The Project is maturing beautifully but needs finishing up. It may be a *real* and *big* thing.

> Cordially
> Lewis W. Hine

Source: Social Welfare History Archives.

> September 21, 1937

Dear Mr. Hine:

I am sure of all agencies we of Survey Associates can bear witness to your pioneering in the field of social photography. Our acquaintance goes back for thirty years. We have not only published your distinctive work-portraits as art features in *Survey Graphic,* but have, as you know, enlisted your collaboration in every large piece of investigation we have embarked upon. You have combined a gift for research with your prowess in engaging and dealing with difficult personalities, and in handling subjects under exacting conditions of light.

While much of your work for us had dealt with modern economic conditions, you have always had that inveterate bent of yours to dip back into social history. You have made ancient hand-workers live for all time in your prints. There's no other man to whom I would look with such confidence, no time like the fleeting present to get into your sensitive films the record of that craft and industrial evolution which links modern American life with its past. I can, out of very practical experience with you and your work, heartily endorse your American Craftsmen project in both its parts—your survey, and your plan for a permanent depository.

Every best wish that you may enlist adequate backing.

Sincerely,

Paul Kellogg

Survey Associates, Inc., was the corporation that published the *Survey Graphic*.
Source: Social Welfare History Archives.

October 7, 1937

Dear P. K.;

The material went in to the Corporation. Dr. Keppel acknowledged it himself, so that's that much. "Anyway, us didn't get thowed out." More when it comes in.

Cordially-

lew

Source: Social Welfare History Archives.

October 26, 1937

Dear Lew:

It seems that Paul thinks your photographs will probably go between Eiton Mayo and Kaempffert on the enclosed outline of the special issue, not with the Mayo as he had said last week. He was referring to a portfolio of pictures that you showed him while I was on my vacation, I

think, a portfolio of pictures growing out of your Weintraub work. I'm not sure if these are the ones you brought in for me to see in August, but whatever they were, that group you showed Paul is the group he's after. Perhaps you have others to add to them, and I hope they are released for our use.

Won't you bring them in Thursday or Friday?

The outline will give you some notion of the issue in which we feel these photographs will be a stunning feature. Kaempffert's article is men and machines, and Mayo's is the joy of human association in work.

Equally important to the articles are the features that will run between them. And sine qua non of the features is the *Survey* Album. It ought to be at least twelve pages but will probably be only eight. What I want to consider in the Album or in the early historical articles of the issue is a handful of your earlier things, one child labor, one Ellis Island, one Pittsburgh steel, etc. My recollection of the photographs you have done for the *Survey* in times past is as follows:

Child labor
Pittsburgh Survey and steel workers elsewhere
Immigrants and Ellis Island
Joy in Work—skilled hands
Power makers—giant power issue
City workers in the field of health
Precision jobs in industry
Miners
Technological change

Have I skipped anything important?

AND wherever possible get women workers into your selection as well as men. The Ford article and the Union Pacific have men photographs mainly, stuff taken by the outfits themselves, good stuff too.

Excuse amateur typing, but all the secretaries are busy copying manuscripts.

 Cordially yours,
 Florence

Elton Mayo and Waldemar Bernhard Kaempffert were prominent industry and science journalists who were preparing an article for the *Survey Graphic*.

Source: Social Welfare History Archives.

> ➤ ➤

November 4, 1937

Florence, m'dear;

In case you should use my Empire State head to open the Series, he was one of the skilled workers on structural steel. One of the architects said, "A face that reminds one of his father." The old printer was my first bull's-eye with Craftsmen. The Village Blacksmith, then and now, the precision mechanic building bigger and better machines, and the iconoclast making room for newer models.

Some way, please make sure that it is clearly indicated that I made the N.R.P. studies for "National Research Project of W.P.A.," not headlines of course.

Documentarily Thine,

lew

Source: Social Welfare History Archives.

➤ ➤ ➤

November 5, 1937

Dear R.E.S.;

I finally located that negative you like and have made you a print to keep my memory more green with you.

Have had a coupla visits with Locke and left a bunch of stuff, small and large. It is good to know him and to be able to keep you in better contact.

Recently I met again a man with wide interests, one of them being documentary preservation even to that of doing books and other records in the modern manner. In fact, he was the one who, when in charge of [the] Ethical Culture School, started me off on photography, partly to interpret the school work and also to give me a much-needed outlet at a time of transition. I showed him [a] copy of the chapter on Documentary Photography that Locke sent me and he was *very appreciative* of it— said that he knew of no other person in that field at that time and he is sure he would.

A line from Lydenberg, of N.Y. Pub. Lib., shows continued interest in the question of the library acquiring photo-prints for their collections. Would it be worthwhile for you to see him some time? He is full of quirks but a darn good egg.

The Carnegie bunch is still considering—no news being preferred to bad, of course. If I can be of any help on any of your visits, please let me know a bit ahead, if you can.

Cordially,

Hine

Addressee: Roy E. Stryker.

Edwin Locke was Stryker's assistant at the Resettlement Administration. The two collaborated on an unpublished article entitled "Documentary Photography" (no date), which may have been the source of Stryker's lecture at the Photo League in the spring of 1940 (see Hine's letter of April 3, 1940).

Source: University of Louisville.

➤ ➤ ➤

November 15, 1937

Dear Ed:

Your letter and Arthur's telegram make me realize that things are not settled in New York yet. Here is a leave slip for Arthur. Tell him for god's sake not to send anything else in Esquire envelopes.

I am glad you talked up to your boss. I think it will help. They had better realize that getting on the market with a desirable picture magazine is going to take all the ability of several people, and if they are going to harass and snipe at people they are not going to have much chance of getting out a decent job. Their whole attitude is damned childish. It is a wonder to me they have operated as successfully as they have if this is a sample of their conduct.

I am suggesting the following photographs, obtainable from the Wisconsin State Historical Society, Madison, Wisconsin. I think they will perhaps cost you around twenty-five or thirty cents a piece.

| M158875 | F | Saw crew. |
| M115897 | F | Load of logs. |

M15875	E	Men in bunk house.
M15907	F	Logging crew.
M15854	F	Men floating raft.
M15878	F	Winter scene. Men in logging camp.
29913		Logging scene

They might possibly have other pictures that interest you, but Lee went over them pretty thoroughly.

I am writing Hine directly. I agree with you on the prematurity of releasing this article now. It might be a very bad thing for all of us if this got out now. I appreciate his feelings in wanting to get all the help he can, but I very much doubt the wisdom of releasing this article at the present time.

The pictures should go forward to you sometime today.

Lange's negatives and captioned prints just arrived. Russell just sent in some new stuff, mostly western material, but valuable additions.

Sincerely yours,
Roy E. Stryker

Addressee: Edwin Locke, assistant chief, Historical Section, F.S.A., was also an editor at *U.S. Camera* magazine.

Arthur Rothstein was an F.S.A. photographer whose image "Dust Storm" has become a symbol of Depression-era photography.

I have had conversations with several Stryker experts to determine which article he was referring to in his statement "the prematurity of releasing the article now." Andy Anderson, archivist at the Ekstrom Library (where Stryker's papers are housed), speculates that Hine was sent a copy of an article that Stryker and Locke had written and that Hine showed it to some of their mutual colleagues. This distressed Stryker, whose job it was to promote the F.S.A., not editorialize about nonstaff photographers. Anderson speculates that Hine, by publicizing the article, "interfered and set off an alarm in Stryker's mind. As a result, the article was suppressed and never published." No copies of the article exist.

David Horvath, who compiled the Ekstrom Library's guide to Stryker's correspondence, notes that a bibliography of Stryker materials from this period does not exist. For F. Jack Hurley, Stryker's biographer, this is a confirmation of Stryker's inability "to commit himself . . . Stryker did not want to publicly confront why he had not hired Hine." In an unpublished lecture about the history of documentary photography that Stryker delivered to the Photo League, he lauded Hine as the most important American photographer since Mathew Brady.

Dorothea Lange and Russell Lee were F.S.A. photographers.

Source: University of Louisville.

➤ ➤ ➤

November 22, 1937

Dear Paul;

I am very glad that you did not lose your patience and give up the battle for bigger and better Tippett. If God and man will let up on their demands on our Tom and give him a half chance, the result will be all we have been hoping for so long.

I am still more glad that the new setup may give you a chance to get to know better the personal Tippett as I have been able to do this year—as I have told you over and over, he is the one most outstanding personality I have gotten to know this year and I still have that feeling that you would agree if you could know him just a little.

> Ever-
> lew

P.S. Still no word from the Carnegie cohorts, but here's hoping.

Source: Social Welfare History Archives.

➤ ➤ ➤

November 27, 1937

Paul, m'dear;

Your note and check quite overwhelm me for I have long had a deep sense of my inability to contribute toward the upkeep of the Associates. There will still be time if I can ever catch up with that little pot o' gold that I have felt was waiting for me somewhere around one of these corners. Until then, I'll have to barter my little odds and ends of service for the very vital chunks of encouragement you and the gang have dished out so liberally.

> Ever-
> Thy lew-

Source: Social Welfare History Archives.

➤ ➤ ➤

H- of H-on-H—
November 27, 1937

Dear Florence;

Just back from a few days off. Please tell Ann Brenner that it was both cash and clothes that worried me—the old glad rags have lost their savor, as 'twere—but if there is a place where regulars won't be too conspicuous, I'll be most glad to come. I certainly appreciate all this consideration for all I have ever invested in *Survey* has come back with *heaping measure*.

Gratefully-
Lew Hine

Ann Brenner was secretary of Survey Associates.

Source: Social Welfare History Archives.

➤ ➤ ➤

[November 1937]

Paul;

Hope you can find time to do the introduction for the Hine spread as suggested by Florence.

A coupla government guys getting out a new book on photography are featuring my "documentary photography" as being the only work of that kind between Civil War Brady & the present.

lew

The "coupla government guys" are Stryker and Locke. The use of the term "documentary photography" was subsequently popularized by Beaumont Newhall.

Source: Social Welfare History Archives.

➤ ➤ ➤

January 27, 1938

Dear Philip Youtz;

Dr. Keppel's secretary advises me that the Board does not see its way clear to take favorable action on my proposal of 9/30/37.

After all the work that has been put into the Plan on the part of all who have helped assemble it, it seems to be quite necessary to try to find other ways of putting it through. I have been following several leads for some time and would be glad to have any suggestions from you as to the most likely ways to make application to the Rockefeller people, if you still think it might be worth trying.

Thank you again for all your patient consideration of the details that seem to be necessary in the promotion of this proposition.

Sincerely yours,
Lewis W. Hine

6.
The Social Documentary
Photograph as Art, 1938–39

In 1937 Beaumont Newhall, then librarian and acting cu-
rator of photography at the Museum of Modern Art, curated the first
museum exhibition exclusively devoted to photography. Entitled "Pho-
tography 1839–1937," it revolutionized the public's perception of the
medium: photography was seen as a "high" art form, and the photogra-
pher's status was elevated to that of artist.

The following year Hine visited Newhall and brought a portfolio of
photographs of child laborers, immigrants, and skyboy (Empire State
Building) work portraits. Newhall, who had been unaware of Hine's
work, was deeply impressed by the photographs. In his article about the
artistic value of Hine's images, which appeared in the *Magazine of Art,*
the curator popularized a term coined by John Grierson by referring to
Hine's photographs as "documentary" works. A portion of that article is
worth quoting: "These [Hine's] photographs were taken primarily as rec-
ords. They are direct and simple. The presence in them of an emotional
quality raises them to works of art. 'Photo Interpretations,' Hine calls
them. He might well have called them 'documentary photographs.'"

The article was seen by Berenice Abbott, who called on Hine at
his Hastings-on-Hudson home. Subsequently, she and Elizabeth
McCausland approached him about organizing a retrospective of his
photographs.

➤ ➤ ➤

January 30, 1938

Dear Beaumont Newhall:

We spent a very delightful evening with your book and especially the vivid historical presentation you make.

I feel that my layout was very inadequate for several reasons. The things I showed you comprise a sort of visual hash that has accumulated during the past days when I used to be a sort of handyman for social welfare conventions and the like that wanted some bare walls filled up.

Also, a number of my most significant negatives have been taken over by the organizations, finally stored and broken or sold for glass. This has been my fault, partly, as I have never been able, somehow, to organize my old material very well and did not realize that it might ultimately prove of value in some historical ways.

A great deal of my work has been in social welfare lines, various phases of the life and personality of the underprivileged. Settlement work, housing, health, recreation, etc. Red Cross and government agencies galore—Child Labor was the big job.

With the latter I was interested in bringing out the difference between child labor (the negative, harmful aspects) and child work (that which gives training and educates). Is it possible that this might be a theme in which the Rockefeller Foundation might be interested? There is a deal to be done with visualizing child labor today and the other kind of child work. I'll take it up with Youtz but would like to have your reaction.

> Cordially-
> Lewis W. Hine

Hine was referring to *Photography: A Short Critical History*, a reprint of the text and illustrations of Newhall's landmark exhibition "Photography 1839–1937." It was produced for the Museum of Modern Art's trustees in an edition of 3,000 copies.

Source: Beaumont Newhall.

➤ ➤ ➤

February 1938

Dear Mr. Hine:

The scope and sweep of your work is dramatic and powerful. It is true, of course, that there are many prints which today have lost their significance; but this is true of every photographer I have met. I am interested that you emphasize the Child Labor series; they seem to me the most poignant of the lot, really your best work.

Now there are two ways to look upon your work. The most obvious is the documentary or the historical approach; the other is the photographic. So far as the first approach is concerned, I am not able to give you help. As a layman I was impressed by the picture you gave me of Child Labor, of Ellis Island, of the Drought (Red Cross), and of the Empire State, but laymen's criticisms carry much less weight in these matters than those more technically trained.

As to the photographic end, I feel that I can be of some value. Your work strikes me of excellent quality, possessing that straightforward, clean technique which I believe to be the only valid photographic style.

Beaumont Newhall

Letterhead: Museum of Modern Art, New York City.

Here Newhall is alluding to an ongoing debate between two camps of photographers: one championing a style of "straight" photography, where the negative and print are untouched, the other opting for a more painterly, soft-focus "pictorialist" style, where the negative and print typically are manipulated. Alfred Stieglitz, from 1904 to 1917 editor of *Camera Work,* the first magazine to feature photography as an art form, established these categories. Only with the recent introduction of postmodernist discourse have they lost any relevance.

Source: Archives of American Art.

➤ ➤ ➤

February 19, 1938

Dear Paul;

Another unsolicited bolt from a clear sky. After the encouraging appreciation from Beaumont Newhall, head of the photographic depart. at Museum of Modern Art (he spent part of two days out here excavating

stuff for Museum use, including an exhibit of American photography
to go to Paris), I was called in to see Spencer Miller, Jr., head of the
Workers Education Bureau for so many years.

He told me he is in charge of what promises to be an extensive series
of broadcasts, over Columbia System, coast to coast, once or twice a
week. Also, he wants to do, on the air, the personal, interpretive
things I have done with my visuals. He took me on at once as a com-
bined scout (to locate significant individuals), research (to help work up
the broadcasts), publicity (to visualize them and get their personalities
put out in various ways). The broadcast may be called *Men at Work*.

It is a man-size job and I think has good possibilities for them and
for me. Will keep you posted—it may take all my time, indefi-
nitely—not sure. "Wish me luck."

Ever-

lew

Copy to Philip Youtz.

Newhall's exhibition was such a success that he was invited to curate a second for the Musée du
Jeu-de-Paume in Paris. It included several of Hine's photographs.

Source: Social Welfare History Archives.

➤ ➤ ➤

H-on-H-
May 4, 1938

Dear Paul;

The broadcast scouting makes a lot of vital contacts. Recently, the
British Broadcasting Company called me in to help them fill up an
emergency need for a good American worker, with many definite speci-
fications. Eventually, I ran down a trio of automobile workers at the
Chevrolet plant in Tarrytown, who are also President, Sec'y & Treas. of
the local union, C.I.O., there. They are an alert bunch and filled the
bill beautifully.

Now I wonder if you think it might be worthwhile to arrange for
them to go down to Henry Street Settlement some evening and go over
their broadcast and related subjects with a small group of persons to

whom it might mean something. It would mean a lot to them I am
sure. Not too soon—perhaps after May 15. Just a thought.

Cordially

lewhine

Source: Social Welfare History Archives.

June 21, 1938

Dear Roy Stryker;-

The Hine fortunes are at an all-time low and if they do not change in
the near future, or at least show some evidence of real prospects, the
Home Owners Loan Corp. will have to foreclose on the place and we
will wander forth to cheaper pastures.

I'm telling you this to see if you see any way of taking advantage of
the situation to get some of the service you have said you wanted to do.
I shall probably have to work, for a time, for anything I can get. You
will remember that all my life I have specialized in things that had to
be done under difficult light conditions, as well as those outside. It
might be that I could fit in on that basis.

When do you expect to be in N.Y. again? Could I see you?

Cordially-

Hine

Source: University of Louisville.

July 21, 1938

My dear Mr. Hine:

I have been greatly interested recently in learning that the New York
Public Library is starting a collection of documentary photographs of
American life and labor.

This naturally brought you at once to my attention as being the
person who has done more perhaps than any other in the photographic
field in bringing out the vital characteristics of our industrial system.

Beginning in 1905 with your first service to the National Child Labor Committee when you traveled this country from end to end discovering and exhibiting examples of types of children and youth in various forms of labor on through to the more humane days when the littlest ones were emancipated and you and I both felt we might turn our attention in another direction, you would have a pictorial document of rare interest and one which no one can duplicate.

In my judgment the work you did under my direction for the National Child Labor Committee was more responsible than any or all other efforts to bring the facts and conditions of child employment to public attention. The evils inherent in the system were intellectually but not emotionally recognized until your skill, earnestness, devotion, vision and artistic finesse focused the camera intelligently, sympathetically and effectively on social problems involved in American industry.

> Cordially yours,
> Owen R. Lovejoy

Letterhead: American Youth Commission, Washington, D.C.

Owen Lovejoy, former director of the National Child Labor Committee, was associate director of the American Youth Commission.

Source: Archives of American Art.

➤ ➤ ➤

> August 5, 1938

Dear Beaumont Newhall;

A line from Frederick Allen Whiting, Jr., says he will be glad to use the article as soon as possible.

At your early convenience, when you are adjusted to our hot cobblestones, I would appreciate a little talk with you. Have made a number of contacts and received encouraging reactions from most of them. So far, it is all in the melting pot and until some of it is run out into some kind of molds I cannot judge, of course, what lines are most worthwhile. The New York Public Library has definitely initiated a section of Photographic Documents, of which my nucleus of a collection is "Se-

ries I." They plan an exhibit, probably in the early Fall. Abbott's side-partner is preparing a splurge for the *Springfield Republican,* which she represents. Elizabeth McCausland is her name.

However, it seems to me that the big endeavor should be the contacting of Guggenheim and Rockefeller. An old friend, Frederick A. Blossom, is Asst. Chief of Classification Division at the Library of Congress, Wash'n., and he is now going over my material to see if he cannot engineer a contact for me to present my plan to get my best documents placed in several important repositories—he is one of the close advisors of Dr. Putnam, who is the present Chief down there. B. thinks there is a good chance to get an opening there and possibly to get some financial backing (tho that is not so sure).

I am mounting a series of selected 5 × 7 prints on small mounts that are easy to carry around and that will give a better idea of the range of my work than the same weight of larger prints. A few of the latter, as samples, with a bunch of the contacts, may give better appreciation.

The rest of my prattle can wait until I can see you.

> Cordially-
> Hine

Newhall's first article about Hine's work, entitled "A Documentary Approach to Photography," appeared in the March 1938 issue of *Parnassus.* The second article, entitled "Lewis Hine," was edited by Whiting and was published in the November 1938 issue of *Magazine of Art.*

Source: Beaumont Newhall.

August 9, 1938

Dear Lew Hine:

I had a very good chat with Miss McCausland and encouraged her to go ahead. I hope it pans out well.

> Sincerely yours,
> Victor Weybright

Weybright was managing editor of the *Survey Graphic.*

Source: Social Welfare History Archives.

During the latter half of 1938, Hine's letters focused on his preparations for the retrospective at the Riverside Museum. At this time he corresponded primarily with Elizabeth McCausland and Berenice Abbott, who were responsible for organizing the exhibition. In addition, Hine wrote to numerous colleagues old and new, such as Roy Stryker and Paul Kellogg, to enlist their support. In the end his sponsors also included Alfred Stieglitz and Paul Strand.

In some ways the material in this section encapsulates Hine's thirty-five-year career. In these exchanges a wealth of information is revealed in his own voice, and his exuberance and delight at being recognized is palpable.

> ➤ ➤ ➤

August 10, 1938

Dear V. W.;

I felt sure E. M. C. would qualify. Since I saw you, I have thought out a possible way of using a page or two of "documents" to press in the idea we talked over that, on this line, *Survey* has again scored a scoop. "Let's Look at the Record" and show a selected number of my best things (arranged as documents, if possible) with dates of publication. Didjano [*sic*] that in the Jan. 30, 1909, issue of *Charities and The Commons,* as introduction to my picture story on Child Labor in the Carolinas, the heading is "Some *Human Documents,*" etc.? Match that, my fine friend, if you can for many a year after. On page facing, Florence Kelley avers, "The camera is convincing. Where records fail and parents forswear themselves, the measuring rod and the camera carry conviction." This by the impetuous and imperious Florence who, until I brought in that load of bacon, had "no use whatever for photographs in social work, because they had tried it and been discredited."

Of course it all depends upon how much space you can afford to grant to the experiment and then how much Eliza will need for her part.

Here's hoping you will continue to hope 'n everything.

Cordially-

Lewhine

Addressee: Victor Weybright.

E.M.C. and Eliza are Elizabeth McCausland.

Source: Social Welfare History Archives.

August 16, 1938

Dear Lew:

I think we can squeeze in a few documents—although space will be somewhat cramped in the October issue. Yet it does seem important to run EMC's article as promptly as possible. Would you supply us with a few of the outstanding ones, such as the Human Document pictures from the 1909 *Charities and the Commons?*

I am pleased to hear that *Life* is featuring your scoops, which actually presaged their own magazine.

Sincerely yours,

Victor Weybright

Source: Social Welfare History Archives.

▶ ▶ ▶

H-on-H

August 20, 1938

Dear McC.;-

Vic. thinks you can (and will) do a swell job even with the 2,000 limitation. I told him that, as for me, I thought 200 would be a-plenty. He likes my idea for a little illumination but that will depend upon how he can weasel out an extra page for me.

I hope that in the *Springfield* spread you will be able (and willing) to make a little comment on what Frank Manny did in seeing in the "ugly

Duckling" that I must have been at that time some warrant that the job of school photographer would justify itself. One of his chief jobs has always been to X-Ray potentialities in the rank-and-file while they are still rank and filing.

And, by the way (confidentially, PLEASE), he would make a swell job of personality "Profile" some time—a very remarkable and colorful personality and a marvellous man.

 Cordially-
 lewhine

P.S. *Life* is still jittering around, trying to make up its mind as to whether and what 'n everything.

Addressee: Elizabeth McCausland.

McCausland's profile of Hine appeared in the October 1938 issue of the *Survey Graphic* and was entitled "Portrait of a Photographer" (pages 502–5). Her article about Hine appeared in the September 11, 1938, issue of the *Springfield Sunday Union and Republican,* for which she wrote an art column, and was entitled "A Generation Rediscovered Through Camera Shots."

Source: Archives of American Art.

 August 24, 1938

Dear Mr. Hine:

Since I have had no information from you since my last letter I am wondering what has happened.

I was in New York the other day and wanted to call you, but my time got all snarled up and I had to leave New York sooner than I expected.

Unfortunately, there is nothing more definite now than when I answered your letter. I had asked you a couple of questions to which I would like you to respond.

 Best regards.

 Sincerely yours,
 Roy E. Stryker

Source: University of Louisville.

➤ ➤ ➤

August 25, 1938

Dear Roy Stryker;-

In answer to yours of yesterday, the last letter I received from you was
dated September 29/37. June 21st of this year I wrote you (3900 Con-
necticut Av., the last one I had) asking about possibilities for work
with you but some new lines are opening up now that will need my
presence in, or near, New York for a time.

If you are ever in the Big Town with any time to spare and can let me
know in advance, I'd be glad to talk a bit with you. Several important
magazine articles about my work are ready to appear soon—*Magazine of
Art,* by Beaumont Newhall, *Survey Graphic,* by Eliz. McCausland have
been accepted for immediate use. Others are not so far along but there
is a lot of interest in the documentary side of me before the War.

> Cordially-
> lewhine

Source: University of Louisville.

➤ ➤ ➤

H-on-H
August 25, 1938

Dear E. M. C.;-

Your encouraging letter came just after my scribble of yesterday left.
Many of your hints I have been following up but some are good to work
upon. I'll talk 'em over when we can meet again. The *Life*-guards are
keeping me on the string—they say they want to use my stuff in Labor
Day No., but how much to believe them I do not know.

It is darn swell of you to take so much time and thought over my
predicament. Let me know when you are to have a free quarter hour,
or so.

I wish you could have heard Vic's *eulogy* of your "Profile," and even
the taciturn Beulah Amidon gave it *high praise,* which I think is un-
usual for her.

The Home Owners Loan Corp.(se) holds our mortgage but they are not very anxious to take the old house, so I can hold it a while. The advance publicity (that I am using in a personal way to convince individuals that my work is worth investing in), and the various letters and other kinds of appreciation, are all valuable and will be more so when I am able to get entree to some of the moneybags. Newhall does not think he has enough influence to do much with the Museum folk but he says he will go after Holger Cahill, the Big Boy in W.P.A. Art, for a special assignment for me. That is one of the best ideas yet. The Guggenheim applications are not due for a coupla months and do not begin until next MAY.

Again, Thank you, m'Lady, until you're better paid.

lewhine

P.S. Black Star gets 50% of what they get from prints they sell—so far not any. They worked on one of the upper-ups at *Life* but got tired waiting and took the stuff to *U.S. Camera*. Any special contacts you or I make by ourselves have nothing to do with B. S.

Survey advanced me $50 on work to be done a bit later. Whattalife. It has been like this much of the time since I gave Felix the cold shoulder—maybe it's a "Judgment" as the church folks used to tell us. Anyway, I dread to think what would have happened, if I had stayed with that E.C.S. gang, to my "ME."

Addressee: Elizabeth McCausland.

Black Star, a picture agency, provides photographs to mass media publications and takes a percentage of the fee.

Felix Adler was founder and director of the Ethical Culture School.

Source: Archives of American Art.

➤ ➤ ➤

112 E. 19
Wed. Morn

Dear E. M. C.;

Dropped in here and found a very appreciative burst of applause from V. W.'s office—"It's *Good!*" "Really *third-dimensional!*" As I read it,

had to admit that I really never knew the guy, so how could I judge it?

I finally decided you must have picked my pockets when B. A. was working on me—how else could you get so much from so little? Anyway, I can't help any now—you 'n Vic will have to decide what to do about it.

Really am *very grateful* to you for all *you have done* and *are doing* (and may live to do). Be seein' you before long, I hope. *Life* is still undecided about me; dammum.

 lewhine

Addressee: Elizabeth McCausland.

Hine is referring to Elizabeth McCausland's catalogue essay.

V. W. is Victor Weybright.

B. A. is Berenice Abbott, who made the last photographic portraits of Hine.

Source: Archives of American Art.

➤ ➤ ➤

 H-on-H
 September 7, 1938

Dear emcc:

The Heinzes are much enthusiastic over your outline. Myself has to look at it very objectively as it doesn't all sound reasonable, subjectively, but, if you are willing to risk your reputation on some of the poetic license, who am I should worry? Sara says you have expressed many things she has thought out partly, also that she had a few of the questions-answers coming at herself. Anyway, we enjoyed every minute of it and hope for an encore in the not-too-distant future. I'll contact Morgan soon and see him pronto. Will wait for the magazines and any more recommendations, if you have 'em.

Will follow as many of your suggestions as my memory, reinforced with copious notes, will allow. Naturally, you should have the say about what illustrations will go in. Would there be any point to my taking in a proof or copy of the *Survey* article? I am seeing them today about the possibility of some visual illumination which is not at all

necessary. I like your sly dig at the *Survey* "introducing to the readers," etc. Also the *Nat. Geog.* comment.

With *many thanks* from all three and 'specially-

lwh

Postal, re Moe-of-G, at hand. Wish I could swap some of my loose time for some of the overemployed hours you are putting in. I am trying to make hay, just the same.

Addressee: Elizabeth McCausland.

This letter primarily concerns the essay outline McCausland had prepared for the Riverside Museum retrospective, which focused on Hine's artistic contributions to photojournalism. A portion of it reads: "He was not especially fitted for this detective work, he says today. Personally he is shy, birdlike, easily frightened away. Yet this slender unaggressive man of middle height produced a body of work which anticipated by 30 years the current vogue for the documentary which traversed the sore spots of the United States—slums, sweatshops, depressed agricultural areas. . . ." The rise of the picture magazines and photo publications proves that the American people are being conditioned to be, as Lincoln Kirstein says, a "glimpsing nation." (Kirstein later worked with the photographer Walker Evans, who coined the term "documentary style" to describe his photographs.)

Willard Morgan was the first photo editor of *Life*. In 1938 his Grand Central Exposition of Photography "gave the F.S.A. photographers an entire section, which the Museum of Modern Art toured as a separate traveling exhibition" (Stange, p. 109).

Moe-of-G is Henry Allen Moe, vice president of the John Simon Guggenheim Memorial Foundation.

Source: Archives of American Art.

H-on-H-
September 11 [1938]

Dear E. M. C.;-

The last time Sara made "pickels" she planned a bottle for you that has been delayed, long-time, in delivery.

I am very sorry to hear that B.A. has been having to slow up. Everyone seems to be on a raft of one kind or other. Our raft, out here, may

float us for a time, even thro the winter, especially if R.S.F. limbers up a bit and it now looks as tho your accolade, reinforced by a few weaker attempts (P. M., et al.), would score something soon.

Anyway, our best wishes, ever 'n ever.

 H-

P.S. I just recalled the fact that both Corydon and I are still members of the staff of National Research Project, W.P.A. When our job ran out, in July of '37, we were left on in the hope that they might find more work that needed doing. Sometimes, it is easier to have persons transferred than it is to hire them as newcomers. That might appeal to Mrs. McM.

 H-

P.S. I wonder if it was not a matter of absorption in technique that was the reason the Seceshes didn't accept my social results. From their ivory tower how could they see way down to the substrate of it all?

 H-

Addressee: Elizabeth McCausland.

B.A. is Berenice Abbott.

R.S.F. is the Russell Sage Foundation.

P.M. cannot be identified.

Mrs. McM. cannot be identified.

The "Seceshes" are the Photo-Secessionists, a group of artistic photographers led by Alfred Stieglitz from 1904 to 1917.

Source: Archives of American Art.

September 30, 1938

Dear Lewis,

I am glad to have your letter and George's report of his visit to your home. The hurricane has been pretty close to us and the rush of winter preparation is harder at 70, than it was years ago.

I wish I could give you more information—keep sending questions and some of them may draw fire. I would need considerable time in reflection to get back into the events of those days. Do you recall our talking about a Pilgrim Celebration and a little Russian said he was thankful that the Pilgrims landed on Plymouth Rock. I said I wanted the children of later days to feel equal regard for Castle Garden and Ellis Island. You talked with me about some of the families and items of the old homes kept coming out—there was so much of this in the atmosphere that the inclusion of Ellis Island seems most natural. I went with you early on a trip.

Burritt and Kingsbury were just entering social work from Teachers College and I was called on in this connection by Dr. Folks who spent much time indicating the fields opening to these men. Stone was a factor in this. Were you not with us the evening Bailey Burritt brought the young lady he was to marry to meet us? Florence Kelley was in N.Y. then with Consumers' League—we had known each other well at Hull House. Do you remember when her son Nicholas came to see me about some difficulty at his boardinghouse? (You know Nick now!) Her daughter was still living—we had many concerns over the schooling of her son John. Grace Fichten and others of our students were already active in Henry Street, on the C. League, on Child Labor. (I wonder if any of them met Eleanor Roosevelt who was starting at the same time!)

I had long wanted to use the camera for records and you were the only one who seemed to see what I was after—then too your relations with Dr. Kelley called for compensation. Seldom have I had a need which found someone to carry it out who did not run away with it and leave me out of the part I could do. You were adequate, ready to learn and used not only me but everyone in sight who could help! Jane Addams talked of you for Hull House early—she saw the document possibility. I never felt Dr. Adler or Dr. Elliott saw this—nor Mr. Chubb. Dr. Adler was only interested in moral interpretation and nothing since the Revolution could be used that way—like cheese it must be over-ripe. . . .

Manny

Bailey Burton Burritt and John Adams Kingsbury were journalists associated with the Charities Aid Association.

Henry Street is the Henry Street Settlement, which Lillian Wald founded in 1893.

Elliott and Chubb were executives at the National Child Labor Committee.

Cliff Winfield Stone was an educator and principal of the Ethical Culture School from 1904 to 1906. Manny was superintendent of the school from 1900 to 1906.

Source: Naomi and Walter Rosenblum.

> H-on-H
> [September 30, 1938]
> Pre-Script—Tues. A.M.

Dear M. & A.;

Under "Forthcoming issues," the M-of-A announces the Newhall-Hine exposition of documentary for early issue. I have asked him to try to salvage some returns for me out of it all. Your friend, he of the $24 look, hasn't sent his check yet or maybe did he have a wrong address 'r somethin'?

Jo Israels, my mentor on [the] Empire State job, has just dug up a job that will bring in a little, if it goes through.

Robert Marks polished me off and sent me on, scheduled for about Feb. I thought B. A. listened good, to my photographic ear.

> H

Sara says she loves FIGHT. Keeps her going. She's a belligerent pacifist. O/K

> Postscript—Tuesday P.M.

Dear M.;

To my untutored mind, the family joins in with rounds of applause, the first draft promises to make a knockout. Every new product from you gives me a catch in my breath and a lump in my throat and an increased wonderment, "How does she do it?" One of my early ambitions was to be a second Herrman-the-Great and your new batches of rabbits, flags and whatnot that you pull out of my old battered fedora make me wish I could do a little of that kind of verbal visualization when necessary.

The Porter letter looks like manna to me, especially in the light of what Morgan told me recently. He said he very much wanted to have a

real bang-up exhibit, new enlargements and some big ones, and he thought the *U.S. Camera* might be able to do it in connection with the articles and stand some of the expense. If he thinks that is a good place and can help a bit, I can raise some money to defray whatever is necessary, perhaps could make some under the guidance of our former friend Berenice. Naturally, Morgan wouldn't want to wait too long (Newhall says the Mod. Mus. will not have [a] place until next year). Would it do any good if I took an armful of various things up to Brother Porter? Be glad to do it.

Anyway, I'll be in town Thursday morn and will give you a ring about midmorning and see what time is least obnoxious to you and your program.

Cordially-

h-

Addressees: Elizabeth McCausland and Berenice Abbott.

M-of-A is the Museum of Art.

The Newhall-Hine reference relates to Newhall's forthcoming article, "Lewis Hine," which appeared in the November 1938 issue of *Magazine of Art*.

Herrman-the-Great was a magician from Hine's youth.

Vernon Porter was director of the Riverside Museum.

McCausland's article about Hine, "Boswell of Ellis Island," appeared in the January-February 1939 issue of *U.S. Camera*.

Robert Marks's article "Portrait of Lewis Hine" appeared in the February 1939 issue of *Coronet*.

Source: Archives of American Art.

Among Elizabeth McCausland's papers are notes she compiled from interviews with Hine; these were her source materials for her essay for the exhibition catalogue. Hine's "Notes on Early Influence" obviously expanded on some of her questions and also provided an opportunity for Hine's wife to contribute her memories of the progressive period. It is noteworthy that Hine's point of reference is his own and Manny's letters.

> > >

Notes on Early Influence

Mrs. Hine thinks the trips to Ellis Island were simply the result of an "urge" to capture and record some of the most picturesque of what many of our friends were talking about.

Frank Manny writes that he remembers having, in those early days, strong desires to have the children of later days feel the same regard for Castle Garden and Ellis Island that they had then for Plymouth Rock. Also he recalls that Homer Folks was then drawing into social work such persons as Bailey Burritt (now in A.I.C.P.), Kingsbury and others and that our air was full of the new social spirit. Florence Kelley, formerly at Hull House but at this time marshalling her forces in New York, loomed large to us and especially because I had known in my Oshkosh days a woman who had worked with F. K. and was responsible for the name "Consumers' League." A bit later, when Frances Perkins was a cub investigator of Consumers' League, I worked with her.

Re my getting that first camera dropped onto me, F. M. writes, "I had long wanted to use the camera for records and you [me] were the only one who seemed to see what I was after. Seldom have I had a need which found someone to carry it out who did not run away with it and leave me out of the part I could do. You were adequate, ready to learn, and used, not only me, but everyone in sight who could help. Jane Addams talked of you early for Hull House [the first I ever heard or felt that] she saw the document possibility [I can't fully believe that.] I never felt that Dr. Adler or Dr. Elliott felt this, nor Mr. Chubb. Dr. Adler was mainly interested in moral interpretation and nothing since the Revolution could be used that way—like cheese it must be overripe."

Frank Manny sends me some of the notes I used to write from the field. One, undated but probably 1906, says, "I have just hunted up Mr. Kellogg, Ed. of *Charities* and have started him thinking about the advisability of hiring a man (good-looking, enthusiastic and capable, of course) to do the photography for his magazine and the various societies in the building, part time to be spent writing for *Charities*. As they have all been in the habit of paying $2.00 a print for photos they use, the economy of money and effort appeals to them. [This was not meant to

be sarcastic, I am sure.] Of course, I shall not be hasty in deciding. It means too much to give up all those years of training without due consideration, but it has done its work, perhaps—at least, some work." (Not long after, I held that I was merely changing the educational efforts from the schoolroom to the world.)

Another, about 1910, says, "I'm sure I am right in my choice of work. My child labor photos have already set the authorities to work to see if such things can be possible. They try to get around them by crying 'Fake' but therein lies the value of data and a witness. My 'Sociological horizon' broadens hourly."

About 1910 I wrote, "I have had, all along as you know, a conviction that my demonstration of the value of the photographic appeal can find its real fruition best if it helps the workers to realize that they themselves can use it as a lever even tho it may not be the mainspring of the works. More than the specialists, we certainly need the many who can make practical use of the small (and usually hidden) amounts of photographic talent. I am off here (?), doing another 'sneak.' I have to sit down, every so often, and give myself a spiritual antiseptic, as the surgeon before and after an operation. Sometimes I still have grave doubts about it all. There is need for this kind of detective work and it is a good cause, but it is not always easy to be sure that it all is necessary."

All along, I had to be doubly sure that my photo-data was 100% pure—no retouching or fakery of any kind. This had its influence on my continued use of straight photography which I had preferred from the first. (The last, a note today, 1938.)

HOME EDITION 6:00 P.M.

P.S. While I was taking a little much-needed rest, the first installment (in answer to your prayer, I wonder?) came out in the shape of a feature writer (McGowan) and a photographer, both from N.Y. *Herald Tribune,* routed Mrs. Hine from her garden and announced they wanted a feature story on our being evicted. They seemed to think it would be another case of a wife of a naval hero who could furnish some thrills and more criticism of Home Owners Loan. After an hour of friendly converse, they downed their disappointment and left, but they want ringside seats when anything does break. I told her that there would likely be some publicity about my work (not so exciting as an eviction, how-

ever), and I would be glad to furnish a story when it does. They [*Her.
Trib.*] seem to be just laying for a chance to black up the various gov-
ernment agencies. Sorry they garbled your efforts to do a good turn.
The photo-er tried to get me to let him take a shot at me, which might
mean they are going to run something anyway. Do you think it neces-
sary to phone your contact down there? They said you told him (I forget
the name) that that was what was happening.

> Cordially-
> lewhine

Source: Archives of American Art.

September 30, 1938

Dear Lew:

This is to confirm the go-ahead assignment on the waterfront—seamen,
sailors, stevedores, and so on, for a picture spread, supplementing a
forthcoming article on labor conditions in the merchant marine.

> Sincerely,
> Victor Weybright

Source: Social Welfare History Archives.

October 7, 1938

TO WHOM IT MAY CONCERN:

This will introduce Lewis W. Hine, photographer, and George C.
Stoney, writer, who are on a special assignment for *Survey Graphic* to
portray the maritime scene in a series of special pictures and notes. Mr.
Hine, as a pioneer in documentary photography, has done special work
for *Survey Graphic* for a period of thirty years. Mr. Stoney is a reputable
and competent observer and writer. We shall appreciate any courtesy
shown to them in the execution of this special assignment, the purpose

of which is to show the human side of maritime life and work, aboard ship and on the waterfront.

> Sincerely,
> Victor Weybright

Source: Social Welfare History Archives.

➤ ➤ ➤

> Hastings-on-Hudson
> October 23, 1938

Dear E. M. C.;

From some newly found fossil fragments of early memories (mine and other eyewitnesses), I can now reconstruct more of those early struggles in documentation. The camera was a modified box type with no swing-back and when one wanted to make a vertical composition after doing a horizontal he had to unscrew the box and turn it down onto its side. It had a rapid rectilinear lens with an old type shutter that used a plunger. Films were being used by most persons but, for some reason, I used plates very early in the game and I dunno just why unless it was because one of our sources of information was a photo-supply dealer who retailed suggestions with his supplies. Anyway, they were terribly slow and color-blind and with the plate holders and other apparatus totaled up to a heavy load for a featherweight to tote around. The tripod had to be light even tho flimsy and unreliable in a pinch.

The flashlight was a compound of magnesium and an accelerator, the latter being increased in proportion to the speed desired as the former was very slow. Also, it was rather deadly when it decided to go off prematurely or became caked up and showered sparks over everybody.

Now, suppose we are elbowing our way thro the mob at Ellis (Island) trying to stop the surge of bewildered beings oozing through the corridors, up the stairs and all over the place, eager to get it all over and be on their way. Here is a small group that seems to have possibilities so we stop 'em and explain in pantomime that it would be lovely if they would only stick around just a moment. The rest of the human tide

swirls around, often not too considerate of either the camera or us. We get the focus, on the ground glass, of course, then, hoping they will stay put, get the flash lamp ready. A horizontal pan on a vertical hollow rod with a plunger into which a small paper cap was inserted and then the powder was poured across the pan in what seemed, at the time, to be enough to cover the situation. Meantime, the group had strayed around a little and you had to give a quick focal adjustment, while someone held the lamp. The shutter was closed, of course, plate holder inserted and cover slide removed, usually, the lamp retrieved and then the real work began. By that time most of the group were either silly or stony or weeping with hysteria because the bystanders had been busy pelting them with advice and comments, and the climax came when you raised the flash pan aloft over them and they waited, rigidly, for the blast. It took all the resources of a hypnotist, a supersalesman and a ball pitcher to prepare them to play the game and then to outguess them so most were not either wincing or shutting eyes when the time came to shoot. Naturally, everyone shut his eyes when the flash went off but the fact that their reactions were a little slower than the optics of the flash saved the day, usually.

Other kinds of flash lamps were brought out from time to time— one system used paper cartridges filled with powder and operated by an electric spark. Another used sparks buzzed off a metal into the pan of powder. If it didn't buzz just right, you lost the exposure—*too bad*. Later, some bright man brought out a flash bag that held the terrible smoke and a large part of the light. The smoke, by the way, was a big drawback if you wanted to take a second exposure or if you had any regard for the people who had to stay in the room after you left.

I think that's all just now.

> Cordially
> lewhine

Addressee: Elizabeth McCausland.

By "films" Hine means flexible film; "plates" was the jargon for glass plates.

Frank Manny occasionally accompanied Hine on his photographing expeditions to Ellis Island.

Source: Archives of American Art.

> ➤ ➤ ➤

En route to the grass roots
October 25 [1938]

Dear E. M. C.;-

I forgot a coupla things that may be of some importance.

(1) *Very early* in the game I called on the strong-arm in charge of the newspaper delivery room of *N. Y. American* to ask if he would permit me to make some shots there. It was midnight & young newsies were waiting around to get their papers, others were sleeping near the radiators (cold outside) and it was quite a kind of a hole anyway.

When he barked back at me, "Whadoyou want 'em fer?" I began to think, "If I tell him *all* the truth, he'll never agree to it—just about how much would it be politic to tell him" (all taking some seconds), when he roared, "Now *don't lie to me*—what's the truth?" I did not get the shots. After that, I always had a waterproof nonsinkable reason thought out in advance when trying to outwit the guardians of such special privilege as we were up against.

More significant, however, was one thing that made me extra careful about getting data 100% pure when possible. Because the proponents of the use of children for work sought to discredit the data, and *especially* the photographer, we used—I was compelled to use—the utmost care in making them fireproof. One argument they did use, "Hine used deception to get his child-labor photos; naturally he would not be relied upon to tell the truth about what he found," so the Committee had to assure them & the public that they, in turn, always checked up on Hine to make sure he could be relied upon—all they could say.

The point I hoped to make about Rosskam is that he has gone farther, I think, with real results in synchronizing photos & text than any publisher I know. Take along some of your write-ups in case he hasn't seen many of them. He ought to need you.

Lew

Addressee: Elizabeth McCausland.

Edwin Rosskam was hired by the F.S.A. in 1938 solely to design exhibits and supervise the use of F.S.A. photographs in books.

Source: Archives of American Art.

➤ ➤ ➤

Hastings-on-Hudson
November 7, 1938

Dear Paul;

More and more publicity is following the Portrait by McCausland—
this to culminate in a grand, comprehensive exhibition of the whole
range of my work from 1903 to date. This to be at Riverside Museum
and probably under the direction of the Photo League. Month of
January.

In addition, we want to have a good list of sponsors beginning with
you. Will you serve? No tax. Is it presumptuous of me to ask Helen
Hall? It is the work she would be backing and that she has known a
long time.

Cordially-
lew

Helen Hall was director of the Henry Street Settlement and Kellogg's wife.

Source: Social Welfare History Archives.

➤ ➤ ➤

H-on-H
November 7, 1938

Dear Wictor;-

There are several topics that George & I could document in the near
future in the H.S. area. 1. Social Clubs; 2. Life in the area to be taken
over by Federal Housing; 3. Work with Aliens & Illiterates; 4. Also
some of the varied activities of the Set'ment.

Many of these things are typical of Welfare Work in many large
cities. Now, I wonder if, in our first photo-story done in this district,
we could give a bird's-eye of these several topics that would be as na-
tionwide as possible. The Maritime series is not local—this need
not be.

Ever T-hine
L-hine

P.S. V. W.—Please send me the address of Robert Bruere & his title with the Maritime people. I want to ask him to be on our list of sponsors (see P. K. letter enclosed which please give him).

lew

Addressee: Victor Weybright.

George is George Stoney.

H.S. may refer to Human Services, a codified term for social work.

Source: Social Welfare History Archives.

[November 1938]

To Commodore Vic and the crew of the good ship *Survey;*—AHOY---

Some extracts from the Log of the
Clipper Ship HINE
disabled by collision on the
night of November 8, 1938

Four Bells on the *Eighth Day*

The fog had lifted and the ship, still drifting a little, will soon, we-hope-we-hope, can operate on her (his) own power to new voyages to more unknown ports.

The Captain admits the first long breath since the D.A. was recommitted to his old job of racket chasing.

The Ship's carpenter reports All's Swell, so far.

Also, that, with the sponge-rubber constitution of Youth and the resilience of the Hine-Rich tradition, we are bouncing along over the bounding Main and many-a-happy-day-will-blow when

Hine-Comes-Home-Again.

Hine composed this prose poem to celebrate Corydon's recovery. His "accident," however, is shrouded in mystery. A wood sculptor, he purportedly fell on a chisel. Nevertheless, there has been speculation that the wound was self-inflicted.

Source: Social Welfare History Archives.

➤ ➤ ➤

H-on-H-
November 13, 1938

Dear Wictor;

The enclosed clipping puts, rather mildly, the first score in my most
recent encounter with whatever it is we're all battling most of the time.

It leaves me a bit groggy and hazy over the next question of how to
streamline my horse-'n-buggy outfit so I can drive alone a while. Prob-
ably it will be some weeks before Corydon can do his share again—it
was a serious accident.

The Henry St. documenting will be delayed a while. I told Mc.C. re-
cently, when she was emphasizing my priority rights to certain things,
that I felt strongly that in addition to the title of *has-been,* I still am
able to qualify, in some degree to a little bit of an also-IS, and I can, if I
don't get too many mountains to climb en route.

Hopefully
l-h

Addressee: Victor Weybright.

The clipping reports on Corydon's accident.

Source: Social Welfare History Archives.

➤ ➤ ➤

H-on-H en route
November 22 [1938]
Pardon pencil note

Dear R. E. S.;

Survey Graphic is using a small bunch of my "Work Portraits" in a spread
in next number (Anniversary) due Dec. 1. They have a note of appreci-
ation with it that I want to send to Carnegie Corp., to stimulate their
lagging interest and I would like to enclose a copy of what you & Locke
wrote for [the] book. Mr. Locke thinks (with me) that it could do no
harm to any of us and might strike a sympathetic chord.

Am pretty busy with a lot of odds & ends. Hope to see you sometime.

Cordially

Hine

Addressee: Roy E. Stryker.

The reference to the "copy of what you & Locke wrote for [the] book" refers to the ill-fated "chapter" in Hine's letter to Stryker of November 5, 1937, which was subsequently referred to as an "article" in Stryker's letter to Locke of November 15, 1937, and has now been introduced by Hine as "for the book."

Source: University of Louisville.

H-on-H

November 24, 1938

Dear E. M. C.;-

The old folks will be having a quiet Thanksgiving by themselves but it is one of the realest ones we ever had—Corydon walked around a bit yesterday and they expect to turn him loose before long, loose to lie fallow until he can get back all he has lost and make up a lot he was in arrears for many a moon past.

Yes, we still have a telephone—that Zurfleih person is one of the breed that wants the world to turn back when they want a bit of a job done and then kick if you dare to charge for what is due. I left word at home that any *important* word could be relayed via your place and his came through after I called you. Mrs. H. does not answer phone calls much when alone and we try to have someone here when I am out.

Z. wanted *one* photo of a home in Hastings.

Hope you can get some time off today, anyway.

L-

(over)

Dear B. A.;-

After reading Mc.C's rough draft of what you wrote Moe (I take it as her style), I am moved to say that, if you & I could hit the heart of the bull's-eye with our shots as often as she does with that facile pencil of hers, we would not be a-waiting until our gay nineties roll around for

the long due recognition. If Uncle Moe doesn't respond to that kind of presentation he's surely lacking in what the old-timers in college used to call "Apperceptive basis" 'r somethin'. Let's cross fingers and tell our beads until the decision is made.

 L-

 (over)

Addressee: Elizabeth McCausland.

Zurfleih evidently was a client who thought Hine's services were too expensive.

The final portion of this note was not among McCausland's papers.

➤ ➤ ➤

 H-on-H

 November 27, 1938

Dear McC.;-

You know I wouldn't add a single one to your box of troubles but I think this point is significant. In the first flush of appreciation, Willard Morgan told me that he was sure Edward Steichen would like my stuff. The other day I asked Morgan if it would be better for him to write E. S. about sponsoring our Big Show or for me, and he thought I better do it. On second tho't, it seemed to me a bit presumptuous to burst in on him, after what little he has seen, except for Ellis Island, when W. M. is in so much better position to convert him. Also, I think it would be better for Morgan to be given some responsibility for the show. (This is just between us, of course.) I suppose the reason I did not get a chance at *U.S. Camera '39* was that it is more current but I still feel that I should not back out of the live ones into the limbo of the past, too fast, at least judging from what came out in *Sunday Times* roto today.

Also, you said Photo League would help mount the prints—is it possible that their name would lend a bit of backing or prestige or something if they could be the group sponsor? I'm jest eskin'.

I think it will be necessary to use some of my barrel of enlargements and a lot of 5 × 7 & 4 × 5's also 8 × 10's, simply because I'm not likely to have much time to run out new stuff. Morgan offered, in a moment of out-loud thinking, to have the *Quarterly* make some big

ones as its share of publicity in a hypothetical exhibit we were discussing before the Riv. Mus. came into the picture, and I spoke of it to him later. I feel that you have so much more inflooence there, but if you prefer I'll go to bat with him on all these matters.

Shall be kept at home, most of the time—C. is being prepared for the homecoming but just how we can handle his convalescence and Mrs. H.'s comeback hasn't been revealed. They are both improving. I do not seem to be getting far with my own readjustment to work and to finances. It will have to come gradually and I know it will be an improvement on what preceded the accident.

> Hopefully-
> L-

The rotogravure section featured a two-page photo spread of "the best work published or exhibited in 1938." The images were chosen by editor Edward Steichen for the annual *U.S. Camera 1939*.

Source: Archives of American Art.

In 1938, three years after his first letter to Stryker, Hine apparently recognized the futility of attempting to garner F.S.A. assignments and changed tack. He asked Stryker to suggest sponsors for the Riverside Museum retrospective, which Elizabeth McCausland and Berenice Abbott had organized; Stryker promptly did.

November 30, 1938

Dear Roy Stryker;

A lot of publicity for my documentary stuff has been getting into the magazines and more to come—this to culminate in a grand-and-glorious retrospective showing of the whole story, from soup to nuts, in the Riverside Museum (formerly Roehrich), in January.

We are gathering a good series of sponsors, photo-folk and social welfarers, and hope you will consent to serve in your official capacity if you are able (and willing). Please let me know soon.

> Hopefully-
> lewhine

Source: University of Louisville.

▶ ▶ ▶

[December 1, 1938]

Dear M. C.;

Thanks for the data. I had to send the outline yesterday but will revise it.

You often remind me of that first Greek lady (they called 'er Pandora) who was keeping busy opening chests, etc., and then trying to mop up what she had loosed, only yours are usually on the asset side of the ledger (I hope—I hope). Remember Robt. Marks's account of B. A. & her lame dogs?

Priority in the field is the big fundamental but I do not want to go on record entirely as a *has-been*. I want to be a bit of an *also-is,* and some of my postwar stuff will qualify for that I feel sure even tho it doesn't stack up with some of the moderns.

I would like to borrow back (like a damn Injun-giver) whatever 5 × 7 prints you do not need much. Will drop in some day to get 'em, not a social call. (I'd call it high adventure, 'r somethin'.)

I gave you & Paul K. as references to Uncle Moe. Maybe he thought you had given advance sponsorship.

Spent another morning up at Tarrytown Relief. Finally, they doled out an order for five dollars' worth of groceries. That's all, so far. Now I'm trying to get hold of the W.P.A. Federal Art Man.

This all goes into the Record, but I *much prefer* not to have it published for a time at least.

Addressee: Elizabeth McCausland.

The Robert Marks account has not been located.

Because of his problems with finding work, Hine was forced to register for welfare.

Source: Archives of American Art.

➤ ➤ ➤

H-
December 2 [1938]

Dear Mc.;-

A few years ago, I did an interesting series of studies of textile workers
for Sidney Blumenthal (president of Shelton Looms), who is noted for
as rational attitude on labor as most good employers can have in [the]
present system, I hope, and I am thinking of asking him to be a spon-
sor. One reason being that, some day with the proper approach, he
might be willing to contribute something toward our enterprise until
it gets off the rocks. I know his private sec'y personally and Sidney
himself pretty well, but he has told me that he cannot follow my "per-
suasive tongue" too far. However, what would you do?

Tom Tippett, with whom I worked very closely on Nat. Research
Proj. the first half of last year, heard of my situation so he ups and
writes to Henry Allen Moe, whom he knows very well, having written
a book on his miner's life (*Horseshoe Button* [*sic*]) for the Fund. It
sounds plausible to me and didn't leave much left for anyone else to
write when it is hitched up to what you [and] (B. A.) and O. L. sent in.
Lydenberg, Dir. N.Y. Pub. Lib., wrote recently that Moe had asked
him for opinions and he had given the best he was capable of. B. N.
hasn't said whether "they" would let him be a sponsor. I have jacked
him up again.

After your first question mark re. getting Alex. King to sponsor, I
asked W. Morgan and he seemed to think it was worth getting, so I
sent a note to him—just rec'd reply from his sec'y who is good friend of
me. I guess we're in for putting him in somewhere and maybe they'll
come thro.

Paul Harris, Director, The Des Moines Association of Fine Arts,
sounds well, as will Philip Youtz, Consultant & Director, Golden Gate
Inter. Expo. (if he consents—he always does) and me friend Dr. Adams
of Albany.

I swear, to high heaven, that if you live through the next six weeks,

I'll never never ask you to do any more extras on my behalf. If I can't float by that time, let 'er sink, sez I.

Ever-

L-

Sara thinks A. C. Langmuir, a neighbor & friend, who is known as [the] donor of a thousand dollar annual prize for achievements in chemistry and also as [the] brother of the great Irving Langmuir, Nobel winner, etc., might be a help as sponsor. He has done a deal in documentary photo-ing himself. Or are we just cluttering up the front page of [the] catalog needlessly? A postal on Sid. B. as well as A. C. L., sometime please.

Addressee: Elizabeth McCausland.

Tom Tippett's book is entitled *Horse Shoe Bottoms* (New York and London: Harper & Brothers, 1935).

O. L. was Owen Lovejoy.

B. N. is Beaumont Newhall; "they" would be the Museum of Modern Art's executive board.

Alex King was picture editor at *Life* magazine. Hine's "Ellis Island Madonna" appeared in its June 6, 1939, issue, page 39.

Dr. Charles Adams was Hine's economics professor at the University of Chicago; later, he served as director of the New York State Museum in Albany.

Source: Archives of American Art.

➤ ➤ ➤

December 2, 1938

Dear Lewis:

Sir:

You do not know what an honor you confer upon me!

I shall be more than happy to serve in any capacity possible on this showing of your photographs. I am delighted no end to think that such a thing has come to pass. You may use my name in any way you see fit to help promote you.

I most certainly would like to come up at the opening if it is physi-

cally possible. There is no reason, though, why my name cannot be used—and the official title attached! There are no objections to such things down here, providing it isn't used for selling or circulation of a commercial sort. I am satisfied this is not.

I have been very much pleased with the articles that are coming out; my only criticism is that they are all inadequate. I was particularly disappointed in the *American Magazine of Art*—it had been my hope that they would give several pages to your pictures.

I have been doing some talking here in Washington, and looking forward to the possibility that some government agency—such as the Archives—might obtain the money and see fit to purchase your negatives, and place you in the position of Editor of this collection. There seems to be so little interest among certain people down here in real good photography. I do not give up hope—I will keep trying.

I wish that, before long, I could have the chance to see much more of your things than I have ever had the chance to do yet.

My last two trips to New York have been so hectic and short that I did not call. Expect soon to make a little more leisurely trip, and will let you know when I am coming to town.

Just a suggestion—please do not make any move until I give you the O.K.—would you be interested in having Rexford G. Tugwell's name as a sponsor? I think, if I can get into town in the next few days, that I could get him to do it; I would have to do it personally. Please do not mention this to anyone. Let me know what is the latest date his acceptance could be made. I would prefer to have Rex—if I couldn't get him, I am quite sure I could get Joe McGoldrick (the Comptroller). If we had plenty of time, we might even be able to get LaGuardia, but that would take quite a little work.

Please be quite frank, and tell me if those two names do not seem to be useful. I am terribly interested in doing everything we can to put this thing across in as big a way as possible.

Also, would you care to have the name of somebody like Professor Harry J. Carmen—of the Department of History, Columbia University? Harry is getting very much interested in the placing of good photography as a part of the historical material of our country.

Even though Harry wouldn't be useful, I do want him to know more about your work.

Best regards to you.

Roy E. Stryker

Rexford G. Tugwell was chairman of the New York City Planning Commission.

Fiorello LaGuardia was mayor of New York City.

Source: University of Louisville.

En route, N.Y.

December 5 [1938]

Dear Roy;

Watta pal! I always felt you were being saved (by the Lord) for some big thing, and now I know. This is going to be the biggest of the Big Shows since Barnum (or before) mebbe.

McCausland, the go-getter, is manag. director. The list of sponsors ranges from Stieglitz & Steichen, Willard Morgan (mayhap Paul Strand) & B. Abbott, PHOTO LEAGUE and *you* (now), thro Lydenberg, Director of N.Y. Pub. Lib. and Doc Blossom, Chief (or Asst. Chief) of Div. in Congress. Library, B. Newhall, of M. of M. A., Paul Harris, formerly with Metropol. Mus. of Art & Cloisters, now Director of new Assn. of Fine Arts, Des Moines, Iowa, mayhap Phil Youtz, big man at Golden Gate Expo, San Fr., then Paul Kellogg, Helen Hall, Homer Folks, Owen Lovejoy, Bob Bruere of the Maritime Com'n, and others pending but not penned yet.

I am to have entire lower floor of Riverside Museum, opening about Jan. 10 so you may have until nearly Jan. 1st to round 'em up or Xmas anyway. (What title may I give you? Make it complete as possible.) Do come to opening. We'll stage something. *Nothing commercial* about it.

Much may depend upon the success of this Show. Guggenheim Fund is carefully following up all the references I gave them & the responses that I have heard from are simply unbelievable to one who has been overlooked for so long because he couldn't join the publicity game while

so long out of a job. Then I could make of N.Y. P. Lib. & Cong. Lib. an Archives (each) & keep the negs. for a while.

Alex. King, in chg. of pix for *Life,* has had 6 pages of me-stuff set up & ready for months but couldn't elbow in. Now he promises to use the R. M. celebration to set off the spark. That, also, will depend upon what we do with the Show.

So, I would say that anything you can do to land Prof. Carmen, of Columbia, McGoldrick, Comptroller, Mayor LaG. of course, if you possibly can—and especially my (former) friend Rex T. If you can't get him, some other national figure, to head up Bruere & Lovejoy & Blossom, of Wash'n and the westerners I told you about.

God Save The King (whoever he is).

> Cordially
> lewhine

Edward Steichen was associated with Stieglitz and the Photo-Secession.

After Newhall left the Museum of Modern Art in 1947, he assumed the position of director of the photography department at George Eastman House, later called the International Museum of Photography at George Eastman House.

By "Congress. Library" Hine presumably means the Library of Congress.

The "R. M. celebration" refers to the opening of the Riverside Museum exhibition.

Source: University of Louisville.

> N.Y.
> December 7, 1938

Dear Vic and Paul;

Things are on the *up* at home so I am putting in more time in N.Y.

The Big Show at Riverside Museum in January is gathering momentum & may be momentous. Am getting swell sponsors, now am anxious to get Madam Perkins to join up. Occurs to me that youse guys might know better how to obtain that permission. She worked with me when she was a cub investigator for Consumers' League, altho she may have forgotten that and me, which makes me hesitate to crash the gate myself.

The show will be as complete a retrospective showing of How-

come-Hine as we can assemble with our very limited means. Have a deal of stuff on hand that can be used and, tho some of it is a bit shop-worn, it will be that much more like old documents.

Now, please be helpful & write to our dear Madam and wangle a good permission out of her. It may be too much to ask of her to try to get up to our Preview—January 10th, 3 to 6 P.M.—but a number of our sponsors, from Wash'n & elsewhere, have asked to be permitted to come to it.

Do try to see a copy of the next issue of *U.S. Camera* magazine, out in a couple of weeks, with its "Boswell at Ellis Island" revealing Mc-Causland at her zenith and the Hineographs well reproduced.

> Hopefully, -ever-
> -Hine-

Source: Social Welfare History Archives.

> Hastings-on-Hudson
> December 8, 1938

Dear Roy Stryker;

As I have gone over your suggestions for sponsors, I am so pleased with 'em that I hereby commission you to think over the field of notables down there and if any looks good to you, from the point of nationwide publicity (so many of those we have are New Yorkers), just go ahead and "esk-'em" and then tell me. Am trying to get Madam Perkins, who worked with me when she was a cub investigator for Con. League, years 'n years ago. I have Owen Lovejoy, my boss on Child Labor so long; Bob Bruere, Chmn. Maritime Com'sn, also a pal; Elwood Street, Dir. of Public Welfare, Dist. Columbia, another co-worker; and YOU— that's all, so far from Wash'n. Following your suggestion, we plan to make an event of the Preview, Tues. Jan. 10, 3 to 6:00. If you land the Mayor and Rex T., it will be a contribution. Please try to make the Preview yourself and all who accept are drafted for similar service, if humanly possible. Abbott [and] Beaumont Newhall, who have been responsible (with McCausland, of course) for my revival, Steichen,

Stieglitz, Paul Strand, Tom Maloney, head of the new *U.S. Camera* mag. The second issue, out in a coupla weeks, has a grand article on my Ellis Island documentation—"Boswell at Ellis Island." Try to get it. I want you to know Tom Maloney, who is trying to work out some rational plan for documentary repositories in connection with *U.S. Camera*. He's a go-getter. Meantime, I am planning to make the N.Y. Pub. Library the first collection that will grow as things work out, and as many others as are possible.

A bunch of prominent social-welfare bugs, a few businessmen and publishers, etc. will round out our list. A real adventure and the best of it is, they all think that I have the goods to back up most of their extravagant statements. Be glad to get your reaction to the article in *U.S. Cam.* mag.—oh, yes, *Life* mag. is promising to bring out a blast just before or during the SHOW.

Keep me posted, and see what you can do with your friends and neighbors—we can stand 5 or 6 more, if they are gettable.

> Cordially & Hopefully-
> lewhine

P.S. Be sure to tell me what title I am permitted to use for you. Also, I have not forgotten that you were beginning the rediscovery of Hine back in the pre-KEN days. If, only, that had panned out.

By "pre-KEN days" Hine was referring to the mid-1920s, when he was virtually unknown outside the social welfare community and Stryker used his photographs in *American Economic Life*.

Source: University of Louisville.

> 170 Edgar Lane
> Hastings-on-Hudson, N.Y.
> December 12 [1938]

Dear Roy;

I cannot find a certain 5 × 7 print of a wistful "Carrying-in-boy in a Glass works"; it is the only good print I have & neg. [has] been lost. I sent it to you for those slides you made for N.Y. talk & do not remember getting that bunch back. If you have it, please Special it to H-on-H.

If you succeed in getting Rex T. for sponsor, would it be hard to

locate Dr. Munro to join up as one of the trio that used my prints?

We do not know, yet, whether the official title will be used. Even tho we do for some, the title (official) can be omitted if it is preferred that way. Plans are working out *very well*.

> Cordially
> Lewhine

Source: University of Louisville.

➤ ➤ ➤

> H-on-H-
> December 13, 1938

Dear Florence;

Briefly, it's this way. The Riverside Museum, for its first foto-show, has asked me to put up a coupla hundred of characteristic studies that will make a retrospective showing of the range of my work from A to Z. Opens January 10.

Some amateurs—Stieglitz, Steichen, Strand, Abbott, McCausland, Roy Stryker, Philip Youtz, as well as our Paul, Helen Hall, Homer Folks, Robert Bruere, Sidney Blumenthal, Owen Lovejoy, *and* Florence Kellogg (and others still less well-known)—have seemed glad to be put on the spot. Inasmuch as there is no obligation of any kind, except to say that one still believes in Hine—and if you can't get to the preview maybe one will try to toddle up on some subsequent day—I think there ought to be no trouble.

The real reason I asked you to paw out these two for me is that, for a long time, I have not known just how much those two did still believe in Hine and it would temper the slap if that kind of reaction could come secondhand.

> Cordially and Hopefully-
> Lew-

P.S. I have had no negative responses, rather a wonderful lot of real appreciation has come back with most of the acceptances. L-

Addressee: Florence Kelley.

From 1908 to 1911 Hine free-lanced for the National Consumers' League, the tenement home work agency that Kelley directed.

"These two" are unidentified.

Source: Social Welfare History Archives.

December 13, 1938

Dear Rex:

I just recently had a letter from Mr. Lewis Hine. I believe you will remember him as the person who supplied some very excellent photographs for *American Economic Life.* I look back now, and realize that his photography made much more impression upon me than I had suspected at the time. During the last couple of years, I have had an opportunity to look over a great deal of his work, and find that he had been doing the type of work which we are now doing, back in 1908 and 1912.

When I first came down, it was my hope that we could have him on the staff, but unfortunately, it was impossible to make the type of arrangements which would be satisfactory to him. Also, I fear that he is not again going to do the type of work he did in his younger days.

It seems as though a group of New York people are promoting a show of the best of his photographic work at the Riverside Museum. I am anxious to do everything I possibly can to make this show a success. I am wondering if you would be willing to let your name be used as one of the sponsors. If you would be willing, there certainly is justification enough on the basis of the pictures used in the *American Economic Life.*

Also, may I ask whether or not you think it would be possible—or feasible—to get the Mayor as a sponsor?

I am sending you a copy of Mr. Hine's letter to me. I know you are continually bombarded by people who want you to serve on committees, and hate like hell to bother you again, but this is a gesture to a hell of a nice fellow, and it may be one of the last things we can do for him. Unfortunately, he is not a person who was ever able to push himself out to the front, and as a consequence, his reputation as a photographer has been known to only a few.

Expect to be in New York sometime this week, and will give you a ring regarding this.

Best regards,

Roy E. Stryker

Addressee: Rexford G. Tugwell.

Stryker is apparently alluding to the fact that Hine was unwilling to relinquish his negatives and photographs and insisted on printing—or at least supervising the printing of—his own work.

Stryker wrote a similar letter to Harry J. Carman, Columbia University, and on November 22 to Joseph D. McGoldrick, Comptroller's Office, New York, to whom he said that "Hine is one of America's greatest photographers." McGoldrick was the New York City comptroller.

Source: University of Louisville.

December 14, 1938

Dear Lew:

Have written Tugwell, but as yet have no answer. Have not had a chance to get to New York yet, so could not take it up with him personally. Expect to be there this week, and will give him a ring.

My title is Chief, Historical Section, Division of Information. It is all right with me if you use the title. It doesn't mean a damn thing, but it sounds good.

Have been trying to think of additional people down here who might be interested in having their names on your sponsorship list. Do you think Senator Wagner would be any addition? I don't know whether I could get him, or whether he would be interested in doing it; don't happen to know him, but might be able to get to him with the idea.

Will write a letter to Tommy Munro, but am not very optimistic about it.

I owe you a thousand apologies: I was sure that all prints which you lent me had been returned. Made a search, and found the whole set; they are coming back to you under separate cover sure.

After the rush is over, I would like to make arrangements with you to get some prints of some of your best things. I will talk to you later about this.

I am awfully glad that things are going along as well as they are.

I might have another name or two to suggest to you when I get to
New York.

> Sincerely yours,
>
> Roy E. Stryker

Robert Ferdinand Wagner represented New York in the U.S. Senate for two terms, from 1927 to
1939, and introduced the Social Security Act, the National Labor Relations Act, the Pension Law,
and other social and economic legislation.

Source: University of Louisville.

➤ ➤ ➤

> H-on-H-
>
> December 15, 1938

M'dear Roy;-

The prints arrived just in the kernick of time and I thank you, sir. The
Show snowball gathers size and importance each day. Lots of apprecia-
tive cooperation by all. Some seem worried that there might be some
subtle financial obligation involved, but 'tain't so—not a holdup but an
uphold. Hope you may be able to plan to take a few extra hours (or days)
in New York. Show runs nearly to end of Feb.

> Cordially-
>
> Lew-

Source: University of Louisville.

➤ ➤ ➤

> December 20, 1938

Dear R. E. S.;-

I fear me I have neglected to tell you that it would be *swell* if you could
get Senator Wagner, but don't go to too much trouble about it. Just
received a lovely letter from Frances Perkins, accepting with a very
cheering letter with reference to our cub days in investigation.

Dec. 28 seems to be about the last day for names to be added to list

of sponsors, but may be longer, especially if a couple of important ones are really pending. Will let you know.

Hastily-
lewhine

Addressee: Roy E. Stryker.
Source: University of Louisville.

December 22, 1938

Dear Rex:

Sorry I did not see you when you were in Washington, the other day.

I asked Grace to remind you of Mr. Hine's coming show. I am assuming that you will let your name be used.

The time is getting close, and I have suggested that Hine give you a ring at your office, so you may be expecting this telephone call.

Regards,
Roy E. Stryker

Addressee: Rexford G. Tugwell.
Source: University of Louisville.

December 22, 1938

Dear Lewis:

I did not get a chance to go to New York, so was unable to see Tugwell in person, but I have learned that he is quite willing to serve on the committee. Suggest that you phone him, and tie the thing up. You can reach him by calling Worth 2-5600, New York City Planning Commission.

My not coming to New York has upset my plans a bit, so I am writing Joe McGoldrick and Harry Carman, asking them to serve on the committee. I will get the letters in and ask them to expect a call from you.

It doesn't look now as if I could get hold of Wagner—too many

people have to be talked to. I can't find the particular one who is most important.

If you will call Mr. Joseph D. McGoldrick, Comptroller's Office, or in the event of his absence contact his secretary, Mr. Haslett, the 27th or 28th, he should have my letter, and will be able to give you an answer.

You can get Harry J. Carman by calling University 4-3200 and asking for him there.

Best wishes for a pleasant Christmas.

> Sincerely,
> Roy E. Stryker

Source: University of Louisville.

> New York
> [December 1938]

Dear Roy;

You have done a swell job but I fear it has taken a lot of time. Tugwell & McGoldrick both accepted. Columbia man is away.

Do try to be at the Preview. If not possible, let me know ahead so I can be sure to be there. On some stated day I can call your N.Y. office when I reach the City & find out what time you can be free.

> Cordially
> lewhine

Catalog will come to you soon.

Source: University of Louisville.

> January 3, 1939

Dear Lewis:

Was in New York for a very short time last week; would have called you, but knew that I didn't have time for you to get into town.

I would [have] like[d] to get hold of Elizabeth McCausland, but she wasn't in, so I left word with Berenice Abbott.

I called in, and found that both Joe McGoldrick and R. G. Tugwell had agreed to let their names be used. I had hoped that we could get one or the other of these people to get the Mayor to let his name be used, but this would have required their camping on his doorstep until the job was done. I know it could have been done, but I just didn't have sufficient time to follow it through.

I am delighted that things are going so well.

Sorry that the letter to Carman went astray; we had sent one special delivery, but it was to the wrong address, and came back. I called him when I was in New York, but he was out—at the meeting of the Historical Association.

Have written a letter to Bob Lynd at Columbia, suggesting that you will send him a couple of copies of the folder, and I have asked him particularly to take time and go down and see the exhibit, and to recommend it to his graduate students.

I am also anxious to have Harry Carman come down and see the exhibit and recommend to the instructors in the orientation courses that an announcement be made to all students recommending their attendance. What I shall do is drag Harry down with me on the opening afternoon, for which you have already sent me tickets. I am going to write him now, and ask him to meet me and come down if he possibly can; if not, he can come later. There are other people around the faculty whom Harry will be able to suggest for attendance also.

Saw Tom Maloney for a few minutes, and he told me that Steichen agreed to have his name on the sponsorship list.

Wish you would send a couple of tickets to Ed Locke, U.S. Film Service, 347 Madison Avenue. He would appreciate them.

Hope the New Year brings you all kinds of success.

With best regards,

> Sincerely yours,
> Roy E. Stryker

Tom Maloney was publisher of *U.S. Camera.*

Stryker's acuity with respect to Hine's photographs as historical documents and original source

material deserving of historians' attention and study is worth noting. To this day the academy tends to overlook the value of pictorial information.

Source: University of Louisville.

H-on-H-
January 6, 1939

M'dear Roy;-

You certainly have done yeoman service in the cause of the rehabilitation of Hine. Many, many thanks. Am following up your suggestions. Really, the Mayor is used so much, he isn't any novelty but the ones we did get are worthwhile (Forty—count 'em). Will look for you Choosday. A number have said they'd come, or try to—many cannot, of course. Just one more thing to fill up your leisurely call on the Big Town— wotta life.

Cordially-
lewhine

Source: University of Louisville.

The Riverside Museum retrospective was the only major exhibition of Hine's photographs in his lifetime. For Hine it symbolized the recognition he had long sought as an artist. In addition, it represented the coming together of important figures in the art, social welfare, public service, museum, and corporate communities, all of whom formally acknowledged the multifaceted contributions Hine made to their respective communities. From the art and documentary photography world such luminaries as Alfred Stieglitz, Beaumont Newhall, Paul Strand, Edward Steichen, Willard and Barbara Morgan, and, of course, Elizabeth McCausland and Berenice Abbott sponsored the show. From the social work community Homer Folks, Helen Hall, Paul Kellogg, Florence Kelley, Owen Lovejoy, Frank Manny, and Frances Perkins were represented. From the public sector of museums and government institutions Dr. Charles Adams, Dr. Frederick Blossom, Paul Harris, Henry Miller Lydenberg, and Philip Youtz acknowledged their support. From the government arena of public service Robert

Bruere, Joseph McGoldrick, Roy E. Stryker, and Rexford Tugwell lent their names. From the world of photojournalism and publishing Alex King and Tom Maloney were supporters. As for the private sector, the lone corporate statesman to stand by Hine was Sidney Blumenthal.

➤ ➤ ➤

January 11, 1939

Dear R. E. S.;-

We missed you terribly but accepted your telegram as gracefully as was possible. A good gang turned out and they all said it is a good show.

My time at the Museum, now on, will be spasmodic. Next week no good. After that, could you plan ahead to get Locke, mayhap Stryker, and any others to meet me there some afternoon that is pretty sure to be free for you.

Am sending catalog.

Cordially-

H

Addressee: Roy E. Stryker.

Source: University of Louisville.

7.
Hope and Loss, 1939–40

After the exposure of the Riverside Museum exhibition and the euphoria it generated, Hine, who was on the relief rolls, was confronted with foreclosure on his home. Once again, Kellogg intervened, but this time his goodwill and letter writing could not help: the Hines lost their home to the Federal Home Loan Bank Board but continued to live there on a monthly basis.

On the death of his wife in December 1939, Hine wrote: "I have not seemed able to make the necessary adjustments and to keep up communications." Nevertheless, he approached Stryker about an exhibition, continued to negotiate with the New York Public Library, and applied to the Guggenheim Foundation for a grant to sponsor a new group of portraits of craftsmen.

Also included here is a diatribe by Hine about the unions' lack of support of his work and a letter written on behalf of Walter Rosenblum, a young photographer and member of the Photo League. Rosenblum was later responsible for "rescuing" Hine's work from oblivion. After Hine's death, Corydon gave his photographs and papers to the Photo League. In 1951, when the League disbanded, Rosenblum took responsibility for the materials and donated them to George Eastman House, which Beaumont Newhall then directed. In 1977 he, his wife, Naomi, and Alan Trachtenberg coordinated the exhibition "America and Lewis Hine," which toured nationally.

➤ ➤ ➤

H-on-H-
January 13 [1939]

Dear Roy;-

I expect to send you either some proof or a copy of *U.S. Camera* mag.
that has my Ellis Island article. One of the associate eds. tells me it
would be a good thing if some of the persons who read it were moved to
write them an appreciation. In your case it would help if you told them
something of your background for judging the merits of my work (and
the article). Also, I think, omit the personal tie between us so it will
not seem to be a setup. There is no rush, but sometime soon.

The real reason for this underground work being that some of the
editors, including Edward Steichen, are very enthusiastic over my stuff
& want an article, before long, on Child Labor, etc. One of the eds. is
not so keen as he might be if he heard from the country at large. After
this, I'll let up on weaseling so much of your time. I certainly do appre-
ciate your enthusiasm and have not forgotten that your real interest in
the rehabilitation of Hine started long before the Newhall, Abbott &
McC. gang got started. Wotta Life!

Ever
T-hine-
lewhine

Source: University of Louisville.

➤ ➤ ➤

January 15, 1939

Dear Victor;-

Somewhat over a hundred friendly spirits managed to get in to the
preview with Beulah bravely shouldering the burden for *Survey*. We
understood why the rest stayed at their post.

I am sending you first sheets of the *U.S. Camera* setup on Ellis Is-
land. One of the editors suggested that it would help put through the
other series on Child Labor, etc., if the voice of the country were a bit

vocal and he said I should ask friends to write to The Editors of *U.S. Camera* magazine, 381 Fourth Ave., N.Y. City, expressing briefly whatever enthusiasm they can bring to bear on them. No real rush but when you can.

Have a small job up in Hartford for this week and my son is able to resume his old job of Assistant Cameraman on part-time. Some more opportunities are beginning to peep out, cautiously of course, but encouraging maybe.

> Cordially-
> lewhine

Addressee: Victor Weybright.

Source: Social Welfare History Archives.

January 23, 1939

Dear Elizabeth:

Congratulations on a very nice job of managing the show for Lewis Hine! You have done an excellent service, and I hope that St. Peter will add one solid gold string to your harp.

I am so glad that Lewis Hine is getting some attention now, while he is able to appreciate it. His pictures are bound to take a more important place in the history of American photography, and as a part of the history of America.

I haven't had a chance to get up and see the exhibit, but will, probably next week. I was, unfortunately, kept in Washington on the day of the opening.

I liked your article in the last *U.S. Camera* very much. It all adds up to a damn good job for Hine.

Those of us who know him, do appreciate the time and attention that you gave to this.

Regards to Berenice.

> Sincerely yours,
> Roy E. Stryker

Source: University of Louisville.

▶ ▶ ▶

January 30, 1939

Dear Lewis:

I got into an awful mix-up down here and was unable to get out of town, so unfortunately I missed the show. Sometime, I think I shall take a few days off, and come up to your place and start looking through your photographs. I have had several words of report, however, from 'round about.

I am inclined to think that it might be advisable for a person like Ed Locke to write to the editors of *U.S. Camera* regarding the article. I would gladly do it, but everybody around the place knows of my interest in your work; they have heard me express myself several times. So I am passing it on with your suggestions. I can give them plenty of basis as to why I can be a judge of such an article. I will be glad to do it, but I think it will be of much more value to you if done this way.

Things will probably be pretty hectic down here for another month, then I should have a little free time, and can get back up to New York. We are getting a new laboratory, and have had to change our plans so many times, that I don't dare be very far away from here at any time.

Please don't worry in the least about "weaseling" my time. You are welcome to anything that I can possibly do. Please don't be hesitant at any time to drop me a note and ask anything that comes to mind, and if I can't do it, I will say so.

I do hope we'll get together before long.

> Best regards,
> Roy E. Stryker

Source: University of Louisville.

March 22, 1939

Paul, m'dear;-

Guggenheim declined, with thanks, but there is still a lot of fight left in the old hulk.

One of my most stimulating backers is Dr. Chas. C. Adams, Director of the New York State Museum, who by the way was in charge of my first class in economics and ecology at the Univ. of Chicago in 1902. His latest suggestion I enclose copy of.

If you think of any way you can help to build a fire under Uncle Shelby before I go to see him, please do it. He has never, in any way I know of, shown any appreciation of what I have been struggling to do all these years. Routzahn never was willing to use anything that he had to pay for—the written word and graphs were his long suit.

I think the R.S.F. should plan to have a set of these prints in their library.

Go to it, old chap, and I'll run around and bark at him when it seems strategic.

> As-ever-and-ever-
>
> lew-

Shelby Harrison was director of the Russell Sage Foundation. Routzahn was a staff member at the foundation whose vision of social work conformed to the charities workers' antiphotographic stance.

Hine reapplied to the Guggenheim Foundation a second time in 1939–40 to produce a series on American craftsmen. In 1938 he had unsuccessfully proposed the same project to the Carnegie Corporation.

Mrs. Routzahn was director of exhibits at the Russell Sage Foundation.

Source: Social Welfare History Archives.

> May 31 [1939]

Memo to V.W.
> F.K.
> P.U.K.

From L.W. Hine

This June *Fortune* has a visualization of "The life & circumstances," as they call it, "of A Railroad Fireman." It is not at all streamlined and not so very modern but I am a bit pleased with the result, *and others are too*.

They do not use much of this kind of material but this is a start.

"A Railroad Fireman" appeared in the June 1939 issue of *Fortune*, pages 78–84. Gil Burck wrote the text, although he is uncredited.

Source: Social Welfare History Archives.

June 25, 1939

Oom Paul-

Anna Bogue called me in for a very delightful talk—she is definitely interested, said she had had good letters from you and others to whom she has written but nothing very promising has emerged, yet.

She has given me a good letter to Raymond Leslie Buell and I am trying to get audience there. It seems possible that that Round Table of *Fortune*'s could make use of some of my work.

Lindemann is much submerged but is interested. Louis Adamic wants to work on my possibilities, soon.

I have found a good literary agent who is enthusiastic of the possibilities of getting out some photo-books on industry and immigrants. I wrote Lindemann that there is still plenty of power in the old motor if only someone will furnish the gas for a while (maybe a little oil too).

Hopefully
Loowie

Anna Bogue was a grants officer at a New York foundation, but I have not been able to identify which one.

Raymond Leslie Buell was a professor of history and economics and a writer who contributed articles about international relations to *Fortune* magazine.

A photograph from Hine's Ellis Island series appeared in an article entitled "The Melting Pot" in *Fortune,* July 20, 1939, page 72.

Edward Christian Lindemann was a prominent sociologist and author.

The writer Louis Adamic used Hine's photographs in his book *From Many Lands* (New York and London: Harper & Brothers, 1940).

Source: Social Welfare History Archives.

*After the publication of his successful photo essay "A Railroad Fireman," in the
June 1939 issue of* Fortune, *and his photograph "Ellis Island Madonna" in a
photo spread in the June 5, 1939, issue of* Life, *Hine envisioned the possibility
of having his images reproduced "weekly or oftener" in a local daily newspaper,*
The New York Post. *On July 6, 1939, he asked Kellogg to write its pub-
lisher and included a "homemade publicity statement that might kindle a
spark." Entitled "Looking at Labor," it is a lyrical iteration of the motivating
influences and social forces at work in his work portraits series.*

July 6, 1939

Dear Paul;-

I enclose a homemade publicity statement that might kindle a spark in
the bosom of the new owner of *New York Post,* Backer, if you could put
over to him, in a brief note, that here is a chance to have a series of my
photo-studies, old and new (weekly or oftener)—"Looking at Labor"—
that could do a lot to get across to their readers the things we have been
hammering on so long.

Please do not spend time on it, but a word might be enough.

Lew-

Source: Social Welfare History Archives.

Looking at Labor
Past & Present

While the new century was being born, baptised and taught to walk,
with Jane Addams, Jacob Riis and so many preaching the new gos-
pel of "my brother's keeper," Teddy R. promoting the idea of the work-
er's human rights in industry and the pursuit of life, liberty, etc.,—

Lewis W. Hine was the visual spokesman for social welfare—the
"Social Photographer." He has, for a third of a century, been interpret-
ing Life & Labor to those who need to know that the worker is not a

lower form of life, necessarily. In his *Men at Work* he says, "Cities do not build themselves, machines cannot make machines, unless, back of them all, are the brains and toil of Men. In this Machine Age, the more machines we use the more do we need real men to make and direct them." In this book and in others he has illustrated, he shows them following the same urge that has driven all men forward since mankind began. The first item in his credo is that *"Work itself has ever been one of the deepest satisfactions that come to the restless human soul."*

To interpret, visually, the strong personalities that have been developed by industry, and upon whom we depend for our daily life, to show the true dignity and integrity of the labor they perform, has been Hine's chief mission in his documentation of all these years.

Source: Social Welfare History Archives.

July 14, 1939

Dear Lew:

I have a letter from Mr. Fahey, chairman of the Federal Home Loan Bank Board, saying that he is having the matter looked into at once and "see what may be done."

> Sincerely,
> Paul

The Federal Home Loan Bank Board threatened to foreclose on Hine's Hastings house because of his inability to maintain mortgage payments. Fahey was trying to arrange a reasonable payment schedule.

Source: Social Welfare History Archives.

August 2, 1939

Dear Lew:

This will let you know that I have received a very friendly and specific letter from Mr. John H. Fahey, chairman of the Federal Home Loan Bank Board, Washington, D.C. Mr. Fahey secured reports from their

New York office carrying reassurance that "every effort is being made to work out some proposal whereby you can carry the loan."

He writes that you should get in touch with the New York State office, submitting the best payment program you are capable of maintaining. This will be carefully considered and "everything reasonable within the circumstances will be done" in order to afford you every possible opportunity to retain your place, adding "you may be sure that everything possible will be done to rehabilitate this loan."

> Sincerely,
> Paul

Source: Social Welfare History Archives.

August 8, 1939

Paul, m'dear;-

Your first intercession with Herr Fahey came in the nick of time and also his report to you, recent, was timely. I am seeing what & whom I may see down at the office, and will let you know.

A lotto things are bubbling all around the lot—getting bigger and better book contacts daily and I am sure some of them will land me somethin'. Also my contacts with Foundations seem to be on the gain.

> Ever-
> -lew-

Source: Social Welfare History Archives.

October 13, 1939

Dear Paul;-

It was your effective note that finally drove the entering wedge into Shelby's cautious mind and he is already looking forward to the "possibility" of more to follow, later, the modest beginning he has sanctioned. This is a "UNIT" of one hundred selected prints on Immigration to go into the R.S.F. Library for use of the School of Social Work,

library reference and exhibit, research, archives and whatnot. We hope to have the collection properly "researched" and adequate descriptive material in usable form. Mrs. Routzahn is working with me on it. The allowance is modest too, but it helps.

Other organizations are leisurely nibbling at various propositions— I hope they may not let the bait get overripe before they decide to do something about it.

I have reconditioned the application for Craftsmen that I tried on Carnegie, brought it up to date, localized it in N.Y. City & State, and sent to Guggenheim. Lindemann is still helping me.

As a result of your intervention with Fahey, the HOLC is granting a delay in the exodus for rest of the year.

More when it comes along.

Lew-

The Russell Sage Foundation purchased 208 enlargements of Hine's work portraits. These were eventually transferred to the New York Public Library's Local History and Genealogy Division in the 1960s but are currently housed in the Prints and Photographs Division.

HOLC was the Home Ownership Loan Corporation.

Source: Social Welfare History Archives.

October 19, 1939

Dear Mr. Kellogg:

This is to advise you further re the loan of Lewis W. and Sara R. Hine, 170 Edgar Lane, Hastings-on-Hudson, New York.

I am sorry to inform you that we have not been able to accomplish anything in this matter and although foreclosure of the account was originally recommended on July 14, 1939, legal action was not instituted until September 1, 1939. Subsequent to the institution of foreclosure no proposal either in writing or verbally was made by Mr. Hine for the purpose of obtaining further favorable consideration. Our New York office on several occasions has written Mr. Hine asking him to submit the best payment program he is capable of maintaining. They report Mr. Hine has failed to communicate with them.

It would appear that our Corporation has done everything possible to

avoid foreclosure in this case but were unable to extend further consideration in view of the fact that they could obtain no suggestions from Mr. Hine as to what his future plans were.

I am sorry we were not able to work out this case more successfully.

Sincerely yours,

John H. Fahey

Letterhead: Federal Home Loan Bank Board, Washington.

Source: Social Welfare History Archives.

October 23, 1939

Dear Lew:

The enclosed, in confidence, comes from Mr. Fahey. I am sorry the impression reached him from the New York office that you did not communicate with them. It strikes me that it might still be feasible to do something to improve the situation if you should do this even now.

With best wishes,

Sincerely,

Paul

Source: Social Welfare History Archives.

October 24, 1939

Dear Paul Kellogg;-

From your report of Mr. Fahey's letter to you, I would say that it gives a picture that is out of focus.

Here are the main facts, according to my records. Although foreclosure was talked about for some time, it was not started. Instead, I gave up my deed in return for a lease giving free rent until Jan. 1st. The Contract Broker, who is in charge of this account, has agreed to consider renting the property to me for a few months next year until I can make necessary adjustments for a proper setup elsewhere.

At regular intervals, through the year, I have gone to the bottom of the situation with various agents, interviewers, etc. in the N.Y. office and finally with Mr. A. P. Plog and his Assistant on June 20th. It all reduced to the fact that [because of] the continued delay in getting my Prospects more definite, I had no financial program to offer. No request for a written statement from me was made.

I feel sure that I have done all I could to cooperate when requirements have been made clear to me. Also, I have felt that the Corporation has been more than fair to me and I wrote a letter of appreciation to that effect to Mr. Fahey on Sept. 29/39.

It is all clear now until the time comes for adjusting the question of rent in the new year, and I am sorry that there has been any misunderstanding to cause you and Mr. Fahey extra trouble.

Again, my sincerest gratitude for all you have done on this, as on so many other needs.

> Cordially-
> Lewis W. Hine

November 2, 1939

Dear Paul;-

A very special friend who is at the heart of things at the New York Public Library tells me, *in very strict confidence,* that if I can contact the two following persons who are Trustees for the Library and much interested in doing things for it, I might be able to get up a real good series of my photo-documents that would be presented to said Library.

Do you know of any way to get a personal interview with Percy Strauss of Macy's? Also Henry James who was active in Regional Planning, I believe?

> Lewhine-

➤ ➤ ➤

November 25, 1939

Dear Paul;-

Just had a very stimulating visit with Beardsley Ruml. Another swell
guy it is a privilege to know. He seems to sense the project I am work-
ing on but also has some ideas for other work he may be able to steer me
into. Mr. Strauss will not be available for another month but some
other things are unfolding.

Whitney F. still promises to give me some help and so I am begin-
ning work on my City Crafts project to build it up to a point where it
will be more attractive to Guggenheims.

R.S.F. collection of 100 prints is nearly complete. Am working on,
not only the N.Y. Pub. Lib., but Lib. of Cong., and Smithsonian and
points between.

Hope I can give you a vacation for a time, except for small, emer-
gency calls for temporary first aid.

 Ever-'n-ever

 Lew-

Publicity still goes on, from time to time.

Beardsley Ruml was a well-known writer who specialized in tax reform.

Whitney F. cannot be identified.

Source: Social Welfare History Archives.

*After months of negotiations with the Federal Home Loan Bank Board to avoid
foreclosure, Hine's financial circumstances grew steadily worse. On December 19,
1939, John Hager, assistant to John Fahey, who had been attempting to ar-
range a schedule of mortgage payments, sent him a letter confirming that the
board had formally taken title. Hager also apologized for the "misunderstand-
ing"—that is, Hine's supposed failure to comply with Fahey's requests for infor-
mation. Hine sent a copy of this letter to Paul Kellogg with the following com-
ment: "At last I got that misunderstanding cleared up. I am getting a reason-
able rent for as long as they do not need the house."*

➤ ➤ ➤

December 19, 1939

Dear Mr. Hine:

Because it evidences that there has been a rather unfortunate misunderstanding, Mr. Fahey intended a reply to your letter of November 16 and had hoped to answer it himself. Owing, however, to the pressure of urgent matters, he has asked that I write you in his stead.

Apparently you interpret certain of the letters you have received as indicative of a feeling on the Corporation's part that it did not have the benefit of your full cooperation. I can assure you that the Corporation is under no such impression.

Reports received here in Washington from the New York Office have always spoken in commendatory terms of your attitude toward your loan obligations and of your willingness at all times to deal with the situation on as constructive a basis as your resources would permit. In clarification of any possible misapprehension, the Corporation is concerned to have you know both that it recognizes the sincerity you showed in seeking a solution of the loan problem, and that this sincerity of purpose is genuinely appreciated.

Earlier letters did, it is true, contain a reference to the fact that the Corporation had received no proposal in recent months which would have justified it in continuing to carry the loan. The purpose of this reference, however, was not, in any sense, to question the earnestness of your efforts, but simply to point out, in explanation of the Corporation's position, that the end result of these efforts was inadequate, nonetheless, to prevent the course of action that the Corporation was finally constrained to adopt.

It is a matter of sincere regret to the Corporation that your circumstances were such as to preclude a payment schedule that would have enabled it to go along with the loan, and instead of the outcome mutually hoped for by the Corporation and yourself at the time the loan was granted, that it finally became necessary for you to offer and for the Corporation to accept, your tender of a deed to the property.

Very truly yours,
John M. Hager

Letterhead: Federal Home Loan Bank Board, Washington.

Hager was executive assistant to the chairman.

Source: Social Welfare History Archives.

December 28, 1939

Dear Friends-B. & E.;-

Time and again, for months past, Sara has expressed her wish to write you and see if you could get out to see her and us.

She has been waging a losing fight with decreasing resistance, but it did not become apparent until she collapsed with grippe which turned into pneumonia. They rushed her to the hospital, put her into the oxygen tent and gave transfusions. Spite of it all, she passed on Christmas morning and today, her birthday, returned to her beloved Mother Nature.

There were so many things she needed to do and to find out—she insisted to the last that you folks could help her answer some of the riddles. There must be some way such a soul can carry on under better conditions—there's no use in anything else.

Sincerely-
L. W. H.

Letterhead: Mrs. L. W. Hine.

Source: Archives of American Art.

January 25, 1940

Dear Paul;-

It is just a month since Mrs. Hine, after a siege with grippe, pneumonia and complications, passed away. I have not seemed able to make the necessary adjustments and to keep up communications.

This will mean quite a different life for both my son and me—we will stay here for a while, maybe for some months, and that is all I know now.

There is so much to be done, finishing up and continuing lines that have been started, and in which she had a real part—it is a challenge and an inspiration that we just have to meet.

After all the spade work you and Lindemann did with Anna Bogue, she agreed to get me a grant of $250 which was whittled down until finally only $150 was given. With this, ten big prints, framed, were purchased for the walls of classrooms of the N.Y. School of Social Work.

Shelby has started the Hine collection of prints for the R.S.F. Library and another proposition is pending.

The Guggenheims do not seem very much concerned over my application on "City Crafts," yet. More anon.

Lew-

Source: Social Welfare History Archives.

➤ ➤ ➤

[February 1 or 2, 1940]

Dear Miss Sabloff;-

When the announcement for Paul's coming appreciation for his refugee work is sent out, please keep me posted if you can.

Lew-

(It ain't quittin' time yet.)

Source: Social Welfare History Archives.

➤ ➤ ➤

April 3 [1940]

Dear Bro. Roy;-

I would like to have my prints back at your very early convenience. They have been away nearly two months and, apparently, have not been much needed. The Bookstore has not even given me the courtesy of an acknowledgement but suppose they're fed up on fotos maybe.

Thank you for making the attempt. I am still finding demand for the stuff locally but not very far afield. Enjoyed your talk at P.L. muchly.

Lew-

The Bookstore was maintained by Stryker's agency. Hine apparently sent photographs there at Stryker's suggestion in the hope that someone would arrange an exhibit of his work.

P.L. is the Photo League, an organization that provided darkroom space to social documentary photographers, hosted lectures and events, and published a newsletter, *Photo News*. Helen Gee notes that it was "founded in 1936 as an offshoot of the Film and Photo League, which itself began in 1930 as a cultural wing of the Leftist Workers' International Relief. . . . The Photo League had an open membership policy and its photographers favored a straightforward style" (*Decade by Decade*, p. 44). Its members included Aaron Siskind, Morris Engel, Arnold Eagle, Walter Rosenblum, W. Eugene Smith, Sid Grossman, George Gilbert, and many others. With the onset of the Cold War the group became a prime target of Sen. Joseph McCarthy, chairman of the House Un-American Activities Committee. McCarthy focused on the members' political orientations and put the group on a list of subversive organizations the attorney general created in 1947. Four years later, because of declining membership and interest, the Photo League folded.

Source: University of Louisville.

April 8, 1940

Dear Lewis:

I am terribly sorry that the Bookshop seems to have delayed your exhibit so much. I don't know what in the world is the matter with them. They have managed to postpone it now about three times. I am getting a bit disgusted, myself.

As you will see by the enclosed circular, your exhibit is to be shown next week. Just as soon as they have finished with it, I will see that it is packed and sent back to you at once. I cannot understand why they have never written you or explained in any way this delay. I have asked them twice to do so; I shall call them again today.

I saw Ed Locke for a few minutes the other day, and he is all for our getting together for an evening. I haven't been back to New York since the trip for the Photo League. I shall probably be up again soon, and will let you know.

> With best regards,
> Roy E. Stryker

Source: University of Louisville.

➤ ➤ ➤

April 16, 1940

Dear Hardman;-

When anyone says, again, that I am not a Union man, give him a few plain facts.

First place, if there were any union that covered just a few of my activities, I'd belong all right.

More than that, anyone who knows the work I have done for a third of a century will agree that I have done much more than most of your 100% Union members who are so emphatic about observing the letter of the union law—visualizing and helping to correct many of the handicaps of the workers, Child Labor, living, recreational and educational conditions of the underprivileged, and, especially, to create better understanding for all persons of the human values and personality of the workers (as I have done on several occasions for the Amalgamated).

Moreover, partly because of this overemphasis upon bare membership in the union, I have had very scanty support for my work from the unions that should be leaders in such kinds of publicity as I have been carrying on. You have been one of the very few union leaders who have appreciated and been willing to use my services and you know, as well as I do, that the Unions and the Workers have been the losers by this lack of vision and understanding.

> Very sincerely yours,-
> Lewis Hine

Addressee: J. B. Hardman, editor and director of educational activities, Amalgamated Clothing Workers of America.

Despite Hine's commitment to celebrating human labor, with few exceptions American unions did not acknowledge his work portraits by hiring him for free-lance assignments or by using material from his archive. In fact, Hine was generally ignored by the unions—because he was not a member of any union.

A note in Hine's own hand to T.A.M. (who is unidentified) reads: "T.A.M. Please return. J.B.H. [Hardman] is a man with vision, yet seems compelled to economize on this kind of work. Another union objects to him about using my work, 'He's not a union man.' Sic S-."

Source: Naomi and Walter Rosenblum.

While preparing for his retrospective, Hine was introduced to the Photo League by Berenice Abbott. This community of social documentary photographers, many of whom unabashedly emulated Hine's style, helped him print and mount the exhibition. But, perhaps more important, the offices of the Photo League became a site where Hine was seen as a doyen of photography. The loft on East 21st Street in Manhattan was a center for lectures, exhibitions, and research. Later that year Hine placed a group of his own prints in its library so that young photographers could study them.

It was during this period that Hine met Walter Rosenblum, a fledgling photographer who was touched by the older man's artistic ability, wit, and compassion. Among the community of like-minded photographers, Hine and Rosenblum enjoyed a special mentor-protégé relationship, one which apparently informs Rosenblum's work to this day.

After the dissolution of the League in 1951, Rosenblum rescued Hine's collection from oblivion. By that time it included Hine's study prints and original photographs, negatives, and letters from the estate, which his son Corydon had donated. When Beaumont Newhall became director of George Eastman House, he accepted the collection. Recently, all of Hine's prints, negatives, and diapositives (transparencies) were transferred to an optical video disc and are currently available for study in this medium.

➤ ➤ ➤

July 12, 1940

Dear Mr. Slover:

I have been thinking over my first reaction to your inquiry of the 2nd and have talked with the only person that I know who would fit into your program. As you may know, I spent six weeks with T.V.A. working out a special series of studies, when the project was just beginning—I think I understand some of your probable needs.

Walter Rosenblum is a very capable, all-around photographer— 23 years old but very mature for his years. He is single, in very good health, does not use alcohol, drives a Plymouth very well.

I have known him for over a year, and have been closely associated

with him in the work of the Photo League, where all agree he has done and is doing a splendid piece of work. He has a very agreeable manner (quite a way with people), an ingrained spirit of service, very cooperative in a sensible way.

Also, he is thoroughly honest, efficient, hard working and with a compelling urge to do the best work of which he is capable and with aspirations to progress. I think he has made very good use of his many contacts with good photographers both in the west and here. He is a little inclined to be too modest about his achievements, not a bad trait, these days. He has a fairly good education but gets his real stimulus from life.

This may sound unreasonably optimistic to you but I have been very careful, all along, to consider the needs of the Authority more than any desire on my part to see him located. In fact, I have looked carefully to find any drawbacks in his setup and have not been able to do so. Therefore, I can give him my very best recommendation to you and assure you that I am convinced that it would be equally advantageous to you all and to him if you should decide favorably.

> Very sincerely yours,
> Lewis Hine

George Slover was director of the Tennessee Valley Authority's Knoxville office. A note to Walter Rosenblum in Hine's own hand reads: "This is a bum copy of the letter I sent to T.V.A. today. The best of it is that it is sincere, every word of it. I suggest you make a copy of it for your file. Someday you might want to make application to somebody else and could use it. Lew."

Source: Naomi and Walter Rosenblum.

September 9, 1940

Dear P. K.;-

Another wave of journalistic appreciation has appeared relative to my work and much of it is wound round the R.S.F. experiment in starting a collection of my studies in their Library. I can show you that stuff later but it so happens that Shelby will be deciding, in a week or so, about what he can allow from next Budget to extend the collection.

Just a line or two might help turn the scales. I have asked Miss S. to try typing up such a note.

> Ever-'n-ever
>
> Lew

Source: Social Welfare History Archives.

> September 20, 1940

Dear P. K., m'dear;-

Again, I thank you. Shelby read me your letter, evidently pleased and impressed, and I am sure it will help me get a larger appropriation for coming year which begins soon.

> Thine-
>
> Lew-

Source: Social Welfare History Archives.

After Hine's unsuccessful grant applications to the Guggenheim Foundation and the Carnegie Corporation to produce a series on craftsmen, in October 1940 he returned to a theme that had preoccupied him from the first, the immigrant experience. He reapplied to the Guggenheim Foundation to examine how "representative individuals of foreign extraction" have influenced American democracy. He sent a copy of his proposal, entitled "Plans for Work," to Roy Stryker for his comments and suggestions.

Fear of ethnicity and the influx of "foreigners," which had pervaded American politics at the turn of the century, reemerged with full force in the 1930s as horrified Americans watched the destruction wrought by Hitler, Hirohito, and Mussolini. Hine's project represented a response to antiforeign sentiment within the country, which would become increasingly shrill after the Japanese bombing of Pearl Harbor a year later.

October 17, 1940

Dear Roy;-

I have a sort of a recollection that I once asked you if I might send in your name as a reference on a Guggenheim Fellowship. However, I took a chance this time, meant to last year. This is the third offence so I ought to get a sentence this time, maybe.

You did such a swell job, rounding up sponsors for the Riverside Show and I'll ever remember it with deep gratitude, also how disappointed we were that you were not able to get there.

I am sure this outline can be revised to advantage so it will bring in the bacon. As you can see, I do not verbalize nearly as effectively as I visualize, and I would want suggestions, later, on how to make the thing more workable. Also, I am sure you can reinforce my efforts, either before or after Mr. Moe sends you word. I enclose a copy of "Plans for Work," submitted recently.

You might think of some way to get the results before the public. I have been, for some time, planning to get up some travel exhibits for continuous use. Rosskam thinks there is a possibility that the results would make a book.

>Ever-'n-ever
>Lew

Source: University of Louisville.

[October 1940]

Plans for Work

I propose making a series of photo-studies dealing with the life of representative individuals of foreign extraction to show their reactions to and influence upon our American democracy.

What Mumford and Adamic have done can be reinforced and amplified, perhaps made still more intelligible to the average person, by

these visuals. The result would constitute an objective and factual document recording the significance, to the country, of the lives of many of our adopted citizens.

Using my collection of immigrant studies made at Ellis Island and elsewhere from 1905 to 1930 as a working base, I would follow a number of these persons and families, and others that came at the same time, to their present homes. During those years I photographed many Poles, Italians, Jews, Russians, Germans and the whole range of races represented—some were headed for the steel mills, some for the mines, many were looking toward the farm life of the West. With the cooperation of agencies working with the foreign-language groups, including the newspapers, I shall find many individuals that adequately represent their racial stocks.

Then I propose to record as many phases as possible of the varied activities of their home life, their work life, community and recreational contacts and participation in fraternal, cooperative and trade union organizations.

If "Our strength is our people," this project should give us light on the kinds of strength we have to build upon as a nation. Much emphasis is being put upon the dangers inherent in our alien groups, our unassimilated or even partly Americanized citizens—criticism based upon insufficient knowledge. A corrective for this would be better facilities for seeing, and so understanding, what the facts are, both in possible dangers and real assets.

Owen R. Lovejoy, the spearhead of child labor reform during the first quarter of the century, wrote, "The work Hine did for the abolition of that evil was more responsible than all other efforts for bringing the facts and conditions of child employment to public attention. The evils inherent in the system were *intellectually* but not *emotionally* recognized until his skill, vision and artistic finesse focused the camera on these social problems in American industry."

Dr. Erle F. Young, Professor of Social Work in the University of Southern California, commenting on my collection of photographs in the Russell Sage Library, wrote, "In my judgment, this constitutes a body of source material in the field of social work and public welfare

which is unique and indispensable for the student. I have been for some years gathering material for a documentary history of social work in England and America."

Source: University of Louisville.

November 21, 1940
170 Edgar's Lane
Hastings-on-Hudson, N.Y.

My dear Mr. Kellogg,-

Russell Sage wrote to my nephew, Corydon Hine, about furthering Mr. Hine's photographic collection.

Corydon would like to know if they have any definite ideas or plans in mind.

He is expecting to leave the house soon. He will do no more photographic work.

Unless he can come to some agreement with Russell Sage Library, the negatives will have to be disposed of, to some other organization.

Write to Hastings, or telephone, between 8 : 30 and 5 : 30 at Testrite Instrument Co., 57 East 11th St., please. Gramercy 3-3340.

Sincerely,
Lola C. Hine

After an operation at the Dobbs Ferry Hospital, Hine died on November 4, 1940. His photographs and negatives were given to the Photo League and later found a home at George Eastman House (now the International Museum of Photography at George Eastman House), Rochester, N.Y.

Source: Social Welfare History Archives.

Biographical Notes

by L E W I S W. H I N E

Hine wrote these biographical notes in 1940 as a "resume" to accompany the application he submitted to the Guggenheim Foundation. He proposed a photographic study to show how "representative individuals of foreign extraction" influenced American democracy.

Topical as his application was in light of the war raging through Europe, he died before the foundation could make a determination on its merits.

Born, Oshkosh, Wisconsin, Sept. 26, 1874.

Parents kept a restaurant until 1890—they, my older sister & I lived upstairs.

Finished grammar school, 1890, and went to work in upholstering factory
 until late 1893.

Depression closed factory and I had long periods of unemployment which I
 filled up with handy work such as cutting & splitting firewood,
 delivering bundles for local cut-rate clothing store and a small
 department store. Sold water filters from door to door. Was em-
 ployed by local bank first as janitor, then collection clerk, hound-
 ing merchants who had drafts drawn upon them for delinquent
 accounts; studied stenography at night and was promoted to work
 on the books and to act as private sec'y to the Cashier.

I was neither physically nor temperamentally fitted for any of
 these jobs and when Frank A. Manny, who had come to the State
 Normal School, Oshkosh, as Head of Experimental Education,

Psychology & Education, happened to make my acquaintance, he made a place for me to work as clerk in the school and sec'y to him. After four years' work in bank ('95 to '99), I went to the Normal for part-time work and the rest for study.

After one year there (1900), he arranged for me to work my way through the summer school at the new Chicago Institute, where I studied under Colonel Francis Parker and other very progressive teachers, preparing for special work in teaching nature study & geography in the elementary grades, and taking special courses in Science, Pedagogy & Education.

In the fall of 1900 I entered the University of Chicago for a year. Spent half time as clerk in the Information Office, the rest in classes under such teachers as Dr. John Dewey, Ella Flagg Young and a young professor of Science & Ecology, Dr. Charles C. Adams, who later became Director of New York State Museum, Albany, N.Y. He was one of my early teachers of economics.

In the fall of 1901, Mr. Manny, who had become Supt. of the Ethical Culture Schools of New York City, brought me to N.Y. for work teaching elementary science in the grades. At the same time, I entered New York University and, in 1905, received degree of Master of Pedagogy.

In 1905 & 6, I delivered a few "Public Lectures" in the then popular series sponsored by the Dept. of Education of N.Y. City.

In 1904 Mr. Manny saw a need for visualizing the school activities (this was in many ways one of the most progressive schools in the country), so he conceived the idea of having a "school photographer" and I was elected to the job.

Until 1908, I carried on this visualizing of the school and at the same time made many trips to Ellis Island, and into the tenements and streets where the underprivileged lived.

My contacts with the social welfare organizations increased and especially with the organ of social welfare, called *Charities & the Commons*. I received much encouragement from the editors of this magazine and from some very liberal persons, John Spargo in particular.

In 1908 I decided to leave school work and devote my time to the visual side of public education.

First I did a series of photo-studies of life in the slums of Washington, D.C., the negro quarters near the Capitol, to illustrate a book, *Neglected Neighbors in our Nat. Capitol*. Then some time in Pittsburgh interpreting the findings of the *Pittsburgh Survey*, which was the first intensive study of life in an industrial community, and it resulted in the publication of the series of volumes, six in all, called the

Pittsburgh Survey. This was really the beginning of my lifelong interest in Men At Work, the fruits of which have been appearing ever since. The first study of a man at work to receive recognition (it is thought) was my Old Printer, done in 1905.

In 1908 I started a more serious interpretation of child labor, which I had begun several years before, and which I carried on, as much of the time as could be spared, for over fifteen years (to 1925). This was backed by the Nat. Child Labor Com'tee. My first trips through West Virginia, the Carolinas & Georgia brought to light, in a visual way, the horrors of child labor and my photo-studies formed the backbone of much of the publicity and propaganda that followed for twenty years or more. I worked through all the child-employing states thro the entire country. At the same time, I carried on publicity work for this Committee, as staff photographer, investigator, lecturer, exhibit director and even as lobbyist and writer.

During these years, there were interpolated special assignments in photographic interpretation, following the *Pgh. Survey,* for all the important magazines—*The Survey, Everybody's, Outlook,* wherever the radical or muckraking magazines carried on. Many of such assignments were done for social welfare organizations, for labor groups and also industrial corporations.

A year in Europe, during the Great War, interpreting the activities of the American Red Cross, chiefly in France and the Balkans, ending with a trip through the Balkans, just after the Armistice, on the Human Costs of the War.

1920—Continued with the activities of Red Cross in America, various photo-investigations for the Interchurch World Movement, such as the life and achievements of the negro, North & South.

1921 to 30—Special assignments interpreting Life & Labor for Social Welfare & Labor Organizations, such as Amalgamated Clothing Workers (1923) & Western Electric Co., Consumers League, Nat. Tuberculosis Com'tee, Tenement House Com'tee mission, Boy and Girl Scouts, Milbank & Harkness Foundations (1925–26), Child Welfare, Recreation Committees. Also cooperated with Public & Private Schools, Libraries and Municipalities.

1930–31—Staff Photographer, showing the man-power of a skyscraper, from start to finish. Empire State Bldg.
Published *Men at Work,* Macmillan Co., an industrial picture book.

1932–33—Series of studies of textile workers for Shelton Looms ending in a Portfolio, *Through the Threads,* widely used for exhibit and school

work; exhibit and loan collections of these prints were furnished the Metropolitan Museum of Art, N.Y. City, Teachers College Library, N.Y. City, Harvard University School of Business Administration.

1933 to 1937—Various Government Projects

 T.V.A.—1933

 T.E.R.A.—1934

 P.W.A.P.—1934

 R.E.A.—1935

 W.P.A., various projects—N.Y. City (1935), Westchester County, et al.

 W.P.A.—National Research Project, various industrial studies, 1936–37.

1938—Photo and research activities for Nat. Broadcasting Company.

1939—Exhibits of Retrospective Presentation of entire range of my documentary photography, 1905 to 1938.

 This was first shown at the Riverside Museum, N.Y. City, then at Des Moines, Iowa, Assn. of Fine Arts and at the New York State Museum, Albany, N.Y.

Other exhibits of my photo-studies have been shown, during the past 30 years, all over the country—the most notable of them World's Fairs at San Francisco, 1915, at Chicago, 1936(?), at New York City, 1939,—

 Also at The Civic Club, The National Arts Club, The Advertisers Club, all at N.Y. City. Some in European countries also.

Source: Naomi and Walter Rosenblum.

Index